Portrait photography

Portrait photography

John Wade

Focal Press
London & Boston

Focal Press
An imprint of the Butterworth Group
Principal offices in London, Boston, Durban, Singapore,
Sydney, Toronto, Wellington

British Cataloguing in Publication Data

Wade, John
Portrait photography
1. Photography – Portraits – Amateurs' manuals
I. Title
77.9'2 TR575

ISBN 0-240-51111-5

First published 1982

Series designed by Diana Allen
Book designed by Roger Kohn
Cover photograph by Jennifer Bates
Printed in Great Britain by Robert Stace Ltd,
Tunbridge Wells, Kent

Contents

Why portraiture?

Frank Peeters

Anyone can take a portrait. The typical snapshot of a friend or relative on the beach is testimony to that. Such a picture may not be a magnificent example of lighting and composition, but it is nevertheless an elementary form of portraiture. That's where it starts for many photographers: on the beach with a friend and a simple camera. But then gradually, almost imperceptibly, the subject begins to get a grip on you, until you suddenly realise that maybe it isn't enough to merely snap a friend standing by the sea. You begin looking for the right *sort* of person with the right kind of face; you start to notice locations, backgrounds; you become aware of lighting, realising that it isn't quite right, not knowing at this stage what's wrong or how to set about improving it, but definitely knowing that you want to try. You're hooked. You're finished with snapshots. You're ready to start taking portraits.

The history

Portraiture is one of the oldest forms of photography, despite the fact that, back in the early days, it was also one of the most difficult. Because of the long exposures involved, models needed a lot of patience, not to mention self-control, and photographers with only one shot per plate were duty-bound to get it right first time. Although the first photograph was taken by Niépce in 1826, the first *practical* method of photography was the daguerreotype, which appeared in 1839, and it was with Daguerre's lengthy, cumbersome and often dangerous form of photography that the first portrait studios opened in the mid-1800s. The model who posed for a photographer in those days would have found himself in a studio, probably on the top floor of a building with a window that ran along the north-facing wall and across the roof, to allow in as much light as possible. Today, as you will see when we come to later chapters,

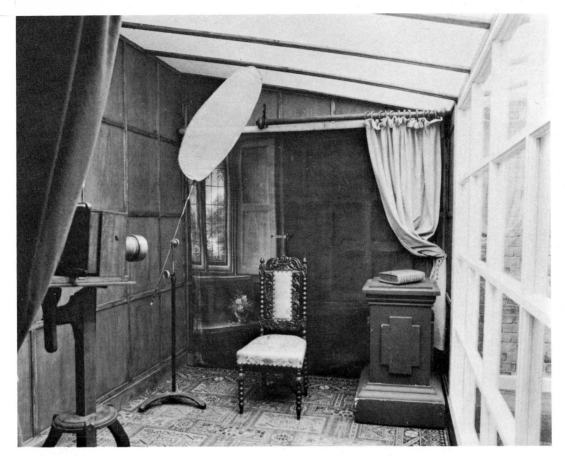

north-facing windows are still best when it comes to available-light portraiture. Equipment and techniques may have changed, but the quality of certain types of light will remain the same for ever. Many studios in the early days were equipped with a series of reflectors to make the most of the light available, bouncing it about the room and getting as much as possible on to the subject. There were even stories of studios that sported a complicated system of mobile reflectors, out in the street, that followed the sun and reflected light on to other reflectors inside the studio, all controlled by the photographer from beside his camera. That photographer would have been using a huge plate camera mounted on a solid tripod and pointed at a chair in which the 'victim' sat with his head resting on an iron support. The support was hidden from the camera, but firm enough to prevent him from moving during the lengthy exposure times. Today it all seems laughable. And yet, before you laugh too loud, just take a look at some of those old portraits, the daguerreotypes, the calotypes that followed, and the immensely popular cartes-de-visite that sprang from the days of wet-plate photography. Some of the lighting, and even the expressions on the faces of the subjects, would do credit to any

Portraiture of the past. An original carte-de-visite, popular during the latter years of the nineteenth century.

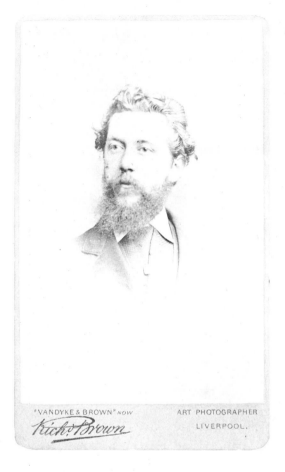

"VANDYKE & BROWN" NOW
Rich? Brown

ART PHOTOGRAPHER
LIVERPOOL.

anything else has changed and will continue to change this trait. It is the introduction of studio flash. Exposure times these days are not just short, they're infinitesimal. Flash stops just about any movement, catching a fleeting expression as it crosses a subject's face, arresting all motion and producing more natural results than ever before. The days when the photographer was forced to ask his model to 'hold it' are gone for ever.

The lure of portraiture

Portraiture, then, has fascinated photographers from the beginning. If you have already tried your hand at it, with or without much success, you know something of its lure. But maybe you are a photographer in search of a subject, and you could be asking yourself, quite simply: why portraiture? What is so fascinating about photographing another person? A face is a face. You look at a whole stream of them every waking hour of every day. Why should you want to start looking at them through your viewfinder, or capturing them on film? The answer must be subjective. Different people have different reasons for taking all sorts of different pictures, and so I can only tell you why I personally like taking portraits. The biggest reason is that I like people. No two people are alike, no two faces are the same, and every one presents a new challenge: finding the right pose, the most effective lighting, a relevant location . . . all the elements that add up to a perfect portrait.

photographer of today. The methods were crude, but the results were often superb.

With the advent of faster film, wider lenses and all the other modern gadgets available to you and me, portraiture should by now have broken away from the old confines to become a more lively art form. Yet so many photographers still produce stiff and awkward shots that might have come straight from the Victorian studio. What is more, many subjects actually demand that they be photographed this way, simply because it's the way they've always seen portraits before. One thing maybe more than

To the committed portrait photographer, a session that is working well can be exciting in a way that no other type of photography ever could be. What generates that excitement is the effect of two people, photographer and model, working together towards a common end, each giving his or her particular talent to the production of a great picture. When a session is going right, you and your subject can feel like the only two people alive, cut off from the rest of the world, locked together and intent only on the next shot, the next expression, each one better than the last. When the photographer is a man and the subject is an

For a male photographer, pretty girls make popular subjects. This shot was taken outdoors against the light and a wide aperture used to blur the background. *Brian Gibbs*.

Right: male portraiture can be very challenging, especially when the chance occurs to photograph a face such as this. *Kevin MacDonnell*.

attractive girl, it would be useless to deny that there isn't something just a little sexual about the whole thing. There is, but in the most innocent of ways. It's like a mild form of flirtation: the photographer with the model, the model with the camera. She knows that he finds her photogenic, and for 'photogenic' she reads 'attractive'; why else would he want to photograph her? He knows that she thinks enough of him to pose, why else would she be there? Yet photographer and model do not have to be of the opposite sex to create a genuine feeling of excitement in a good session. Women photographers often take the best glamour pictures; the male photographer who is genuinely enthusiastic about portraiture will get as much out of photographing another man as he will a woman. There's nothing weird or unnatural about it. It's simply an almost indefinable feeling that occurs when you know you are getting great pictures.

There comes a point in any portrait session when both photographer and model are relaxed, they are comfortable in each other's company, the photographer is giving suggestions for posing and the model is reacting totally without embarrassment or self-consciousness. Given that point, maybe half-an-hour or so into the session, the photographer begins to know exactly what will work and what will not work with this particular model. From that moment on, as you look through the viewfinder at your subject, you'll find every once in a while that an expression will cross his or her face that you *know* is going to make a great portrait. If you're anything like me, you'll actually feel a quick churn in your stomach at that point, a surge of excitement that transmits itself to your fingers and straight to the shutter release. Click. Its in the bag. And you know without a shadow of doubt that it's right.

The same sense of excitement comes with lighting your subject. You sit him or her down, set up the camera and begin playing with the lights. Then, for the first time in the session, you look through the viewfinder and see things from the camera's angle.

The face fills the viewfinder or ground-glass screen. Suddenly it's no longer just a face, it's a potential photograph, and that old stomach-churning feeling comes again to tell you that you are on the right track. To take a good portrait, well composed, sensitively lit, with a model who contributes the right expression at the right moment, and then to see the finished result the way you originally visualised it, can be one of photography's most satisfying experiences.

That's why photographers take portraits. But why do models pose for them? Ask one hundred models and you could come up with as many different reasons, but basically it comes down to vanity. They like having their pictures taken, they like looking at themselves. That isn't meant as a criticism of models. It's just a fact, and one for which photographers should be thankful. Without that vanity, there would be no one to pose for them. The professional model of course poses for the camera as a way of earning a living. Such models know they are photogenic, they know how to make the very best of their looks and they know they can make money out of being photographed. It may have been vanity that got them into the job in the first place, but it's sheer hard work that keeps them there, and any photographer who hires a professional model will do well to remember that fact. Calling a model vain isn't an insult; vanity may be considered a sin by some, but for a model it's a virtue, and it doesn't hurt the photographer to know that it's there under the otherwise perfect personality of his model. Vanity, remember, likes to be pampered and a little pampering goes a long way in portrait photography. It's all part of the lure for your model.

The art of portraiture
Portraiture is one of the few areas of photography in which it is possible to have everything under your control.Compare it, for instance, with landscape photography, in which the photographer must first find the right scene whose elements have been put together for him in advance, and then

must wait until the light is exactly right. How convenient it would be if he could say to a mountain, 'would you mind moving four miles to the left please?', or to the sun, 'could you move lower in the sky to backlight that tree, and try not to change your colour temperature as you move?' The portrait photographer, by comparison, can position his model where he likes, and in the studio he has complete control over lighting. If anything goes wrong, he has only himself to blame.

The purpose of this book is to help prevent things going wrong by telling you how to get them right in the first place. Reading it will help you to take better portraits. In writing the book I am assuming you know little about the fundamentals of portraiture, but equally I am assuming that you do know something about photography in general. You're the sort of person who already owns a fairly decent camera, knows how to use it, but wants to learn how to use it better. For that reason, I have tended not to explain certain common photographic terms in detail. Instead, I have included a short glossary of such terms at the back of the book for easy reference should you need it. A lot of theory has to be included even in a practical book like this, but that theory goes hand in hand throughout with practice. Any advice given is based not on facts culled from some other textbook, but on my own experience. If I suggest a certain lighting set-up or a way of ensuring the right expression from your model, you can rest assured that it works. I know, because I've tried it.

One of the most appealing aspects of portraiture is that it is, in fact, many different types of photography. It's studio, outdoor and available-light photography. It's also candid photography. It can be a form of sports photography and it's definitely a part of glamour photography. Special effects can be introduced to the subject, it works equally well in black-and-white or colour, and it can form the basis of a lucrative freelance business. Your first step, then, is to decide which type of portraiture is

Children make attractive subjects. Even when they are posed, they nearly always look natural. *Ed Buziak.*

for you. Probably the three most popular types are studio, outdoor and available-light portraiture. Each has its own advantages and disadvantages, and each conforms to a recognisable style, although this is a barrier that is worth breaking down.

Studio portraiture's biggest advantage is in its use of lighting. Everything in that direction is under the photographer's control. Pictures can be taken at any time of the day or night, any time of the year. The studio is its own little world where photographer and model can work without hindrance or worry over outside conditions. Sets can be built, backgrounds can be adjusted until they are right for the subject, and work can be carried out in comfort. Unfortunately, much of the time, this can lead to staid, conventional and often totally unimaginative portraiture. If a formal portrait is what is required, then there's nothing to worry about. But once you have learnt the basic rules, don't be afraid to experiment. The studio can be used for informal or way-out pictures too. Special effects can be built and executed with precision; on a more ambitious scale, front- or back-projection can even give the impression of being outside or in places that the photographer and model would never be able to get to in the ordinary way.

The first disadvantage the potential studio photographer faces is expense. Hiring a studio can seem costly when you start looking at rates, yet it is surprising how much can be achieved in only a couple of hours if both photographer and model know what their aim is before they start. And just one sale from one picture taken during such a session can more than pay for the hire of the studio. To fully equip your own studio can also seem extremely expensive at first, and yet amazing effects can be achieved with the simplest and cheapest of lighting equipment set up in a spare room or garage, for example.

Any form of studio photography will of course always be false. The front- and back-projection

gear just mentioned is too expensive for any but the specialist photographer, so for portraiture in natural surroundings the photographer must move his model outside the studio. Straight away you have the disadvantage of waiting for the right type of weather. Since it is rare to get exactly the conditions you want, it is advisable to approach an outdoor portrait session with several different types of picture in mind, telling your model to bring a variety of clothes to suit any situation. In fact outdoor portraiture is rarely as simple as it seems at first. You don't have lights to position, but you must still consider lighting, points which I shall be discussing later in the book. But once you have overcome the disadvantages (and with a little knowledge it's easily done) you can produce wonderfully natural pictures outdoors, using backgrounds and props that would never be available in the studio.

Available-light portraiture is something of a compromise between the first two types, and it is undoubtedly the trickiest of the three. Taking pictures indoors by the light of a window is easy enough, but it needs a little guidance, all of which you'll find in later chapters. Once you have the knack, you'll be producing softly lit pictures with a casual and wonderfully emotive effect that makes this type of portraiture, for many, the most exciting of all.

Portraiture can also be candid photography. This can be purely candid (taken without the subject's knowledge) or a mixture of candid and conventional, in which the subject knows he or she is being photographed, but is going about some business, ignoring the photographer, leaving him to choose the moment. This latter way of shooting an 'unposed pose' is particularly effective for bringing out a subject's character or saying something about their way of life. The actual technique of candid photography is allied to a large extent to outdoor and available-light photography. Go for glamour and you can add studio techniques to those other two. True glamour photography is a branch of

portraiture and one that, for obvious reasons, attracts male photographers. And yet good glamour photography, as opposed to pin-ups or the soft-core porn that is so often mistaken for glamour photography, should not be taken for sexual reasons. Many of the world's best glamour pictures are taken by women, who can approach the subject perhaps more objectively than men and who then produce pictures that are truly glamorous, as opposed to merely titillating. One has only to look at beautifully evocative pictures by photographers like Sarah Moon to see that glamour, in the true sense of the word, is an extension rather than a corruption of portraiture. The best glamour pictures will always flatter the model, not insult or exploit her.

As we look briefly at the different branches of portraiture, one thing becomes clear. The basic techniques and styles are rooted firmly in those first three main categories: studio, outdoor and available-light. Those are your basics, and as you progress you may well find yourself increasingly attracted to just one of the three. For the photographer just starting in the subject, not certain which might suit him best, my advice is to try all three. You'll soon realise which is your particular favourite, and you'll learn techniques in all the types that will help when you come to specialise in one particular branch.

Before you begin . . .
Perhaps the best piece of advice that can be given to the photographer about to embark on portraiture for the first time is: *be prepared*. Remember that in this type of photography you have an obligation not just to yourself but to your model as well, and there is nothing worse for a model than to go into a studio or out on location with a photographer who has little or no idea about what effect he wants to achieve. So plan ahead. Have a few good ideas stored in your mind before you start. Then use those ideas as a basis from which to build your session. Here are some more general points worth considering before you get down to the detail.

1 Decide on your equipment. Choose the format you want to shoot with and standardise around that format. Get to know your equipment. Don't shoot an important session using a new camera or lens with which you are unfamiliar.

2 Decide which type of portraiture you are aiming for, but begin at the beginning. Don't try glamour until you have mastered the art of posing and lighting a normal portrait. Don't try special effects until you understand conventional photography. Ideally, start with studio portraiture. What you learn about placing artificial lighting will stand you in good stead for using all other types of light.

3 Find the right model. Use people who like having their pictures taken. Never try to force someone to pose for you if they don't want to. Look for a model who is photogenic, rather than beautiful, pretty or handsome. Personality can mean as much as looks. The best model is one you have come to know fairly well, but not too well. Choose someone who is an acquaintance, rather than a close friend or member of the family.

4 Don't expect a session to go right first time. Be prepared to waste film while you get to know your model. Be prepared even to waste an entire session if it begins to look towards the end that the next one will be more promising. Understand your model's problems as well as your own. Treat him or her like a human being, not just like another prop or piece of equipment.

5 Don't hurry a session, and work in comfort. A model who is being hurried won't give of his or her best, and if you hurry yourself, you're bound to overlook some important point of technique. If you are shooting outdoors, don't work in too cold conditions. If you are inside, keep the room warm. A little music in the background helps too.

6 Don't be hidebound by rules, but don't ignore them either. Learn the rules before you attempt to break them.

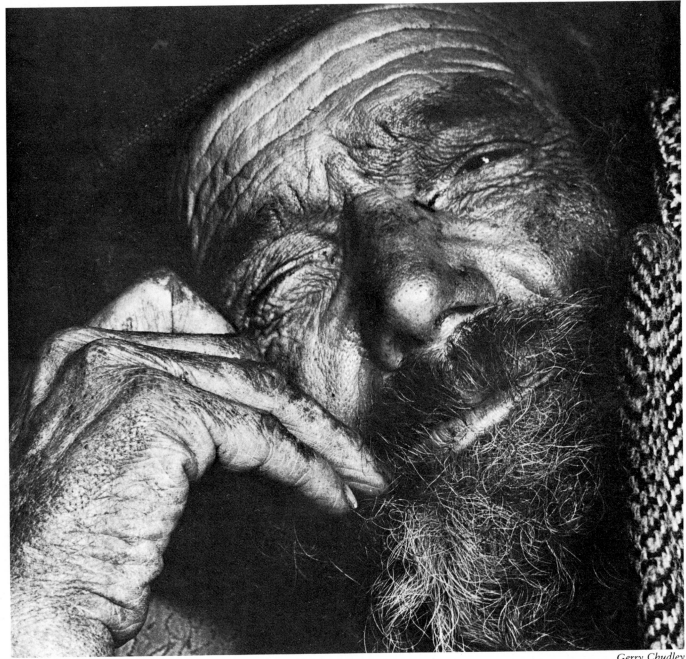

Gerry Chudley

The right equipment

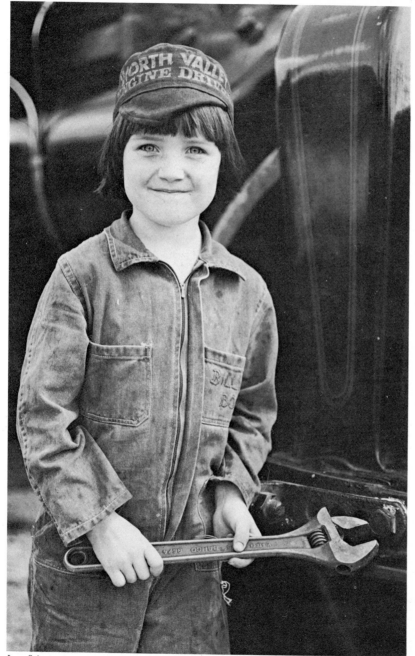

Len Stirrup

You can begin with just about any type of camera, but as soon as you start to take the subject more seriously, you'll need more specialised equipment. The right camera, the ideal lens, a good tripod and, for studio work, a suitable range of lighting gear. The first rule is to sort out your *wants* from your *needs*. Don't buy more than you need, but always spend as much as you can afford on the most suitable piece of equipment for the job in hand. Don't sacrifice the essentials for gimmicks that look good but do very little when it comes to the practicalities. Auto-exposure, auto-focus, built-in motor drive and integral flash might *look* good, but ask yourself how many of those features are going to be of any real value to you as a portrait photographer. Money spent on luxuries you can do without would be far better spent on something more basic. A manual camera on a good, solid tripod is going to be of far more use to you than some mechanical marvel mounted on a cheap, wobbly support. So let's look at the basics.

Cameras

When we think about portraiture, more often than not we think of a head-and-shoulders shot. That means filling the frame with an area of around half a metre square, which in turn means moving in close. So you need to avoid the problem of parallax. And to avoid perspective distortion in close-ups, a camera with interchangeable lenses is a must. Add these two considerations together and you come up with a single-lens reflex as the obvious and preferred choice.

Preferred certainly, but not essential. With suitable care, you can take good portraits with a fixed-lens, non-reflex camera. For full-length or three-quarter-length shots you would probably be using a standard lens anyway, and working at the distance necessary for such shots you would be

hard put to notice any serious effects of parallax. But move in close for a head-and-shoulders picture and things begin to go awry. The difference between the view through the lens and the view through the viewfinder, hardly noticeable at 5 metres, suddenly takes on a whole new meaning at 1½ metres. The viewfinder is usually mounted above the lens and often to one side. So a face that fills the viewfinder frame might be off-centre and higher or lower on the negative. The resulting picture may show a face touching or cut off by one or two frame edges, although some interchangeable-lens rangefinder cameras have parallax-corrected viewfinders that largely eliminate this problem. You *can* use a non-reflex camera for successful portraiture, as described on pages 47–48. But while the non-reflex camera owner should not be discouraged from trying his hand at this type of photography, he would certainly be ill-advised to buy such a camera specifically for the job. Which brings us back to the preferred choice: the single-lens reflex.

The 35 mm single-lens reflex is the most popular style of camera on the market today, and one that is excellent for portraiture. Previewing the picture as actually formed by the lens, rather than through a separate viewfinder, eliminates all possibility of parallax, while the facility for changing lenses helps you to avoid perspective exaggeration and allows you to pick the optimum viewpoint for every subject from full-length to close-up. The number of models available is almost unbelievable. Nearly every major manufacturer makes a range of 35 mm single-lens reflexes with perhaps three or four cameras in that range. To pick the one that's right for you might seem, at first sight, to be impossible. On closer examination, however, you will find that there are a lot of different models, but a lot fewer different *types*. Most of the manufacturers ape one another, producing cameras that, apart from minor details, do no more than echo the competition's latest model. So I won't deal with individual brand names; I'll deal instead with 35 mm SLR types and how each will help or hinder you in portraiture.

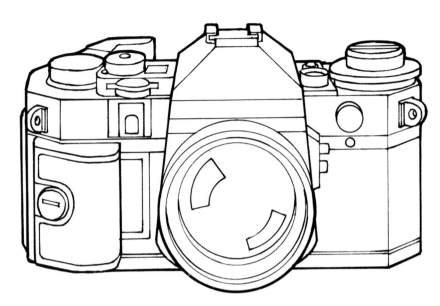

At the lower end of the range, there is the completely manual SLR – manual, that is, as far as exposure is concerned. Shutter speeds and apertures must be set by hand, and the exposure reading to determine those adjustments must be made with a separate meter. Next comes the semi-automatic SLR: this has a built-in meter, and exposures are determined by turning the aperture ring or shutter-speed dial until correct exposure is indicated in the viewfinder, sometimes by matching two needles, often by signals from light-emitting diodes (LEDs).

The word 'automatic' as applied to SLRs refers both to totally automatic cameras and to those that feature manual override. Let's take the latter first. These break down into aperture-priority and shutter-priority models. On the former, the user sets the aperture and the camera automatically selects and sets the correct shutter speed. On the latter, the user chooses the shutter speed and the camera selects and sets the correct aperture. Additionally, there are a few models that offer the photographer the choice of shutter *or* aperture

The 35 mm single-lens reflex, the most popular type of camera on the market today and one that is excellent for portraiture.

priority at the flick of a switch. Each type has its advantages, but aperture priority is better for portraiture: in most cases, depth of field – and therefore the choice of the correct aperture – is more important than the shutter speed in use. As for the totally automatic cameras, these are traditionally aperture-priority models that don't even have a shutter-speed selection dial. The speed the camera is choosing and using is often displayed in the viewfinder, but the photographer cannot select it himself. Some manual override is possible, but only by operating a 'plus or minus one or two stops' switch, or by adjusting the film-speed setting.

Now we come to the crunch. You can have all the automation you want, but for portraiture you'll take better pictures without it. For reasons I shall come to later, it's far better to take exposure readings separately, close to the face, and then to transfer the appropriate settings to the camera manually. So you need no more than a manual camera. On the other hand, the vast majority of SLRs these days have some kind of through-the-lens (TTL) metering built in, and if you want a decent model you'll find it difficult to buy one *without* a meter. That's no bad thing because, as I'll describe later, there is a way to use your built-in meter like a separate hand-held meter. The answer is to buy the best camera you can afford for your needs, but *make sure it allows full manual operation*. As far as portraiture is concerned, steer clear of fully automatic cameras.

Those are the basic types of 35 mm SLR, but within those types you will find various refinements and accessories that will be of advantage to the portrait photographer. One such refinement, found on some single-lens reflexes but not all, is the 'depth-of-field preview' button. Most modern SLRs focus and meter at full aperture, stopping down to the 'taking' aperture only at the moment of exposure. What you see in the viewfinder and what is recorded on the film can therefore be two different things as far as focus is concerned. A depth-of-field preview button allows you to stop

the lens down to the required aperture before making the exposure, so you can see how much of your subject and/or background is actually sharp when you are focused on your model's eyes.

Most SLRs these days have a good range of slow shutter speeds, starting at one second or slower. Make sure yours is one of them. You'll need slow speeds when working in the studio by tungsten light and for available-light shots. A delayed-action device is handy for self-portraits, but since few photographers try that particular idea, it's far from essential.

Watch out for the different methods of flash synchronisation. With automation coming so much to the fore, more and more cameras are being built with only a hot-shoe connection. It makes life easy for the snapshooter, but difficult for the serious portrait photographer who wants to use flash. Without an appropriate adaptor, he has no way of firing a flash set-up except with at least one gun mounted in the worst possible place: right on top of the camera. So make sure your intended camera has the more old-fashioned type of flash sync socket to which you can attach a cable.

Most single-lens reflexes have rangefinders, usually a combination of split-image and microprism. The former splits part of the picture into two halves that match up when sharp focus is achieved; the latter breaks the picture into tiny dots that disappear when it is in focus. The split-image section is the more accurate part of the rangefinder, but this tends not to work too well with the long-focus lenses needed for portraiture, so the rangefinder isn't too important when considering your camera choice. In fact, a plain focusing screen would be more advantageous, but few SLRs use them and only a minority of manufacturers offer them as an interchangeable accessory.

Unlike 35 mm single-lens reflexes, which all give the same 24 × 36 mm format, the larger rollfilm reflexes offer a number of different formats

according to the model. They all use 120 and/or its double-length equivalent, 220, but formats vary from 6 × 4.5 cm to 6 × 7 cm, taking in 6 × 6 cm on the way. The rollfilm SLR has many advantages over its 35 mm counterpart, not the least of which is the better picture quality that comes from a larger format. The extra cost of the basic camera plus at least one extra lens needed for portraiture, however, can make it prohibitively expensive.

Although at least one model has a fixed pentaprism and looks basically like an overgrown 35 mm SLR, most are designed more cube-like, with the film running vertically rather than horizontally. They usually offer interchangeable viewing systems too: eye-level or waist-level. With the camera mounted firmly on a tripod, the waist-level finder is particularly useful for portraiture. With the oblong formats, however, it is a disadvantage. To get the vertical format normally demanded by a portrait, the camera must be held or mounted sideways and the screen viewed from one side, at 90 degrees to the subject. Added to that inconvenience, the picture is now upside down on the screen. If portraiture is your speciality, then, it is better to stick to a pentaprism viewing system.

Some of the more expensive oblong-format rollfilm reflexes get round this problem by fitting a removable and adjustable film back. Here, instead of turning the camera on its side to obtain a vertical format, the photographer simply rotates the film back, leaving him free to choose whichever viewing system appeals most. Another advantage of a removable back is the way it can be replaced by a second back halfway through the film, making it possible to shoot in colour and black-and-white during the same shooting session. Extra interchangeable backs also permit rapid reloading. Some rollfilm reflexes accept special lenses that incorporate a second shutter. With the camera's focal-plane shutter locked open, the between-lens shutter can be used to synchronise flash at speeds higher than the flash sync speeds of the focal-plane shutter.

More expensive than 35 mm, but a better bet for quality, is the rollfilm reflex. This model is fitted with a medium telephoto lens.

One other type of rollfilm camera remains: the twin-lens reflex. Unfortunately for devotees of this particular style, few models are now available. The viewfinder doesn't actually look through the taking lens, so we're back to the problem of parallax. And with the viewing lens always at its widest aperture, there is no way to preview depth of field, except by estimating it with a built-in depth-of-field scale. Only one major-brand expensive TLR currently offers interchangeable lens facilities, which are doubly expensive because you have to buy a set of *two* interchangeable lenses, one for taking, the other for viewing. Conventional TLRs are stuck with a fixed, standard lens.

On the good side, twin-lens reflexes have large, bright focusing screens, and since they are all square-format models there is no trouble with having to turn the camera sideways for vertical portraits. The predominant format is 6×6 cm on 120 or 220 rollfilm and so, moving back from the subject, the fixed lens can be used as the equivalent of a medium telephoto on a 35 mm format. But that, of course, sacrifices any extra quality obtained by the larger format.

Larger still is the 5 × 4 in single-lens reflex, designed for use with cut film. These models are bulky compared with their 35 mm and 6×6 cm counterparts, and are aimed squarely at the professional market. In theory, they are perfect for portraiture; in practice, you would be ill-advised to invest in one unless you are preparing to begin professional portraiture in big way.

The only other type of single-lens reflex available is one of the 110 cartridge-film cameras that are gradually gaining in popularity. Interchangeable lenses are available and the cameras can be used for portrait work. But the extra small format, a lack of control over automatic exposure facilities on some models and the limited range of films available all add up to make the 110 SLR largely impractical for serious portraiture.

Lenses

The focal length of lens needed for portraiture varies with the format in use. A standard lens has a focal length approximately equal to the diagonal of the film format. That means around 50 mm for a 35 mm camera, but more like 80 mm for medium-format models. Standard lenses, while perfectly acceptable for three-quarters and full-length portraits, are totally unsuitable for head-and-shoulders work. This is because, to fill the frame with a head and shoulders, the camera must be moved in to around 1½ metres from the subject, and that produces perspective distortion in the face.

Contrary to what is sometimes believed, perspective (and therefore the degree of distortion) in a picture is not reliant on the focal length of the lens, but rather on the distance between lens and subject. Use a standard lens at around 1½ metres from your subject's face and he or she will appear to have an exaggeratedly large nose. Move back to around 3 metres for the same shot and perspective distortion disappears, but the face will be too small in the film area. If you stay at 3 metres and fit a longer focal length lens the frame is filled again, this

time without distortion. The extra space between you and your subject also allows more flexibility with lighting, which can now be placed in front of the camera if necessary. And it is less intimidating for the model, who could easily end up cross-eyed staring at a lens not much more than a metre from the end of her nose!

If you are used to using a 50 mm lens on a 35 mm camera, however, don't make the mistake of thinking that the 80 mm lens on a medium-format camera will solve your perspective distortion worries. Filling a medium-format negative with an 80 mm lens means moving in to the same distance as that needed to fill a 35 mm negative with a 50 mm lens, resulting in the same degree of distortion. The very least focal length you should use for head-and-shoulders work is one that is about double the standard.

My own preference is for a 135 mm lens on a 35 mm camera, although many photographers favour an 85 mm or 105 mm focal length for that format. A 150 mm lens works well on a 6×6 cm camera. If possible, buy a lens made by the manufacturers of your particular camera. If money is tighter, buy one of the independent makes of lens. The quality of many of the independents these days, as opposed to a few years back, is extremely high and the vast majority are designed to couple with the automation of individual cameras, focusing at full aperture and automatically stopping down at the moment of exposure.

Apart from lenses of standard focal length, there are long-focus lenses, telephoto lenses, mirror lenses and zoom lenses. The difference between a long-focus and a telephoto lens can be seen in its actual physical length. A long-focus lens must be at least as long as its focal length. A telephoto lens compresses the same optical focal length into a shorter space. It is therefore physically smaller than its long-focus counterpart and naturally easier to handle. A mirror lens is even shorter: it uses a mixture of lenses and curved mirrors, both convex

and concave, to reflect the light backwards and forwards along a short, stubby lens barrel. The result is an extremely compact telephoto, but one that is found only in the extra-long focal lengths, usually of around 250 mm or longer. On top of that, the lens construction dictates a fixed aperture. Broadly speaking, then, the mirror lens is impractical for all but the most specialised forms of portraiture.

Zoom lenses, to a certain extent, are still living down the bad reputation they picked up when first introduced. In those days, the quality rarely matched that given by a prime lens of fixed focal length. Most of the early problems have been ironed out, and some zoom lenses now give quality fully comparable to their fixed-focal-length equivalents. They are particularly useful for portraiture. Once a studio set-up has been arranged, it often proves awkward to move a tripod-mounted camera backwards and forwards to arrange the subject size in the viewfinder. It's much easier to use a zoom lens to change the focal

length until the required effect is achieved. Zoom lenses are also used for certain special effects in portraiture, of which more later. When choosing a zoom lens, go for one that takes in a focal length of twice the standard lens and a little more each side: an 85–270 mm perhaps, or a 100–200 mm on a 35 mm camera. The 35 mm user has a vast range from which to choose. For medium format the choice is more restricted, both in the limited number of zoom lenses available and in the extremely high cost.

If your budget doesn't stretch to an extra lens, you can achieve similar effects with teleconverters. They fit between lens and camera body, converting the standard lens to one of a longer focal length. A 2× converter doubles the focal length, a 3× converter trebles it. So, with the aid of a converter, a standard 50 mm lens can become one of 100 mm or 150 mm focal length, both of which are ideal for portraiture. Using teleconverters offers two basic problems, however. The first is a reduction in the effective f-stop of the prime lens. The second problem,

For head-and-shoulders portraiture the focal length of the lens should be at least twice the standard. Others, while useful for full-length and three-quarters shots, are totally unsuitable for close-up work, as shown here. Left to right, the frame has been filled with a 28 mm, 50 mm and 135 mm lens.

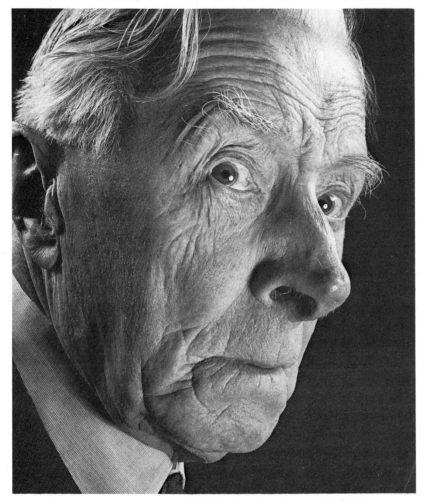

further broken down into simple, battery operated flashguns and the more professional, mains-powered studio flash systems with their own individual range of accessories. Tungsten lighting is losing popularity in the modern studio, but it should not be ignored. A good tungsten lighting set-up is cheaper than its equivalent in studio flash, but it could prove more expensive in the long run because bulbs have an extremely short life compared with flash tubes. The other disadvantage of tungsten lighting is the heat it gives out, uncomfortable for model and photographer alike after a while.

Ordinary household bulbs are forms of tungsten lighting; with the fast films and wide apertures available today, bulbs used to light an ordinary room can often be used for portraiture. In the studio, two different types of lamp with slightly differing colour temperatures can be found. The Photoflood is an over-volted bulb available in two sizes. The No.1 consumes 275 watts, but since the filament burns at a higher temperature than normal the output is more in the region of 650 watts. The No.2 burns 500 watts and gives a light equivalent of 1250 watts. Their working life is about three hours for the No.1 and ten hours for the No.2; colour temperature is 3400 K. Because of the short working life and the difficulty in some parts of the world in obtaining type A colour film, balanced for 3400 K, many photographers these days are turning to 3200 K tungsten photolamps. They are longer lasting, but less bright, being available in standard wattages of 250, 500 and 1000. All these bulbs can be used in a variety of reflectors to give different effects. The deeper the reflector's bowl, the more concentrated the beam of light; the more polished the bowl, the harsher the light. The three most popular types of reflector, based on that principle, are these:

1 A highly polished, deep-bowl reflector to give a narrow, harsh beam of light, almost like a spotlight. It is used most often on the main light in a portrait.

Rules are made to be broken. A focal length of at least 100 mm is recommended for portraiture with a 35 mm camera, and yet here a 28 mm lens was used to distort the image and help bring out the subject's character. *Kevin MacDonnell.*

which is more important, is a loss of definition. A teleconverter, then, makes a practical stopgap if you can't afford an extra lens, but it's no match for the real thing. The exception is one of a special range of teleconverters (sometimes referred to as 'matched multipliers') that have been designed especially for use with a specific lens.

Lighting
There are two basic types of artificial lighting available to you: tungsten and flash. Flash can be

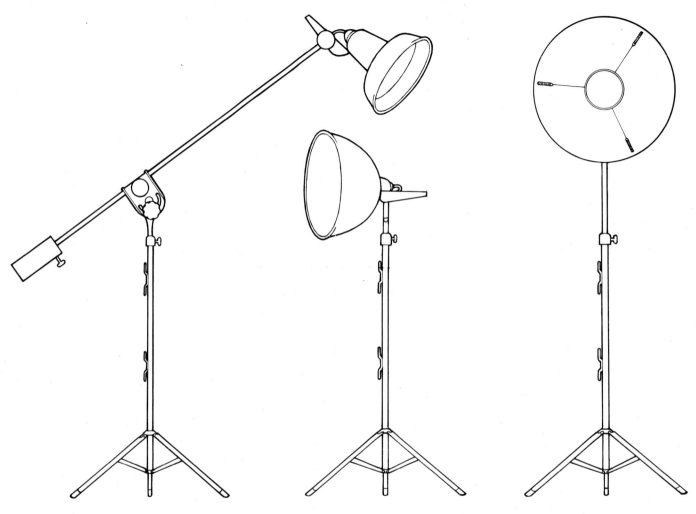

2 A shallower, matt-silver reflector that gives a wider, softer light. It's a good, all-purpose reflector that, because of its spread, is more useful for three-quarter or full-length portraits.

3 A very shallow-bowl, matt-white or matt-silver reflector. The actual bulb is shielded from the front by a suspended metal disc so that no direct light falls on the subject, but is reflected back from the bowl instead. The light is even, wide and casts very

soft shadows. It makes an ideal fill-in light.

Photofloods are also available with built-in reflectors, metal shields that prevent direct light from escaping from the front, the light output coming from the small reflector behind the bulb. Such lamps are useful in emergencies, but expensive compared to normal photolamps, and restrictive compared to the better effects obtainable with standard reflectors.

Tungsten-light reflectors. Left: deep, highly polished reflector gives a harsh light. Centre: wider mouth and less polished interior gives softer light. Right: extremely soft lighting from a wide, shallow, matt-white reflector, with a metal mask suspended in front of the lamp to prevent direct light reaching the subject.

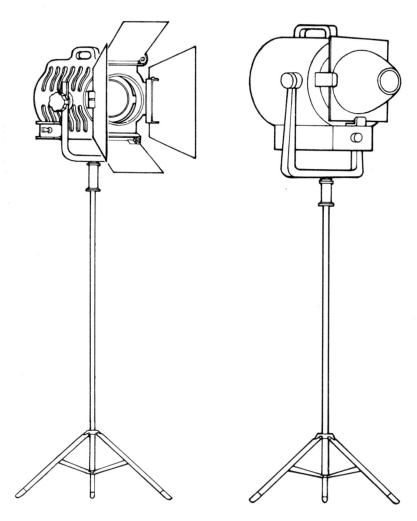

gas that fills the bulb reacts with the burning tungsten to prolong life, allow higher pressures and temperatures to be used and prevent blackening of the bulb's interior. The result is a longer-lasting, brighter, whiter light. Tungsten-halogen lamps range from 650 to 1000 watts, each with a life of around seventy-five and 400 hours respectively. The lamps are used a great deal in cine lights and large-bowl reflector lamps, but most of all in spotlights. These use reflectors behind the bulb and lenses in front to focus the light, varying the diameter of the beam from anything between about 15 and 60 centimetres. The smaller the beam's diameter, the harder the light.

All these lights are supplied with suitable stands: a single metal stem opening to three supporting legs at the bottom, for the lighter units, or a more solid arrangement with castors on each leg for the heavier lamps. For those with limited storage space there are stands that take the form of small clamps, designed to fit the backs of chairs and the like. Useful accessories, mostly used with spotlights but equally useful for certain types of flood, are barndoors and snoots. A set of barndoors consists of four flaps hinged on each side of a square. It slides in front of the lamp and, when closed, totally obscures the light. Opening and closing the flaps, as needed, holds back the light from certain parts of the subject or prevents the light from shining into the camera lens. A snoot is either a tube or a cone that fits over the light to restrict its beam to a particular small area for special effects. A large sheet of white translucent plastic also makes a handly lighting accessory. Stretched across a wooden frame, it can be used in front of a lamp to diffuse the light and so make it softer.

These days, flash photography is taking over from tungsten light for portraiture. Flash equipment is light and portable, allows far shorter exposure times, produces a cold light that is more comfortable for the model, and can be used with daylight-balanced colour film. Its disadvantage lies in the fact that its effect on the face of the model

A spotlight allows you to concentrate and focus a narrow beam of light on your subject. It can be fitted with barndoors (left) or a snoot (right) to give extra control of the 'shape' of the light.

One problem with tungsten lighting is the way the bulbs grow dimmer with age, owing to the tungsten filament burning away and forming a deposit on the side of the bulb. This blackens the glass, making the light output dimmer. On top of that, as the filament burns away, the overall light becomes more red. You won't spot the difference with the naked eye, but colour film will pick up the change in colour temperature. The problem is solved with tungsten-halogen lamps. In these, a halogen in the

cannot be seen in advance the way it can with tungsten light, though even that has been overcome with many of the more professional studio flash set-ups we shall come to in a moment.

With electronic flashguns now relatively cheap, flashbulbs have virtually died out. They still survive in basic amateur and specialised professional equipment, but are not suitable for the serious portrait photographer. The simplest type of electronic flashgun has a fixed head and a single light intensity. Exposures are calculated by using the guide number. Only slightly more expensive is the automatic flashgun. With this, a fixed aperture, dependent on the speed of film being used, is set on the camera; as the gun is fired, a tiny sensor on the front picks up the light reflected from the subject and quenches the flash to produce correct exposure. So the gun might be firing at anything between 1/500 and 1/50 000 of a second, depending on the flash-to-subject distance. Some automatic guns allow a choice of two or more apertures, adjusting the intensity of the flash according to which one is in use. On others, designed for specific electronic cameras, merely fitting the gun into the camera's hot-shoe automatically sets the right shutter speed and aperture on the camera the moment the gun is fully charged and ready to fire.

An automatic gun can be used on the camera or on an extension cable with the gun pointed directly at the subject. If the flash head is fixed, facing in the same direction as the sensor, an automatic flashgun cannot be used for bounced-flash work unless it is switched to manual and the exposure calculated by means of the guide number. On automatic, the sensor assumes that the wall or ceiling being used to reflect the light is actually the subject and adjusts the flash accordingly, underexposing the real subject. This is a fault that is now being recognised, and on many modern automatic guns the head can be tilted upwards or sideways, while the sensor remains pointing at the subject, automatically calculating the correct exposure. Also, some of the

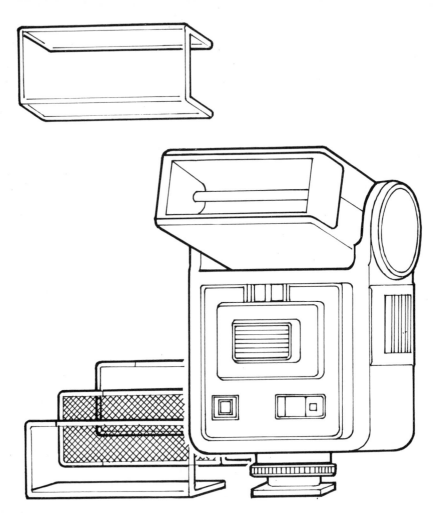

more sophisticated guns can be used with small accessory screens that clip above the head and bounce the light back to the subject, giving a more even, diffused light.

Another type of flash gaining in popularity is the twin-head gun. The main head can be angled through 90 degrees to bounce its light from a ceiling or wall, while a smaller, subsidiary head provides a fill-in light direct on the subject. The

Left: flashguns have come a long way since the first electronic units were introduced. This example has two heads, one for a main beam and the second for a fill-in light. The main head can be tilted through 90° to provide various degrees of bounced flash. There is a set of coloured filters that can be attached to the main head to give, for instance, coloured highlights to the model's hair.

Right: a studio flash can be used direct or bounced into a brolly. The lamp is for modelling only; on some models it blinks off as the flash fires.

usual sensor calculates and adjusts the exposure accordingly. Some of these guns are supplied with coloured filters that fit over the main head and can be used in portraiture to give coloured highlights to a model's hair, while the second head provides a normal white light for the face.

The serious portrait photographer, however, will not use any one of these flashguns alone, and certainly never attached to the camera. Rather, he

will buy two or three separate guns and use them in traditional lighting set-ups as described in the chapter on studio portraits. They will not always be used straight-on, but more often bounced from some kind of reflector. And that leads us to the more professional studio flash unit, which has its own reflector and lighting stand. It plugs into a separate, mains-operated power pack that provides power, not only for the flash, but also for a special low-powered bulb, built into the unit. The bulb is used as a modelling light. It shows the photographer the precise type of lighting he will be getting from the flash, where the shadows fall and which parts of the face are illuminated. On many of these units, the bulb winks off as the flash fires.

These studio flash units can of course be used with accessories such as barndoors and snoots, as well as diffusers. More often than not, though, they are used with brollies. Although a brolly *can* be used with tungsten lighting, it is far more often used with flash, where it gives one of the most natural forms of lighting. Essentially, the device is nothing more than a white umbrella with a fitting for a flashgun. The brolly is fitted to a lighting stand and the flash positioned to throw its light back into the inside of the umbrella. The subject is then lit from this large, soft flood of reflected light. Brollies are also available with silver or gold linings. The silver lining provides a harsher light in the same, even spread, while the gold lining provides a warmer tone to the subject for colour photography.

Possibly the most necessary accessory for flash photography is the extension cable. Even with the simplest flash shot, taken with a single gun, it is inadvisable to mount the flash on the camera. A cable is necessary, then, to move your flashgun away. When it comes to studio flash, the cable is needed to fire at least one of the heads. The rest can be fired by light-activated slave units. These plug into the flash terminal of each gun in use. As the first flash head is fired by the camera, light-sensitive cells in the slave units detect the sudden burst of light and fire each of their respective heads. In fact,

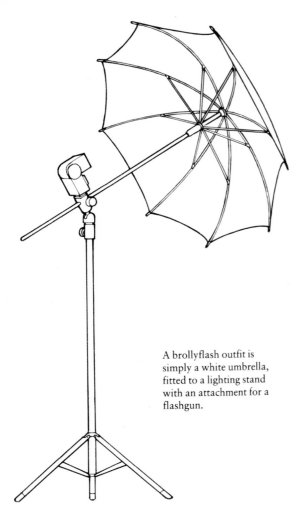

A brollyflash outfit is simply a white umbrella, fitted to a lighting stand with an attachment for a flashgun.

in this instance, the extension cable can be eliminated completely by fitting a slave unit to each flashgun and firing them with a special, low-powered flash on the camera, or by infra-red flash. The light from this triggers the slaves, but does not affect the subject.

A studio flash set-up isn't too expensive when you consider its advantages over tungsten light. Several manufacturers make up kits of everything required for the photographer starting in studio flash. In one such kit, and for the price of a fairly sophisticated SLR, you get two professional electronic flash heads, stands, filters, a barndoor attachment, a background, brolly, light diffuser and flashmeter.

Film

Monochrome or colour, negative or reversal? The choice is yours. Let's start with monochrome. Like all other types of film this is available in different speeds, ranging basically from ISO 32/16° to 400/27°. It exists in speeds each side of those limits too, but the majority of films fall between the two boundaries. A slow film such as Ilford Pan F (ISO 50/18°) or Kodak Panatomic X (ISO 32/16°) obviously needs a longer exposure than a fast one. It also produces greater contrast. For those two reasons, it is best to avoid slow black-and-white films. The contrast, unless carefully controlled in the processing, can lead to stark white faces and jet black hair, and the longer exposure times needed, despite the wide-aperture lenses on most of today's lenses, are still a strong disadvantage when working with tungsten lighting. On the positive side, slow films give finer grain than fast films; if your interest is in 20 × 16 inch (50 × 40 cm) exhibition prints, it is often worth sacrificing speed for grain.

At the other end of the scale, fast films such as Ilford HP5 or Kodak Tri-X (both ISO 400/27°) allow much briefer exposure times, but show a strong increase in grain over their slower counterparts. There are times when that grain can give an interesting effect; in fact there are instances, such as available-light portraiture, where it is inevitable. But for the conventional portrait, in which you probably wish to flatter your model, you're far better off without it. A less obvious disadvantage of using fast films for portraiture is their false rendering of colours into tones of grey. Some of their extra speed is achieved by making the film oversensitive to red, causing complexions in general and lips in particular to appear too dark on the negative and hence too light on the print. A pale blue filter might correct that defect, but then the

increase in exposure needed for the filter defeats the object of using a fast film in the first place. Between the fast and the slow, there is a range of medium-speed films such as Ilford FP4 and Kodak Plus X (both ISO 125/22°). They are excellent for portraiture. Their rendering of colours into shades of grey is as accurate as it's possible to get, contrast is about right, and exposures needed make a suitable compromise between those needed for fast and slow films. Having said that, it must be admitted that a preference for these medium-speed films is purely personal. Some photographers prefer to keep extensively to fast films, ignoring their pitfalls for the sake of their convenience in low light levels and at fast shutter speeds in difficult conditions. My own view is that portraiture is mostly a carefully planned form of photography in which you will inevitably be arranging your own lighting and nearly always have access to a tripod; this is a small price to pay for the increased quality obtainable from slower films.

None of this applies, however, to the chromogenic films recently introduced. Ilford XP-1 and Agfa Vario XL are black-and-white films which, unlike their more conventional counterparts, do not rely on silver to form the image in the final negative. Instead, the image is exposed on a silver-type emulsion that is bleached out during the processing, a colour-dye negative image being formed at the bleach-fix stage. The result is a film that can be underexposed and/or overdeveloped far past the point previously considered possible, while still retaining a high degree of quality in the image. Unlike conventional black-and-white films, the apparent grain actually gets *better* the more the film is developed. In effect, then, chromogenic films can be exposed at vastly different speeds and on the same length of film. If, for instance, you start exposing a roll for a film speed of ISO 400/27° and then, half-way through, switch to exposures based on a film speed of ISO 1600/33°, you merely process the film for the time demanded by this latter speed. Those negatives exposed for the slower speed will be overdeveloped, but the structure of

the film is such that the negatives will still give acceptable prints, better in many cases than those that might have been obtained from a conventional film of a similar speed. Ilford XP-1 can be used at any speed between and including ISO 400/27° and ISO 1600/33°; Agfa Vario XL can be exposed between ISO 125/22° and ISO 1600/33°.

Everything I've said about grain and contrast with conventional black-and-white film applies equally to colour, but with the latter you also have the problem of colour temperature. This is something that is explained in more detail in the chapter on handling colour. For the moment, you need only know that colour film is balanced either for daylight or for tungsten light. Electronic flash, despite the fact that it is actually artificial light, is designed for use with daylight film. Tungsten-light stock is divided again into type A for Photofloods and type B for 3200 K tungsten. But with so many photographers replacing their Photofloods with 3200 K photolamps, type A film is gradually dying out. Colour film is further divided into *negative* and *reversal* stock: the former gives negatives from which colour prints can be made, the latter gives transparencies for projection or for viewing in a small hand-viewer. Remember that colour prints can be made from transparencies; also, if you are interested in getting your work published, printers much prefer to work from transparencies.

The majority of colour negative films range in speed from ISO 64/19° to 400/27°. For speed and contrast reasons, a medium-speed film such as Kodacolor II or Vericolor II Type S (both ISO 100/21°) is best for portraiture in daylight conditions when colour prints are needed. Some of the extra-fast colour negative films such as Kodacolor 400 (ISO 400/27°) are excellent for low-light portraits but, just as with black-and-white, show more grain in the final print than would be seen with a medium-speed film. For best results, colour negative film such as Vericolor II Type L (ISO 25/15° to 80/20° depending on exposure time and type of illumination) should be

used for tungsten-light studio work, since it is designed for relatively long exposures and balanced for tungsten light.

With colour reversal stock there is no intermediate stage to correct colour balance, so the appropriate film must be used right from the start. The majority of colour reversal films are balanced for daylight, and range in speed from ISO 25/15° to 400/27°. A slow film such as Kodachrome 25 (ISO 25/15°) gives ultra-fine grain, coupled with high resolution and a good exposure latitude. Its extra-slow speed is a disadvantage, though, especially for studio work. A better bet for general use is an ISO 64/19° film such as Kodachrome 64 or Ektachrome 64, or a medium-fast film such as Ektachrome 200 (ISO 200/24°). An ultra-high-speed reversal film such as Ektachrome 400 (ISO 400/27°) can be used when conditions demand it, but for reasons already given it should be avoided for general portrait work. For tungsten light, the choice of film is far more limited. You have only films such as Ektachrome 160 (ISO 160/23°), Ektachrome 50 Professional (ISO 50/18°) and type A Kodachrome (ISO 40/17°), although the Kodachrome is not readily available in the UK.

Meters and other accessories

The most common form of metering is that which is built into the camera and which, in the case of an SLR, takes its reading through the lens. These meters can be used for portraiture, but they are not ideal. If, for instance, you are picturing a subject against a brightly-lit, white background, it is often a good idea to arrange the lighting so that the background is actually overexposed by one or two stops compared with the subject's face. In those circumstances, the meter, whose position is dictated by the placing of the camera, would take an average reading and the face would be underexposed. You can use TTL metering accurately in a way that I shall come to on page 80, but it is far better to use a separate, hand-held meter. Go for one that gives you incident-light facilities. This can be used in the traditional way, holding it a few centimetres from your model's face and taking a reading from the

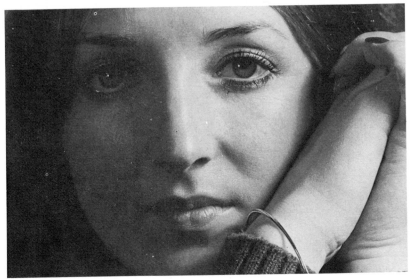

light reflected from the subject; or, with the incident-light baffle fitted, it can be held in front of the subject's face and the reading taken from the main light. See page 84 for further details.

The first hand-held meters used a selenium photovoltaic cell. When light falls on selenium a small electric current is generated, and this is used to operate a galvanometer needle. The more light, the more current, and so the greater the needle's deflection. More recent designs use cadmium sulphide (CdS), which doesn't generate a current. Instead, its resistance increases as more light falls on to it, so a battery must be used to power the meter. A cadmium sulphide meter is more sensitive and reacts quicker than a selenium model, but is less accurate at the red end of the spectrum and is useless if the batteries fail. Because CdS can 'remember' bright light, and is slow to react to low light levels, meters now use silicon or gallium cells. These may be used as light-variable resistors or as photovoltaic cells. In either case they need a battery-powered circuit to interpret and amplify the information. Often the display is by LED or LCD, dispensing with the fragile galvanometer movement of older meters.

When lighting is directional, as in this picture, extra care must be taken with metering, preferably taking a reading from close to the subject's face. In such circumstances, a hand meter, separate from the camera, can be especially useful. *Paul Broadbent.*

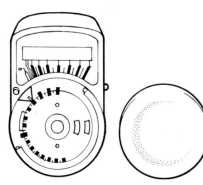

Three methods of measuring exposure. Left to right: a selenium-cell meter with cone for incident-light readings; a silicon-cell type that can be used for straight light readings or as a flashmeter; and a spot-reading attachment which, when fitted to the appropriate meter, narrows its angle of acceptance to only one degree.

If you must meter from the camera's position, a spot meter is invaluable, though rather expensive. While a normal meter takes in an angle of view of anything up to around 60 degrees, the spot meter has an angle of view of between one and nine degrees, depending on the design. You can look through it, aiming it at a small and specific part of your subject, from which the meter will give an accurate reading. A flashmeter, as its name implies, is for use with flash lighting. Such meters are used in much the same way as conventional hand-held meters, but they react quicker. Usually a flashmeter is held in front of the subject just as a normal incident-light meter would be; a few flashmeters can also read reflected light. As the flash set-up is fired, the meter picks up the light and gives a reading. Since you are dealing with flash, it gives only an aperture. If you have a lot of money to spend, there is also a range of expensive meters on the market now that can be used for both normal light and flash.

Tripod The most important thing to remember when you buy a tripod (and you *must* buy one if you are taking portraiture seriously) is to buy a sturdy one. A tripod is not the place for false economies. The best camera in the world with the sharpest lens will be useless if your tripod wobbles at the moment of exposure. Go for one with a pan-and-tilt head. Preferably get one on which the table to which you screw your camera hinges up to 90 degrees and locks. This allows you to use the

camera in the vertical position without having to turn it sideways on the tripod head with the pan-and-tilt handle pointing straight up or down, making for more convenience and preventing strain on the locking mechanism. A camera clamp is useful for places where a tripod is impractical. It takes the form of a G-clamp with perhaps a ball-and-socket head fixed to one end. The whole assembly can be screwed tightly to a chair or table.

Cable release Even with the camera on a tripod you can still get camera shake if you don't use a cable release. Buy one at least 30 cm long.

Lens hood There is a lot of flare in a studio with so many lights around, especially as some of them will be shining back towards the camera. So buy a good, deep lens hood for each lens you own. Make sure that it shields the lens without obscuring any of the edges of the picture area, and that the inside is matt black. If it isn't, or if it begins to wear, paint it with matt black paint, available in small cans from hobby shops.

Filters There are a number of filters that are especially useful to the portrait photographer. In black-and-white photography a green filter is useful for darkening Caucasion skin tones outdoors. In colour photography there are several conversion filters for adapting film to a different type of light. An 80A is a strong blue filter that allows you to use daylight film in tungsten light (3200 K). An 80B is

another strong blue filter for exposing daylight film in Photoflood light (3400 K). An 85B is an amber filter for using tungsten film in daylight, and an 85 is a similar-looking filter that converts tungsten-balanced Kodachrome 40, type A, to daylight use. An 81A is a very light yellow filter for use with daylight film. It takes out the blue tinge that might otherwise be seen in a face photographed outside in cloudy weather and can be used with type B film, balanced for tungsten lighting, when shooting under Photofloods. Together with the 81B and 81C it warms up shadow areas in fine weather, correcting the blue cast in large areas of shade, indirectly lit from a blue sky. The 81 series can also be used for warming skin tones if your electronic flash set-up gives too cold a rendering. In all, there are six 81 filters, any one of which will do the job, depending on the amount of correction required. The 81B is probably the most popular for this particular effect.

Background paper However good a studio portrait may be, it can be ruined by the wrong background. A plain, well-ironed sheet or tablecloth might be used behind a head-and-shoulders shot, but for best results you'll need a few rolls of seamless background paper. These are sold in widths ranging from 4½ to 12 feet (about 1½ to 3½ metres). They can be supported at ceiling height by a specially made stand and unrolled to any length desired. Start with a roll of black, a roll of white and a couple of different colours. Yellow is a good first choice. It can be underexposed to photograph as a deep yellow-ochre colour or overexposed to a pale lemon tint.

Reflectors These are rarely worth buying; they are so much cheaper to make. A plain piece of white cardboard, a conventional projection screen, a sheet or tablecloth, even a sheet of newspaper, all make adequate reflectors. Large sheets of polystyrene are particularly useful. They reflect light without hot-spots, and their light weight makes even the largest easy to handle. Aluminium foil can also be used to good effect. The glossy side will give a harsh reflection, the matt side will give a softer reflection. Each of these materials reflects light of its own colour, so reflectors can be made in different colours for different effects. White is naturally the most common colour for a reflector but, surprising as it might seem, black can also be used, provided that the reflector is made from a material that bounces back light. Since black obviously reflects a lot less light than white, larger reflectors than normal are needed. The reflected light, coming from such a large surface, is softer than it would be from a conventional reflector. A gold reflector not only fills the shadows, it warms them as well, giving a pleasantly tanned look to skin tones. Blue makes the shadows colder. Special foil in different colours can be bought from professional photographic studio suppliers. Buy what you need and mount it on a sheet of hardboard for best results.

Motor drives and power winds A device that winds the film on after each shot is useful, particularly in portraiture, where in my opinion anything that frees the photographer's mind from technicalities and leaves him to concentrate on his subject can only be a good thing. A motor drive allows continuous shooting at (in the case of at least one professional outfit) anything up to fifteen frames per second, while a power wind merely winds on the film after each shot. For portraiture, you don't need a motor drive. A power wind, however, is another matter. I would never recommend buying one as an essential accessory. The money would be far better spent on other, more useful equipment. But if you are working in a good session with a lively model whose expressions and poses are changing all the time, a power wind allows you the luxury of continuous shooting without removing the camera from your eye. What's more, with a long cable release you needn't even be near the camera to shoot and wind on, leaving you free to move around a studio, talking to your model and generating the casual atmosphere that leads to better pictures. It's an advantage you'll never appreciate until you've tried it.

Len Stirrup

The model

Ray Chappell

Whether you are photographing a woman or a man, a pensioner or a child, one of the most important rules to remember is this: never photograph someone who doesn't like having his or her picture taken. You must acknowledge that there are some people who really don't like being photographed. It's almost a phobia with them. Such people can often be persuaded to pose for a portrait, simply because they are too polite to say no. But they will spend the entire session in a state of anxiety, eager for it all to be over, and that's not the way good portraits are made.

You need someone who enjoys being on their side of the camera as much as you enjoy being on yours. When we talk about models, we are of course talking about all types of people from young girls to old men. For most of this chapter, however, I am assuming that we are talking about the most popular subject for portrait photographers everywhere: a pretty girl. Straight away, you must decide whether you are going to use an amateur or a professional model. Each has advantages and disadvantages.

Amateur models
The most obvious advantage of the amateur model is that she will settle, at the most, for a moderate fee or, at the least, for a set of pictures. The disadvantage is that she is inexperienced and needs more direction from the photographer than would a professional. Having decided, however, to use an amateur model, you must know what to look for. First of all, she should be photogenic, and that doesn't mean necessarily beautiful. A plain girl who knows how to use makeup and how to vary her expressions, who has patience and understands what is required, will photograph much better than a stunningly attractive one who has no idea of what portrait photography is all about.

So look for a girl who is vivacious and takes a pride in her appearance, one who has good dress sense, looks after her hair and makeup and generally knows how to make the best of herself. She should be confident and may be a little extrovert too. When you ask her to pose for you, she probably won't be too surprised, because she knows she's attractive. She may be the kind of girl that other girls don't take to because, they say, she thinks she's something special. Don't take any notice of what other people say, especially other girls. Contrast this girl with one who is naturally pretty but just doesn't seem to know it, or perhaps want to admit it. Given a choice between the two, the first girl might not be such a nice person, but she will make the better model. I'm not suggesting that all the best models are stuck-up and difficult to like, but simply that this type of girl is often an especially good model. On the other hand, the naturally pretty girl who is surprised you have asked to photograph her can also make a good model once you have persuaded her you are serious.

Certain features of a face are more important than others. The eyes are the most striking part of any portrait, so a girl with beautiful eyes has a head start over her rivals. Cheekbones too are important, giving shape and modelling to a face. Watch the way a girl smiles. Does her whole face light up when she laughs? If it does, it's a fair bet that she'll be able to recreate the expression for a picture. Conversely, there are some people who never smile without their mouths turning into a kind of sneer. You might not notice it when you are just talking, but capture that look on film and you'll have a bad portrait. If the girl is photogenic but doesn't have a good smile, don't despair. She'll still make a good model for serious-faced portraits. But if her smile is good, then she should also have good teeth. This all sounds rather personal, not to say insulting, if you begin mentioning what you are looking for to your prospective model. The trick is not to mention it at all. Everything you need to look for can be seen in a few minutes of general chat. That way you can sum up her personality too, which is as important as looks. Watch her face as she speaks. Some people have a deadpan expression that hardly changes at all whatever they are talking about. Others employ a range of expressions, all constantly changing as they 'live' the story they are telling. That sort of person knows how to be expressive and makes a good model.

So where do you find such girls? One obvious place is your local drama group. An amateur actress already thinks enough of herself to be confident about appearing in public. If that's the case, there's little doubt that she'll enjoy modelling too. The fact that she is an actress means that she knows how to use gestures and facial expressions to their best advantage; she is used to taking directions from a producer and will react to a photographer in the same way, with (you hope) the same patience. Local beauty contests are another place to find models. Most towns have carnivals and all carnivals have queens. These, again, are girls who know they look good and like people to notice them, so it's a fair bet that they'll be interested in having their pictures taken.

But of course there are potential models all around you: in discos, shops, pubs and clubs, even just walking along the street of your home town. Actually finding a prospective model isn't difficult. The difficulty lies in approaching her and asking her to pose for you. (This is especially true for a male photographer. To far too many people, the amateur photographer is a man who haunts rather dubious studios, pretending to take photographs of naked girls with an empty camera. It's untrue and unfair, but the impression is there in the minds of many.) You must look sincere, appear confident and give a totally professional impression right from the start. So be prepared. Have some business cards printed with your name, address and telephone number on them. But, most important of all, have some of your work with you, in the form of a few prints. Once you have her interested, give her your card, tell her to think about it and to give you a ring. It's surprising how many will phone you

36

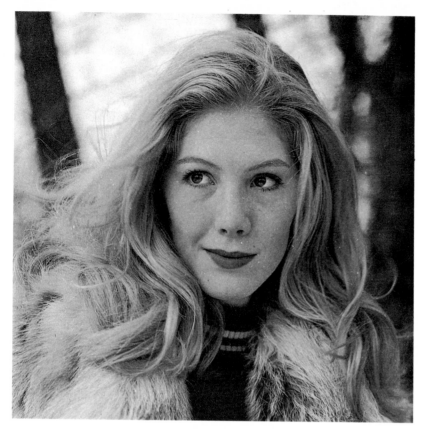

would like to attend. If they say yes, tell them that they are welcome to come along of course, but that the model is often embarrassed at having someone so close around, which makes for bad pictures. And quite honestly, it's downright boring for anyone who isn't actually involved in the session. During this preliminary meeting, you will also get to know the girl if she was a complete stranger at the outset. You'll see how expressive she is, what sort of things make her laugh and, by the time you get to the shooting session, you'll be at that point in a friendship that is just right for photographer and model: close enough to know how each will react to certain things, but nowhere close enough for her to be embarrassed or think it is silly posing for you. For this very reason, it's amazing how difficult it often is to photograph close friends or even your own wife or husband! At the end of the first session, prepare a set of 10×8 inch (25×20 cm) prints and give them to the model with your compliments. If she is pleased with those, you will have the basis for a second, and maybe more adventurous, photo session.

Professional models

The advantages of using a professional model are obvious. You don't have to look for a certain type of girl, because the professional *is* the right type of girl. She mixes with photographers every day of her life, knows all about makeup and clothes, is never self-conscious, understands the basic principles of photography and knows exactly how to behave in front of a camera. Her disadvantage, as far as the amateur photographer is concerned, is that she can be expensive.

Many studios that you hire by the hour also run their own modelling agency and will have pictures of their models to show you, together with their fees. You can book the girl when you book the studio, discussing at that point the sort of pictures you want to take, the sort of poses you have in mind, what clothes she should bring to a session, etc. All the best models have agents, most of whom are based in London. If you want to book one of

Different people smile in different ways. Watch the way your chosen model smiles and then use that as the basis for a simple, natural expression when you are shooting her portrait. *Michael Barrington Martin.*

back a few days later to say yes. All this applies of course to approaching complete strangers. If you're luckier, you might find the right model where you work or at a club you belong to. Seeing her frequently and letting her get to know you will make things much easier.

Once you have your model lined up, it's often a good idea to meet on some neutral territory to discuss the shooting session. Her home, with family or friends present, is ideal. There you can talk about the sort of pictures you want to take, discuss clothes and look through her wardrobe with her to decide what would be best. You would be wise to tactfully discourage anyone else from attending the session. Ask relatives and friends whether they

their girls, you must do so through them. To help you choose, directories are available that list and illustrate hundreds of models (including men and children), together with agents and details such as height, vital statistics, shoe size, colour of hair and eyes, and the type of assignments undertaken. Any agent will put you in touch with the publisher of such a directory.

Before you even think about booking one of these models, however, make absolutely sure you know what you're letting yourself in for. Unlike any amateur model you have used in the past, professionals are not doing you any favours by posing for you. They are there purely to earn their living. So get to know the terms and conditions under which they work. A working day for the professional model is between 9.00 a.m. and 6.00 p.m. with a minimum of one hour for lunch. You can book her by the hour, but exceed those limits and you'll end up paying overtime. At the least, that could mean time-and-a-half outside normal working hours during the week or on Saturdays, and double-time for Sundays. In some places the rates could be higher still. If you want a model to come to you, you'll have to pay travelling time as well. That is charged at a percentage of the hourly rate. All these charges will be invoiced to you personally, and payment will probably be due within thirty days at the latest.

Time is money for the professional model and, since it is your money we are talking about, it isn't in your interest to waste time. If you are booking a professional, then, prepare as much as possible in advance. Decide the type of poses you are going to be taking and the wardrobe required, and get your equipment prepared before the model arrives, using a stand-in to check lighting and camera angles. Load cameras in advance, and try to have a spare on hand, even if you have to borrow one. If something goes wrong, you won't have time to sort things out. It's better simply to change to another camera and worry about jammed shutters and the like later, when time is less precious.

A professional model can be a great help to the inexperienced photographer. She knows what poses work best, which is her best side, how various facial expressions look on film. If you *are* inexperienced and feel she knows more about posing than you do, don't hesitate to tell her so. There's nothing worse than an inexperienced photographer trying to direct an experienced model into poses that she knows are useless. Better to come clean in the first place and ask her advice.

But by the same token, beware of the model who always thinks she knows best. Some professionals have a set routine, and the moment you begin to photograph them they'll go through that routine irrespective of the sort of shot you want to take. That's fine if you have no real ideas of your own. But if you want to take a certain type of picture, then be firm and confident, explaining exactly what you have in mind and asking her to suggest the best way of going about it. The best results come from a photographer and model who respect each other's work. Given the right people, that respect can be earned within the first few minutes of working together.

How to treat your model
Whether you are using an amateur or a professional, treat your model as a human being, not as just one more accessory to go with the camera, tripod and cable release! Remember that an amateur model who hasn't posed before is probably quite nervous. Even professional models have to be treated correctly if you want to get the best results. I know of one top professional who always hated working with a particular photographer because he continually grumbled at her while they were working. Despite the fact that she had posed for hundreds of photographers all over the world, his attitude made her nervous and bad pictures resulted. Then one day, she hit back. She tried grumbling at *him*, and discovered that that was what he wanted all along. That was the sort of person he was. A new rapport developed between them and the next batch of pictures turned

out better than ever before. But of course the model shouldn't have had to act like that. It was the photographer's business to get the best results, and his attitude was ensuring just the opposite. If it made a professional nervous, just think what it might have done to an amateur.

It's a good idea, when you first meet the model for a photo session, to spend a while talking ideas over. Say exactly what you have in mind and how you aim to go about it. Don't be afraid even to go into technical details. The more the model understands, the better your results will be. Once you start on the session, keep talking. There's nothing worse for a model than to be put in front of a set of bright lights and then to get no more than a series of short, sharp directions from a photographer whose head is buried in his viewfinder. Set the camera on its tripod, frame the shot and focus, and then try to keep clear of actually looking through the viewfinder every couple of seconds. Let your model see your face while she is talking to you, not the top of your head.

Even with professional models, it often takes a while for them to relax to a point where expressions and poses come naturally, so don't expect to get your best results in the first twenty minutes or so. I know some people who even have a dummy run without a film in the camera just to give the model time to relax. I don't recommend it: you'll probably miss some unrepeatable shot. It's better to waste film than to lose pictures. While you are shooting, tell the model what is happening and how things are looking. Enthuse a little. If a particular shot looked good to you, then tell her so. Boost her ego and the pictures will get better. Portraiture is a two-way process and works best when both model and photographer are on the same wavelength.

Model release forms
If you aim to use your pictures for any commercial purpose (selling them, having them published, entering them in photographic contests, etc.) it's important to ask your model to sign a model release form. This is a printed declaration that puts in writing the model's permission for you to use the pictures you have taken for any purpose you so desire. The very fact that she has agreed to sit for you in the first place might seem to presuppose that she gives her permission anyway, but the law doesn't see it that way. Very often, there is a big difference between what *you* think and what *she* thinks is a good picture. Publish one that she doesn't like and she might have cause to complain, unless she has previously signed a model release form. There is nothing underhand about the action, it's just the safest way of preventing any possible unpleasantness at a later date. Model release forms are available from various professional bodies.

Makeup
Different models will have different ideas about makeup. Some favour a lot, while others go for the least amount possible. A professional should know just what she needs to wear for the best effect, but if you are dealing with an amateur who doesn't know what is required, a good starting point is to tell her to use the sort of makeup she would consider right for a formal night out. Then, from that starting point, you can begin to experiment with more ambitious effects. She should have a supply of translucent powder on hand to help reduce shine, important especially if you are working in the studio with tungsten lighting. Never forget how hot it is on the other side of the lights. Your model should be careful not to overdo foundation. The shade she chooses should be close to her own skin colour and just enough should be used to smooth out any skin blemishes, 'Cover-up sticks' can be used to hide the odd spot.

Eyes are undoubtedly the most important feature of any portrait, so particular care should be taken over their makeup. If the makeup is too dark, the eyes will photograph like black pits; too light and they will lose their impact. Colouring on the eyelid should complement both the model's hair and her eyes, especially for colour photography. Natural

MODEL RELEASE FORM

This release refers to photographs taken of ..

on .. at ...

Name of Photographer ..

If job was commissioned, state name of Client ...

State whether photographs will be used for EDITORIAL or ADVERTISING:

...If photographs are to be used in advertising a

product or service, state brand name and name of advertising agency concerned:

..

In consideration of having received the sum of £...................... , I hereby

give..*the absolute right and permission to

publish in any media, the photographs taken of me on the date and at the

location referred to above.

Signed: ...

Name & Address of Model ...

..

..

Guardian or Parent's Signature if model is a minor:

..

Name & Address of Parent or Guardian if model is a minor:

..

..

..

Signature of Witness ...

Name & Address of Witness ..

..

..

Date ..

(*Insert name of photographer or client.)

A model release form helps cover you in case of complaints from your model. This one is issued by the Bureau of Freelance Photographers.

colours like browns and pinks work well, but your model should be encouraged to stay clear of bright blues and greens. They tend to blend too much with the eyes, causing the combination to photograph like bright-coloured blobs. Mascara should be used to emphasise eyelashes and, if your model's are short or sparse, false lashes can work wonders. But make sure they look natural. False eyelashes designed for the stage, for instance, look far too thick when you move in close for portrait photography.

A brown contour powder, intelligently used, helps modelling. A slightly too thick nose can be made to look thinner by blending a little of the powder just inside the nose, next to the eyes. It is also useful for accentuating cheekbones, by brushing it under the bone. Brushed under the jaw, it will project the face forward. Contour powder should always be used to accentuate features, not to hide them. The same goes for blusher. This should be applied directly to the cheekbone, starting near the tip of the ear and ending two fingers' width from the nose. The line between blusher and contour powder should of course be carefully blended so that the camera will not reveal where one ends and the other begins. When blusher is applied, it should be balanced around the face. So, while the cheekbone is the most important place, it should also be lightly applied to the temples and the cleft of the chin.

Lips look more effective when they are outlined with a lip pencil of the same colour, but a shade darker than the lipstick. Red, not surprisingly, is the best shade for both colour and monochrome photography. Ideally, lipstick should be applied with a lip brush, beginning at the outer edges of the mouth and working towards the centre. To make weak lips fuller, the pencil line can be drawn a little outside the natural lip line and then filled in with lipstick. Conversely, lips can be made to look thinner by drawing the pencil line just inside the natural lip line. Naturally, the pencil line and the lipstick itself should be blended so that no sharp edges are seen between the two.

Hair

Simple, uncomplicated styles photograph best. A girl who is aware of her appearance will often know which style suits her face. So if she has one particular style, don't try to persuade her to adopt another style that she might not like. If she doesn't like her hair, she won't give her best for the pictures. Equally, don't be put off photographing someone simply because she has a style of hair that you don't happen to like much. You might not like hair pulled tightly back from the face, but if the girl who wears her hair like that makes her face more attractive on account of it, she's going to be more photogenic that way too. So learn to overcome your own prejudices about what you personally think is right and wrong.

When a girl agrees to pose for you, she'll probably assume she should wash her hair the night before to look her best. Maybe that will help her *look* her best, but it won't necessarily mean that she'll photograph well. Freshly-washed hair is notoriously wispy; as soon as you get a backlight on it, those wisps will stand out uncontrollably and maybe spoil an otherwise good picture. Washing hair also removes grease, and while too much grease gives hair a lank appearance that photographs badly, a little bit adds a shine that actually enhances a photograph. You should ask your model, therefore, to wash her hair a couple of days before the photo session. Then, ideally, if she has a set of heated rollers, get her to use them immediately before you start taking pictures to give her hair a little bounce. Finally, try to stay clear of ultra-modern or way-out hairstyles. Hopefully, you are taking pictures that will last for years, and there is nothing more off-putting than last year's hairstyles. They date your pictures and detract from their effect on account of it.

Clothes

The colour of your model's clothing is naturally important in colour photography, and the way colours can be used to their best effect is dealt with later on pages 112–115. For monochrome

photography, avoid colours that will register as a similar tone of grey to the background if you want to keep a decent contrast between the two. Don't dress your model in complicated styles, tops with intricate collars or dresses with vivid patterns, for example. Your model, and principally her face, is the main subject of your photograph so nothing should be allowed to detract from that.

For the head-and-shoulders work that makes up most portraiture, I favour a dress or top that leaves the shoulders bare. There is no collar or neckline to detract from the model's face, and there is no difference in tone between the face and the upper part of the body that might otherwise spoil the shot. If you do use this type of clothing, though, watch out for the model who makes up only her face. Remind her to apply some foundation to her shoulders too. The alternative is a natural-looking face on strangely pale shoulders with, worse still, a distinct line between the two.

Other models

Girls of course are not the only models available to you; the serious portrait photographer will get as much pleasure out of photographing a man or a child. Again, you can use an amateur or a professional, and much of what I've already said about finding the right model applies equally to men. You want someone who is photogenic. For a man, that usually means a strong face with interesting features, handsome rather than (for the want of a better word) 'pretty'. Previous advice over hair and makeup might seem, at first sight, to be inappropriate here, but male models (especially professionals) need to take as much care over their appearance as female models.

The previous advice over hair is no less applicable; makeup, however, is rather different. While much of a woman's makeup is used subtly to help the portrait and give modelling to the features, most of it will still be evident in the final picture. Makeup is a normal part of a woman's face and should be seen as such. For a man, it's different. He might need

some makeup to help the picture along, but it will be a makeup that won't be immediately obvious. Mostly, then, we are talking about light foundations to give the model a more tanned look where necessary, and perhaps a very light lip makeup in certain circumstances. All this is basically the prerogative of the professional model, and unless you have expert assistance from a trained makeup artist it is inadvisable to try with amateurs. Clothing, however, should be well thought out. Simple jackets with uncomplicated patterns work well for the formal type of portrait, and roll-neck sweaters are good for the more casual approach.

Children make excellent models, but they can also be very frustrating for the serious portrait photographer, since they don't respond well to direction. That particular problem is dealt with in the next chapter, but for now, let's consider the type of child you are looking for. Good looks are not necessarily a prerequisite. You are looking essentially for a child with character and with his or her own personality. Such traits develop very early, practically from the time children learn to sit up, but the best minimum age is around three. At that age, they begin to understand what the camera is all about and they will enjoy posing, rather than being let loose in the studio to be caught at the most photogenic moment. A few years more and they start to become self-conscious and embarrassed, neither of which makes for good portraiture.

Children should be photographed when they are not tired, and preferably when they are not hungry either. If you are photographing them in a studio, it is a good idea to show them around before the session starts, allowing them to gradually grow used to the surroundings. Look at your studio through a child's eyes, the eyes of someone who doesn't understand what lights, tripods and the like are all about, and you'll see just how frightening it could be. Simple explanation is the best way to kill fear. It's amazing how much children will begin to take for granted once they have seen there is nothing to worry about.

Children with real personality and character of their own make the best models. With some, it is almost impossible to take a bad picture. *Ed Buziak.*

Ron Tenchio

The art of posing

A portrait can be either the subject's picture or the photographer's picture. The former should present a true representation of the model's personality, while the latter becomes much more of a picture in its own right, representing the *photographer's* personality sometimes even at the expense of the model's. What decides more than anything else the course the portrait is going to take is the way in which the subject is posed.

Subject's picture or photographer's picture?

If your intention is to capture someone's personality on film your first duty is to get to know that personality. Watch the way models behave, the way they use their hands when they are talking, facial expressions that they might use more often than others, the way they hold themselves. These are things that your models won't necessarily have noticed for themselves, but when you come to take your picture you can use your observations to direct your subject into a pose that best sums up his or her individual mannerisms. The picture of the girl grinning zanily straight at the camera has created a lot of amusement over the years, and for that very reason it has often been condemned by editors and judges alike. Yet this picture summed up the personality of that particular girl at the time it was taken far more than any serious portrait ever would, and for that reason it can justifiably be called a good picture.

If your subject is a man or an old person with a lined face, don't try to hide the wrinkles. Instead, use your lighting to emphasise them. If you are dealing with a pretty girl, you are more justified in hiding any small imperfections in her features with a soft-focus filter or lens. Also, don't think portraits always have to show people smiling. Some people are naturally more serious than others, indeed some find it all but impossible to smile naturally. If that's

their nature, photograph them that way. Such people will look far better adopting a serious expression than being forced to smile or laugh.

Character can also be summed up in a portrait by accessories and surroundings. If your subject, for instance, is a man who is a habitual smoker, don't be afraid to photograph him with a cigarette; if you are picturing a girl who has a particularly way-out dress sense, photograph her in one of her off-beat outfits, rather than in the traditional dress or skirt that would make a more conventional portrait. The picture of the old lady watering flowers in her window box shows how surroundings can tell the viewer something about the subject. In this picture, the old lady is the smallest element in the whole composition, yet she is definitely the most important. The almost claustrophobic conditions in which she lives, coupled with the fact that she still manages to grow a few flowers, tells us a lot about her character.

The second type of portrait, in which the photographer sets out to create an interesting picture in its own right irrespective of the model's actual character or personality, is far more creative and so can be a lot more satisfying to take. However, if you want to try it, don't forget to tell your model in advance exactly what you are doing. Don't give him or her the impression that you are taking a nice, conventional portrait when, in fact, the lighting or the location is turning it into something far removed from that. Remember that, in agreeing to pose for you, your model has given you a measure of trust and has no real way of knowing what he or she looks like from your side of the camera.

Portraiture of this type is unlike its more conventional counterpart in so far as the model rarely sparks the initial idea. What comes first is the theme of the picture itself. That was very much the case with the picture of the girl standing alone in the empty landscape. It was also the case with two of the pictures shown on page 90: the man in front

46

Surroundings can say a lot about your subject's character. This picture looks like a candid shot, but was in fact carefully posed.

of the power station and the girl on the railway line. All these pictures were taken at the instigation of the photographer, rather than the subject. In each case, the location came first and was used to inspire the idea for a picture. Having formulated exactly the way the finished picture should be, a suitable model was found to make it work. Professional models are ideal for this type of portraiture because they spend most of their working life posing as different characters, and the end product is their fee rather than the picture. That's their job, so provided you don't make them look silly they won't mind if the picture shows them different from the way they see themselves. Amateur models might be more fussy. The best are those who have had some experience in amateur dramatics and who are willing to 'act out' the idea you have for a picture.

place relative to the surroundings, and then not the smallest bit more than is necessary of those surroundings should be seen in the picture area. More often than not, however, a portrait is a picture of a person, a single person and nothing but that person, so the subject should fill the frame.

Learn to look through your viewfinder. Far too many pictures are spoilt simply because the photographer has not obeyed that most basic of rules. It's all too easy to concentrate only on the main subject at the expense of everything else that might be in the picture area, ending up with your subject too small in the frame. It's not so bad with black-and-white or colour-negative film with which you can enlarge just the part you need, but with colour slides it's fatal. Here's a simple test to try. Pick up your camera and look through the viewfinder at an object filling about half the frame. Now *really* look through the viewfinder. Keep the camera still and move your eye around the four corners. There are few people who can take in the whole picture area without moving their eye.

So move in close and use the right lens to fill the frame accurately with exactly what you require. A single-lens reflex of course makes your task simple, but with practice you can equally use a non-reflex camera, even when working close. Learn the relationship between the viewfinder image and the lens view in close-ups; with a bright-frame finder, discover when to use the parallax marks. There is no way I can give you exact instructions on the precise point to position your model, since it will vary with different non-reflex cameras. (With some, the camera's finder provides the required correction automatically as the lens is focused.) But a little trial and error is a wonderful thing. Take a few shots, placing your subject further and further out of the viewfinder frame each time, and make a note of the positions. By the time you have taken and seen the results of half-a-dozen shots, you'll know just the place in the viewfinder of your particular camera that will produce the desired effect on the film at a given shooting distance.

The photographer's picture, as opposed to the model's picture, does not necessarily have to sum up the subject's personality. The idea for this portrait was dreamt up by the photographer, who then found the right model to make the idea work.

Many examples of this type of picture are reliant on locations to provide individuality. But others can be taken in a studio, where it is often the lighting or the application of some special effect that differentiates the subject's picture from the photographer's picture. A later chapter is devoted to special effects, many of which should give you ideas of how to bring your own touch of individuality to your portraiture.

Filling the frame

Posing your subject for an effective portrait begins, not with the subject, but with the camera. A portrait is essentially a picture of a person, and that person should dominate the picture. If the background or surroundings are an integral part of the picture, the subject should be posed in the best

You will, however, have another problem: perspective distortion. In talking about non-reflex cameras, we are often talking about cameras without a facility for changing lenses. A fixed-lens camera is usually fitted with a standard lens, and to fill the whole frame with a single face means moving in to around 1½ metres or closer, at which distance your subject's features will begin to look unnatural. The problem is made worse by many of the non-reflex, compact 35 mm cameras currently on the market, most of which are fitted with semi-wide-angle lenses. There is a solution, though not a very good one. You can step back and take the picture from further away. This prevents perspective distortion and parallax problems. But you will have to blow up the final result to fill the print area, and that means a loss of quality. So, to repeat what I said on page 18, it is possible to use a non-reflex camera for portraiture, but given the choice it's not recommended.

Two of the problems of using a non-reflex camera for close-ups. Perspective distortion is seen here in an exaggeratedly large nose, and eyes that appear too close to the sides of a slightly fat face. Parallax is shown by the broken line (the view through the viewfinder) and the solid line (the image likely to appear on the film).

Relaxing your subject

The professional model knows how to relax, or at least how to *appear* relaxed. For an amateur model, looking relaxed in front of the camera is an art still to be learnt. There are a number of ways you can help. Remember that someone who has been asked to pose for the first time is probably quite nervous. It's up to you to relax the model by talking, giving reassurance of the way things are going, and saying things look good even when they look bad.

Tell an inexperienced model to smile and the result can be grotesque. The reason is simple. Naturally smiling people do more than merely turn up the corners of their mouths. A smile is reflected in the eyes as much as in the lips. So those who smile with their mouths without bringing the right light to their eyes will record badly on film. This is something that, as a photographer, you will learn to notice, but many people go through life without knowing it about themselves. So remind your model of the fact. Talk to her, crack a joke or two and make her laugh. Then stop her and remind her of how she was smiling naturally. Once she has

48

noticed it for herself, she will be able, with practice, to teach herself the right way to smile for you.

Eyes and mouths, then, are your main concern, so learn how to deal with each in turn. Tension can cause your model to tighten the muscles around the mouth, giving an unnatural expression. To relax that part of her face, ask your model to fill her mouth with air a few times, to blow out her cheeks and then to let the air out through her lips. It gives the mouth something to do and the muscles 'forget' their tension for a moment. It is also a pretty silly exercise and will probably make your model laugh, all of which helps her to relax. Licking the lips also helps to relax the mouth. It relieves the dryness caused by nerves, and at the same time adds a highlight to the lips that photographs well.

The trouble with eyes is the way they tend to go dead while the model is waiting for the shutter to click. The actual difference between 'dead' and 'alive' eyes is an infinitesimal change in expression

Right: engage your subject in conversation during the session and you'll get a more natural look to your portraits. *Kevin MacDonnell.*

that you would be hard put to describe in words. But you'll recognise the look when you see it and you'll soon realise that it's enough to ruin a portrait. If you find your model is beginning to take on the glassy, blank look, there is a simple way of bringing the life back to her face. Tell her to look away from the camera, either down at her toes or around to one side; then, when you are ready to take the picture, get her to turn quickly back to face you. The blank look will have gone and you can safely press the shutter. Alternatively, ask her to close her eyes for a moment and then to open them wide as you take the picture.

The way *not* to relax your model is to attempt to direct her into an awkward pose. So start the session with simple, natural poses. Sit her down and make sure she is comfortable. You may only be photographing head and shoulders, but the position of her arms and hands will dictate whether or not she feels relaxed. So allow her to rest her hands in her lap. The more comfortable she feels, the better your pictures will be.

The pose
The most popular type of portrait is the head-and-shoulders shot. To finish with a good picture, you must begin by considering something that might, at first, seem to have little do with either photography or the model: decide what your subject is going to sit on. A backless stool is best, simply because, with a chair, it's all too easy to include the back in your picture without noticing it, thus making an unwanted distraction. The lack of back, however, can present a problem to the sitter, who without that support might tend to slump forward slightly, presenting a round-shouldered look to the camera. Keep a careful watch on that, and always encourage your models to keep their backs straight, even when they are perhaps leaning forward into a pose. 'Straight' does not have to mean 'vertical'.

Faces have two sides to them. An obvious fact, but one that shouldn't be ignored, because very often

49

one side of your model's face will be more photogenic than the other. Look carefully at your model and you'll soon see which side is best. It might be a hairstyle that is parted to look better from one side than the other. Many people, both men and women, have noses that point slightly more to one side of their face than the other. The side to which the nose points is generally the more photogenic. Whichever is the better is clearly the side to shoot from.

The actual position of the subject's head in a portrait is simple to visualise, once you know a few basic rules. Look at the face and imagine a line drawn vertically down its centre, bisecting the nose. Now imagine another line drawn horizontally through the eyes. The resulting cross should always be placed off-centre. Imagine your picture area overlaid with a noughts-and-crosses grid. The horizontal line of your cross should be along the top line of the grid and the vertical line down the left or right vertical lines. If the subject is looking to the left, the right-hand line should be used, to give more space for the subject to 'look into'. If the subject is looking to the right, the left-hand line should be used for similar reasons. Given the choice, position your subject on the right, looking towards the left. The viewer, who is used to reading from left to right, will also look at a picture that way and his gaze will consequently move across the picture, into the subject's eyes. The effect is obviously far more pleasing than scanning the picture so that your eyes start at the back of the subject's head.

If the cross is exactly upright, the portrait will look fairly formal and a serious expression will suit best. In any form of photography diagonals always suggest movement, and portraiture, although essentially a static subject, is no exception. Tilt the cross forward, so that your subject is leaning into the picture, and the portrait becomes far more relaxed and informal. Tilt it back slightly and a feeling of vitality will be conveyed, but only when coupled with a happy facial expression. Tilt the

head back with a more serious expression and the subject will begin to appear aloof. When working with this type of composition, beware especially of tilting the head too far back. The right amount might give the impression of someone throwing back their head to laugh, but go just a fraction further and your picture could look more as though the subject is about to overbalance.

There are three basic positions for a head-and-shoulders portrait: full face to the camera, three-quarters view, and profile, Each gives the picture its own particular mood. A full face, looking straight at the camera, gives immediate contact between the subject and the viewer, building a feeling of intimacy and a certain amount of formality. Keeping the face where it is and flicking the eyes from the camera can change everything. The feeling is that the model has meant to look at you, the viewer, but has been distracted at the last moment by something outside the picture area. The expression becomes one of suspicion or even fear. Tilting the head to look down, then bringing the eyes back to the camera, changes things again. It widens the eyes, giving a woman a vulnerable look. For that reason, it's an expression that doesn't work well with men.

Keeping the eyes on the camera but now changing to a three-quarters view of the face gives an informal, relaxed look. Different moods can be conveyed according to the subject and expression. A woman might look coy, as though the photographer has caught her out; a man in the same pose might look suspicious. The three-quarters view of the face in which the eyes look straight ahead and obliquely away from the camera gives the impression that the subject is aware of the camera, but is preoccupied and has no interest in it. The subject in this pose will look pensive, especially if the whole face is tilted slightly down. When shooting any three-quarters view of your subject, take care not to turn the head too far. Don't let your model's nose meet or intersect the profile of the far cheek. If it does, ask your subject

Leaning forward into the picture gives the pose a more relaxed and informal look.

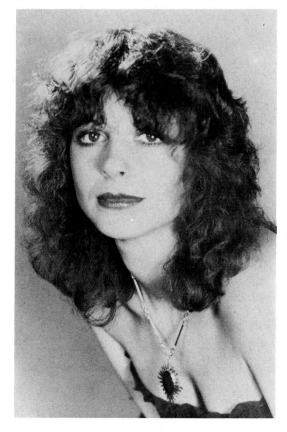

Page 52: if you have difficulty positioning hands, why not exaggerate them? It may not be considered traditional portraiture, but it can make an effective picture. *Brian Gibbs*.

Page 53: a three-quarters shot can be posed in much the same way as a close-up. The girl's natural expression was produced by asking her to look away from the camera, then to swing her head back towards the lens. She held the expression for no more than a fraction of a second before the exposure was made.

to turn his or her head slightly back towards the camera. The profile portrait, in which the subject looks straight ahead at 90 degrees to the camera, makes a dramatic shot. There is no eye contact between the model and the viewer, leaving the impression that the subject doesn't even know that the camera is there. People shot in profile tend to look aloof or more interested in something going on outside the picture area.

However you pose your subject's head, it is inadvisable to pose the body square-on to the camera. Even in a full-face shot, your subject should be seated three-quarters to the camera and then asked to look back. The person who is posed

square-on to the camera will appear to have a far broader (not necessarily *fatter*) body than normal. If you are dealing with a lively subject, a young girl with a vivacious personality perhaps, you can even turn your model so that she is facing in a three-quarters pose *away* from the camera, then ask her to look back at you. Be careful with this pose, though. When setting it up, start with the final position for the head, then ask your model to slowly turn her body away and stop while she is still comfortable. Asking her to look too far back can be extremely uncomfortable, and the discomfort will show in the portrait.

It's very easy, when posing your subject, to look only at the face or, worse still, no further than the eyes. Watch the whole frame and pay particular attention to the shoulders, one of which will normally be nearer the camera than the other. Make sure that the angle you are using doesn't make the nearer shoulder unnaturally large. Also, make sure that the nearer shoulder is higher in the frame than the far one.

Hands are perhaps the most difficult element to introduce naturally into a portrait. If in any doubt, it is best either to leave them out, relying on the face alone to give the picture its impact, or to go the other way completely, using the hands in an exaggerated pose such as that in the picture of the girl with her hand spread before her face. If your aim is to include hands in a more natural way, make sure they are in the same plane as the head. A hand has only to be fractionally nearer the camera than the face to look disproportionately large, and the narrow depth of field common to portraiture will quickly render it out of focus. There's nothing worse than an over-large, blurred blob in the foreground to spoil an otherwise perfect portrait.

If you are moving in close, make sure you show enough of the subject's arm to indicate that the hands are actually attached to his or her body. It's all too easy to position your model's face on one side of the picture, with a pair of disjointed hands

that might as well belong to someone else coming from the other side of the frame. This is one place where a traditional, hard-backed chair can be an advantage. Turn it so that it faces three-quarters away from the camera, then get your subject to sit sideways, looking back at you and resting his or her arms along the back. It immediately gives a relaxed pose and one that makes a good starting point for positioning hands and arms. Arms along the chair back can look suitably casual, but beware of a distorted elbow pointing at the camera. You might also ask your subject to rest only one forearm on the chair back and then to sit with the opposite hand resting lightly on the first. Relaxation is the watchword when introducing hands into any portrait, so never ask your subject to adopt a pose that is unnatural or uncomfortable. Well positioned, your model's hands will help tremendously to convey his or her character. In the wrong position, they can ruin the whole picture.

Most of what has been said above applies only to posing head-and-shoulders portraits, but much of it can equally be applied to the three-quarter-length or full-length picture. As with head-and-shoulders pictures, unless you are going for a specific effect it is rarely a good idea to pose your model square-on to the camera. It's better to ask them to pose facing at 90 degrees in profile and then to swivel their body from the hips back towards you. A full-length pose is usually best shot in conjunction with some accessory or background that is pertinent to the picture. The reason is simple. The average person is 1½ to 2 metres in height by about half a metre wide, and that makes a very awkward shape to photograph when the person concerned is the only object in the picture. Shoot the subject together with a suitable background and you begin to get a more conventional shape to the composition. A serious-minded man, for instance, can be photographed maybe in a library, where the books in the background form an integral part of the picture and tell you something about his character. Shoot a full-length portrait from between eye and chest level and the subject will look slightly shorter

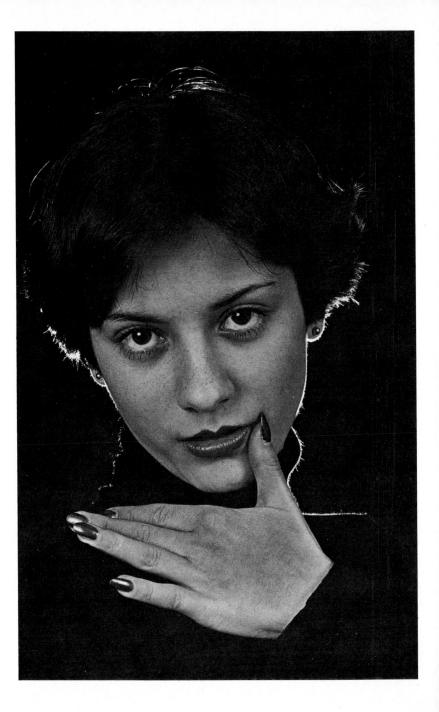

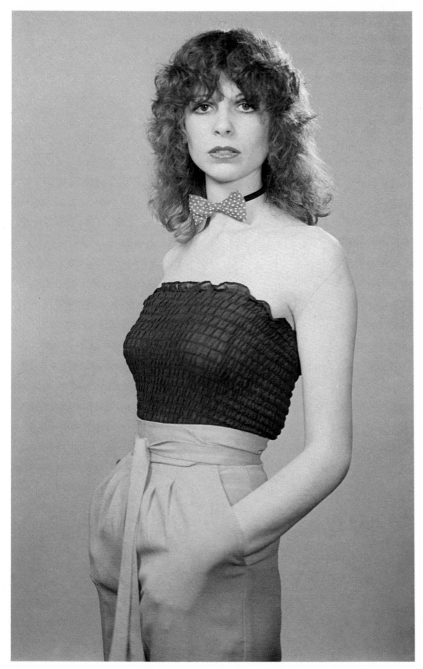

than he or she really is. Shooting from below knee level makes the model look taller, emphasising legs in a pretty girl. If a full-length portrait is to be shot of the person alone, it's not a bad idea to ask the person to sit down and so immediately take on a more compact shape.

Good portraiture of course means more than following a set of rules blindly. If we were talking about still-life photography, for instance, you might be able to produce great photographs by following the rules. Top-class portraiture, however, relies on learning the rules and then applying them, bending them, even breaking them when the occasion justifies it. Because never forget that your subject is a living person, and it's up to you to find how the rules best apply to each individual you photograph. Rules that work for one face won't necessarily work for another.

Finding just *how* they work best is largely a matter of personal experience, but it doesn't hurt to learn from the experience of others. Portraiture is all around you. Pay attention to the work of recognised photographers whose pictures are published in books or on show in galleries. Look through women's magazines, especially at the cosmetics adverts. Copy poses, and then adapt the ideas of others to formulate ideas of your own. Watch television, particularly soap opera. The programmes that predominantly feature women usually compose each shot to show the stars to their best advantage. The way they stand and move can tell you a lot about posing and give you a wealth of ideas for your own pictures.

Children
You *can* pose children in all the ways mentioned above, but you must allow for a certain lack in their powers of concentration. Children over the age of three will respond to direction, but only for a time. So you can start by posing them the way you would an adult. But the moment their attention begins to wander, it's time to try a new line of approach. Have a few objects available that will interest

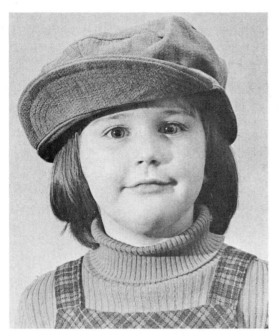

Find the right child, make sure he or she doesn't become bored and you have the recipe for great pictures. This little girl was given the cap and glasses to play with and her expressions changed as fast as the shutter clicked.

A craftsman often feels more at home in his own environment than in the studio, and so that's the best place to take his portrait, allowing him to work while you shoot. *Roy Pryer.*

Another example of how the unposed pose works well, telling you more about the subject than a conventionally posed shot ever could. *Jim Standen.*

Alternatively, if you take him into the studio and ask him to dress in his boxing shorts and look mean for the camera, all you'll get is a picture of someone whose embarrassed expression reflects the strange surroundings in which he has found himself. He's not a professional model, he's a boxer, and nothing is going to make him relax enough to give you the sort of picture you are after.

For the best pictures in these circumstances, then, you should photograph your model on location, in the boxing ring. But remember you are a portrait photographer, not a sports photographer. In this particular example, you wouldn't be shooting pictures of the boxing match itself, but maybe using a long-focus lens to pick out expressions on your subject's face as he goes about his business, shooting him between rounds as he sits in his corner, preparing himself for his next bout. The same goes for most types of sports people: tennis stars, runners, gymnasts. Photograph them in action, but watch too for pictures before and after the action. A picture of a runner, taken as a full-length shot as he speeds along the track with the background blurred behind him, is a good sports picture; a close-up shot of the runner's sweating face, racked with exhaustion at the end of the event, is a better *portrait*.

Another place where the unposed pose works well is in photographing craftsmen: the potter at his wheel, the woodcarver intent on his subject, the craftsman working at his lathe. The biggest problem will be working in conditions suitable to the subject rather than the photographer. Instead of bringing your own lighting to the subject or taking your subject to the best place for your photography, you will have to work wherever that subject is most at home. That could mean vastly different locations ranging from, say, a large sports arena to a small workshop. Wherever you work, you can use techniques described in later chapters to light your subject. For the most part, this will mean applying what you learn from the chapter on available light.

them, not necessarily toys. In the set of pictures on pages 54–55, I merely gave the little girl an old denim cap she likes playing with and my own glasses, then shot the pictures in rapid succession, the child's expression changing with every click of the shutter. The skill comes in applying the rules about posing, together with other rules you have yet to learn about lighting and such, in an almost candid form of photography, watching for exactly the right moment to take the picture.

The unposed pose
Sometimes a pose works better if it isn't actually posed. Take as an example the portrait photographer faced with photographing a sporting personality. Think of a boxer. Without doubt, those words conjure up in your mind a vision of a powerful man, stripped to the waist, gloves on hands, a determined expression on his face and ready to lay into his opponent. Take that man, dress him in a suit and ask him to smile in a studio and you completely destroy his personality.

The character of an athlete who might be embarrassed at posing for the camera in the normal way is captured perfectly by a candid shot taken at the end of a race. *Mervyn Rees.*

The unposed pose can often tell you more about your model than a formal studio portrait ever could. *Mervyn Rees.*

The technique for posing your subject isn't unlike working as a candid photographer (see later). Unlike the victim of a true candid picture, however, your subject will nearly always be aware of being photographed. Don't let this work against you. Someone working at a lathe, for instance, having been told that you want to take his picture, might think that he has to put on clean clothes and not get his hands dirty. So explain that you want a natural picture, that you are out to photograph him the way he works. Once he has begun to work, he will rapidly lose himself in the job, forgetting all about the cameraman who is watching him through a viewfinder. That leaves you free to watch for interesting expressions, capturing the picture at the best moment. When it comes to subjects such as sports photography, you can either ask your model to go through his particular routine in private for the camera, again choosing the best moment for the picture, or you can work at actual events, shooting from a distance with medium- to long-focus lenses. The latter way of working is the best, producing splendidly natural portraits of your subjects.

Children too are good subjects for this particular method of shooting. Earlier in this chapter, we dealt with the best way to pose children formally. Going for the unposed pose, on the other hand, gives far more natural results. Children at play have a wonderful concentration on what they are doing at any particular moment that cuts them off from anything else going on around, and that includes you and your camera. Don't go out of your way to be unobtrusive, because that could begin to attract them to you. *You* will become the thing they start to concentrate on. Instead, explain to them that you want to take a few pictures as they play. Once the initial novelty has worn off, they will soon become involved with something else, forgetting all about you and leaving you to follow them around, shooting from only a couple of metres away. The best location for such pictures is out of doors, in a playground or in a field where the children are playing. For lighting, think in terms of the points covered in the chapter on portraiture outdoors.

60

Disguising defects

Even the best models are rarely perfect. Certain poses should be avoided with certain features, while other poses can help hide the defects. If you are photographing someone looking back at the camera over a shoulder, watch out for lines and wrinkles in the neck. These can be flattened out a little by asking your model to look down before he or she looks at the camera; then, looking back, the head is lifted again. Baldness can be hidden by lighting your subject predominantly from the side and shooting from below the chin line. Conversely, a double chin is best hidden by shooting from slightly above head height, so that the subject is forced to look up at the camera. If your model has some unsymmetrical feature such as a slightly twisted nose, don't shoot head-on. If a nose or chin is unnaturally large, never shoot in profile. A large nose, as long as it is straight, can be shot head-on. The longest practical focal length of lens can then be used to compress perspective and so 'shorten' the defect. Lighting should also be arranged so as not to cast a long nose shadow.

If your model has a lined and wrinkled face, you might want to use your lighting, in ways described later, to emphasise the points and so bring out your subject's character. There are times, however, when it might be more prudent to disguise those very characteristics. A middle-aged woman, for instance, might have a few lines on her face that she doesn't want to admit to. She isn't old enough to warrant a character-study type of portrait, but she isn't young enough either to justify a glamour approach; you need something in between. Lighting plays a large part here. The more the main light is taken away from the camera-to-subject axis, the more those lines will show. To help disguise the defect, lighting should be kept more to the front and not too far above head height. The light should also be softened. A hard light in a deep reflector or from a spotlight will emphasise shadows in the lines of the skin, so keep your main lights in shallow reflectors or bounced from umbrellas. (See the next chapter for actual techniques.) Soft focus can also

Children photographed outdoors are often best left to their own devices. The mischief they get into will soon lead naturally to lively pictures.

help 'iron out' lines and stressmarks on a face, and this can be achieved in a number of ways, soft-focus lenses and filters being the two most popular and convenient. See page 133 for fuller details.

Blotchy skin or freckles can be hidden to some extent in black-and-white photography by the use of filters. Since filters lighten their own colour, a pale straw-coloured one such as an 81A or 81B will reduce the effect, especially when coupled with frontal lighting. But at the same time it will reduce the tone of lips, a fact that should be prepared for in advance by the use of a darker than usual lipstick. The same filters can be used to give a more healthy look to pale skin in colour photography; in mono, a blue filter will have a similar effect, while lightening blue eyes. Both effects are particularly useful in male portraiture.

If a person is naturally short and maybe a little fat, a three-quarters length pose can add a certain amount of apparent height. Don't pose the subject in a way that emphasises a defect; if your model has a large stomach, keep it out of profile, shooting head-on, but with lighting more to the side. Side lighting tends to 'slim down' a face, while frontal lighting makes it appear broader. The right choice of clothes also helps: vertical stripes on a shirt or dress give an apparently slimmer look than horizontal stripes. And remember that the two sides of a face are often quite different. One might be slimmer than the other, so that is the side from which to shoot.

Finally, spectacles and ears. If your subject wears spectacles, watch first for unwanted reflections, then make sure you can see the eyes behind the lenses. If you can't, try a slightly lower viewpoint. If the subject has ears that stick out a little too much, photograph him or her in a three-quarters pose. If the shot must be head-on, reduce the lighting slightly on each side of the face, using barndoors on the lights.

Michael Barrington Martin

Gibbs

Studio portraits

Taking portraits in a studio can be both satisfying and frustrating. Satisfying because you have literally everything under your control; frustrating because despite that fact you have only to overlook one factor to ruin your picture.

The studio

You can hire a professional studio or you can build your own. Professional studios vary enormously in what they have to offer. Some have just the studio facilities, others run a model agency as well. Many contain no more than the bare studio and lighting equipment while some might feature, along with the studio, changing rooms, sunrooms, a reception area to meet models, showers and even a bar. They can be hired by the hour or by the day. Look at the classified advertisements in the photo press or in your own Yellow Pages to find the nearest and most convenient for your purposes. If you are serious about your portraiture, however, you'll want to build your own studio. You'll need a room at least five metres in length, because that's the minimum in which you'll be able to take full-length shots or head-and-shoulders portraits with medium telephoto lenses, while still keeping a decent distance between the subject and the background. The width should be no less than around two and a half metres.

If your studio is going to be permanent you can afford to decorate it correctly. White emulsion is ideal for walls and ceilings. At all costs avoid glossy surfaces. The floor should be covered in a material that is non-slip, easy to clean and doesn't mark easily. A plain vinyl covering such as that sold for domestic kitchen flooring works well. Windows should be fitted with blinds or blackout material to keep out extraneous daylight, but easily removable for available-light shots or for a mixture of daylight and artificial light. One ideal and often overlooked

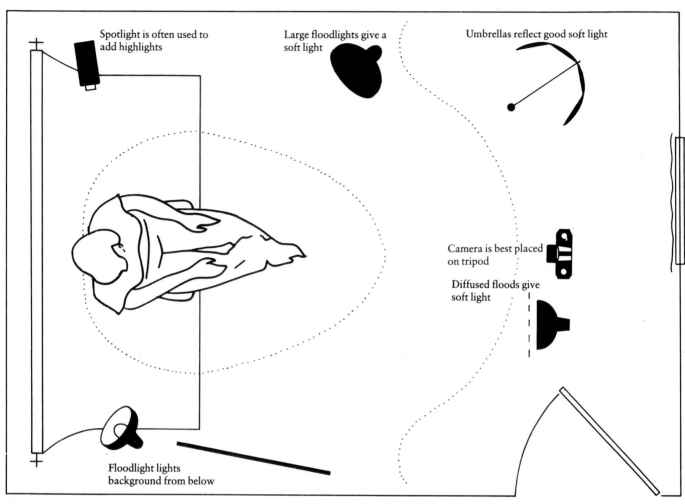

Spotlight is often used to add highlights

Large floodlights give a soft light

Umbrellas reflect good soft light

Camera is best placed on tripod

Diffused floods give soft light

Floodlight lights background from below

A typical studio layout
Any uncluttered space can be used to take photographs. The minimum length for taking full-length portraits is about 5 metres (17 feet), and a studio needs to be at least 2.5 metres (8 feet) wide. Artificial lighting can come from tungsten or flash units.

A roll of coloured paper makes the best background, but a plain wall is a possible alternative.

Black, white or coloured reflectors give lighting flexibility.

Give the model room to move.

The photographer needs room to move.

Door opening takes up space.

Black out windows.

place in the average house is the garage. If your studio is doomed to be a less permanent affair you can use any decent-sized room in the house. Remove any pictures or mirrors from the walls whose glass might cause unwanted reflections, and hang heavily-lined curtains that can be pulled to keep out unwanted daylight. You'll have to manage with the floor, ceiling and walls as they are, but watch out for strong colours in any of these surfaces that might throw unwanted casts on to the model's face.

The coloured background paper mentioned on page 33 can be used in both permanent and temporary studios, hung from a commercially available stand consisting of two legs that are specially sprung so that they support themselves between floor and ceiling, with a bar across to hold the roll of paper. The system can be easily erected and taken apart at the beginning and end of each session if necessary. When working in a studio, always use a tripod, essential for the relatively long exposure times demanded by tungsten lighting. This isn't to say a tripod should be ignored when working with flash. With the short exposure times that flash dictates, the camera *can* be hand-held, but it's still better to leave it set up on a tripod while you arrange lighting, position your model, etc. And, provided that the model is sitting or standing in one position, it obviates the necessity for continually adjusting focus. Once your camera is on its tripod, add a lens hood and cable release, decide whether you want to use tungsten or flash lighting, load your camera and you're ready to begin shooting.

Lighting effects
Every studio portrait, irrespective of the number of lights used to take it, relies on just one light for its principal effect. This is the 'keylight'. It is usually the strongest of all the lights used and the one that dictates the degree of modelling on the subject's face. It's a good idea, then, to start by learning the various effects created by placing one light in a number of different positions. Find a patient model,

sit him or her facing square into the camera, and take eight pictures while systematically moving that one light around the face. Use tungsten light with a deep reflector or direct flash to give you maximum contrast. Here are your eight lighting positions and the effects they create.

1 With the light close to the lens and aimed straight at the subject, the face appears fat and almost two-dimensional. There is no modelling to the nose, the eyes have no depth, and the lips are dull and fat.

2 Begin moving the light straight up. As you move it, your subject's eyes appear to recede into the head, gaining more character and life. A shadow develops below the nose and the lips begin to look better formed. The face has more modelling to it, but shadows, especially in the eye sockets, are ugly.

3 Move the light back again, down to a position below your subject's face. Shadows are now directed upwards, giving a weird, unreal look to the face.

4 Return the light to its central position and move it to one side. The face starts to look more narrow and modelling improves. With the light at 45 degrees to the subject, the shape of the face is at its most natural, modelling is well-defined, but the nose casts an ugly shadow across the cheek.

5 Moving the light around to 90 degrees divides the face in half, one side in shadow, the other over-lit. The eye on the dark side disappears completely and even the one on the light side is thrown heavily into shadow.

6 Take the light further round, level with the subject's head and at 45 degrees behind it. The face is still divided down the centre, light on one side and shadow on the other, but now there is more texture to the lit side. The light side of the face shows more modelling, but there is no light in either eye.

7 Move the light all the way round to the opposite side of the model, so that it is shining straight back into the camera lens, but obscured by the subject's head. The face is now thrown completely into shadow with only a rim of light traced round its outline. There is no modelling at all, only dark and light with no shades in between.

8 Finally, bring the light round to the front and side of your model again and raise it above head height. Position the light at 45 degrees to the side and 45 degrees above. The lighting should now be dramatic and show a lot of texture. The nose shadow just touches the lip and there is light in the eyes. The face is rendered as its correct shape. This last position is the classic one for a keylight, although as explained later it needs at least one more fill-in light before the finished result gives anything like a good portrait.

You should now have eight pictures showing your model lit in eight different ways. None of the pictures is necessarily a good portrait, but taking them has been a useful exercise in learning what light does to a face. Keep the pictures. They will be useful for future reference. Finding different lighting techniques is one of the joys of studio portraiture. But there are certain basic rules of lighting and they are not the sort that are made to be broken. Maybe you can bend them a little, adapt them to your own ideas, however unconventional. But remember that there is a whole world of difference between an *unconventionally* lit portrait and a *badly* lit portrait. So learn the rules first. Here are some lighting ideas using one, two and three lights. Use these as a basis for your own experiments in lighting.

One light
A portrait will usually have a keylight plus some kind of fill-in. That doesn't mean, however, that portraiture with a single light is impossible. For the right kind of portrait, it can be very effective. If you have only one light, start by positioning it to one side of your subject and just above eye-level. Place

it on the side your subject is facing, and watch the shadows. The nose shadow should be angled down and away from the light. Don't let it cross your model's upper lip. Watch the eyes: don't let the shadows of the eyelids cross the pupils.

With the light at around 45 degrees to the side and 45 degrees above your subject, every line and crease in the face, every pore in the skin will stand out. That can make powerful lighting for a male character study, an old man maybe with a weather-beaten face. It is, however, totally unsuitable for a woman, a young girl or any type of portrait in which you wish to flatter the subject. Bring the light round towards the camera and down so that the two angles are reduced to more like 30 degrees each; the effect becomes softer, more glamorous and obviously better suited to female subjects. These angles apply to a portrait in which the subject is facing straight into the camera. As the head is turned, so the light must be moved around and away from the camera accordingly.

A single light is best softened to reduce shadows to a minimum. A large shallow-bowl reflector with tungsten, or flash bounced into a white umbrella, is one way to get the required effect. Another is to hang some kind of diffusing material a few centimetres in front of the light. Use a sheet of white tracing paper or a length of white plastic such as the type made for shower curtaining, but beware when using tungsten lighting. Don't hang your diffuser too close to the hot lamp unless you want to start a fire. A third way to soften a single light source, whether tungsten or flash, is to position your subject a metre or two from a light-coloured wall and direct your light at the wall so that the model is lit by reflection.

A good reflector intelligently used can work wonders for a one-lamp portrait. With the light at 30 degrees to the side and above, position a large white reflector on the opposite side of your model at 90 degrees to the face. It bounces the light back, filling in harsh shadows and giving a more

A lighting set-up that gives a particularly flattering effect. Keep the light high and the camera just above head-height. Ask the model to look up into the lens.

Don't be afraid to move in close if your subject has the right sort of face. The picture was taken with an extension tube on a 145 mm lens, used on a medium-format camera. Lighting was from a single diffused flood at 30° to the right and above the model and a large white reflector at 90° to the left. The slight soft-focus effect comes from a special aberration control on the lens.

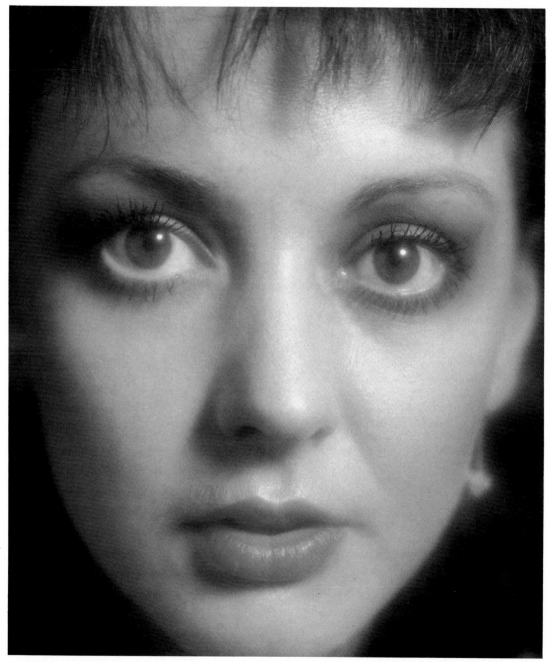

One light used to unusual effect. A spotlight was placed directly behind the model, rimlighting her hair, while her face was lit only by a gold reflector beside the camera at head-height.

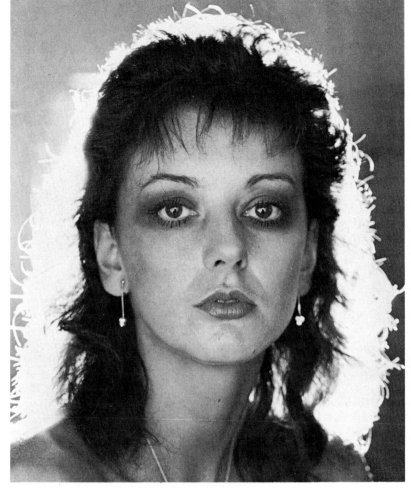

glamorous effect. A white reflector gives a contrasty result, most suitable for men; a large black reflector soften the features, but keeps the roundness in the face, making it better for women. For a more dramatic effect, use a spotlight or flash with a snoot as your single light source, with a reflector still to the side. It's a good light for men, but not so good for women unless your model has a strong face, full of character. She must also have a flawless complexion. If her skin is anything less than perfect, this lighting will bring it out. Conversely, a softly diffused light, used above the model and just to one side of the camera with black reflectors as close as possible to each side of the face and slightly angled towards the camera can give a beautiful, flattering effect. Keep your light high and ask your model to look up slightly to light her face evenly and to keep her eyes out of shadow. Cheeks are hollowed and cheekbones accentuated on account of it. This is a lighting set-up that works particularly well with a soft-focus filter.

Move the light round to 45 degrees behind your model and you have what has come to be known as Rembrandt lighting, after the type of light favoured by the painter for his portraits. We have already seen the effect of this in our lighting experiments earlier in this chapter, but to turn the experiment into a worthwhile portrait, add a reflector on the opposite side of the face to reflect some light back into the shadows. Another interesting effect can be obtained with a single light by positioning it above the subject at 90 degrees. The model is then turned,

70

profile to the camera, and asked to look up into the light or (for the sake of comfort) just slightly to the camera side of the reflector. With this set-up, the features are lit and the rest of the face falls away into shadow. Finally, for a particularly striking effect, move your single light behind the model so that it is shining back towards you and merely rimlighting the subject, then add a reflector to one side of the camera to bounce light back into the face. The features are lit only by reflected light, but with a halo of bright light round the face and hair.

For this shot, the model lay on the floor and the camera was suspended above her. The lighting, however, was as conventional as if she had been sitting upright with the camera in front of her: keylight to the left, a metre or so above the floor; fill-in light suspended from a boom beside the camera. In effect, a standard two-lamp lighting set-up turned through 90°.

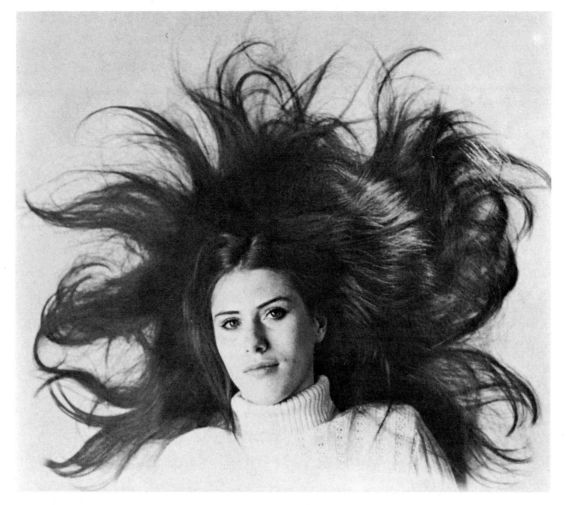

Two lights

The second light in a portrait is often there to help iron out problems that the keylight might cause. It is not there to change drastically the overall lighting effect. In fact its most common use is as a fill-in. Once you have that, the keylight can be used in a harsher reflector than that associated with its use as a single light source. It is the fill-in light that should now be as soft and as shadowless as possible, so this should be used in a wide, shallow reflector or bounced from a brolly. The intensity should be somewhat less than that of the keylight, otherwise it will destroy the modelling.

Start by arranging your keylight to one side and above your subject, the nose shadow angled down towards the upper lip. Now place your fill-in light as near to the camera as possible, level with the lens and preferably on the same side as the keylight. On its own the fill-in light would give a flat effect, but coupled with the stronger keylight it serves to fill in the shadows. Move the light backwards and

forwards along the lens axis. As you take it further away from the subject, less light falls on the face and so the shadows become more evident. Adjust the light until you get the required degree of contrast between the highlights, lit by the main light, and the shadow areas, lit by the fill-in. Don't trust your eyes. They adapt for the differences, but your film won't. So take exposure readings (see later). For monochrome work, keep the contrast ratio of highlights to shadows between 2:1 and 4:1, according to the particular effect you want. A fair-skinned model with blonde hair, photographed with a 2:1 ratio, will give a high-key effect; a darker model, photographed at the other end of the scale (4:1 or even more) will give a picture more approaching low-key. Colour film, however, finds it hard to deal with a contrast ratio of more than 2:1 without losing detail in one of the areas.

The lighting just described is probably the most traditional of two-lamp portrait set-ups. It should be mastered before moving on to others. Once it is mastered, however, don't be afraid to begin experimenting with your second light. A good starting point is the one-light portrait, already mentioned, in which the light is placed at 90 degrees to the camera and the model looks up into it. Set this up again, but this time place your second lamp immediately behind the model so that it draws a bright rim of light all the way round the head. Because of the position of the main light, the back of your model's head has disappeared into the shadows. The thin rim drawn by the second light doesn't fill in the shadows, but it does 'sketch in' the shape of the head. There is no detail, but the fact that the viewer now knows where the back of the head ends makes it a better portrait. The mere suggestion of the shape of the head in this case is better than correctly exposed detail.

Another position for a second light is diagonally opposite the main light, at about the same height. This is best used with one of those one-light portraits plus reflector to fill in the shadows. The second light casts a halo of light around

72

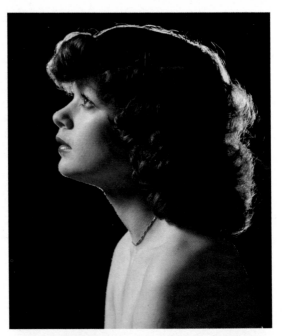

Two lights were used here: a large diffused flood in front of the model, at 90° to the camera, and an amber-filtered spotlight directly behind her.

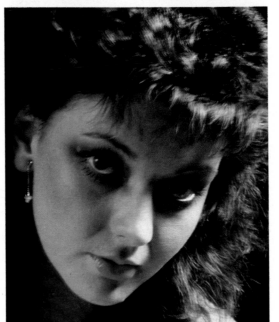

An effective picture using only one lamp, in a large shallow reflector, at 90° to the right and a gold reflector at 90° to the left.

Two lights, one at 30° to the right and above the model and a hair light suspended on a boom above her head. A large white reflector at 90° to the left filled in the shadows.

three-quarters of the face and one shoulder, while some light is also splashed over the top of the head. It gives an extra kick to the hair and, if you are photographing a dark-haired model against a dark background, it helps to separate one from the other. Similarly, a light suspended from a boom above the model's head helps to hold the hair away from the background, adding a more three-dimensional feeling to the picture. The second light can also be used purely for the background; reflectors may fill in the ugly shadows that a single

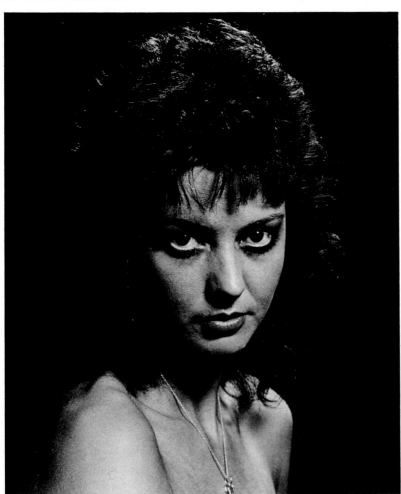

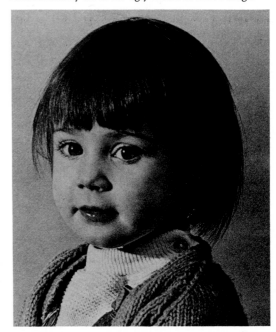

Two lights (in this case, a couple of simple flashguns) were used to capture a subject continually on the move. One flashgun was bounced from the ceiling, giving an overall, soft light to the face, while the second was directed from 45° and a little above head-height from the left.

An effective two-lamp set-up that works well with glamour portraiture.

With the lights soft, this set-up can be made to look like natural light from a nearby window, giving a wonderfully atmospheric appearance to the picture.

light casts on a face, but they can do little for shadows cast behind the subject. If you can't move your model far enough from the background to prevent shadows falling on it, take a one-lamp portrait, but use a second lamp to light the background alone. Place it behind your model and to one side or on the floor, shining up at the background. Either way, make sure none of its light falls on your model's face.

Two lights can be used in a mixture of bounced and direct light. In this instance, aim your main light at the ceiling mid-way between you and your model. The effect is soft, but with nasty shadows in the eye sockets and below the nose. So now use your second light to fill in those shadows, adjusting the contrast ratio as described earlier. For a strong character portrait in which you are not afraid to show your subject's lines and wrinkles, try placing two lights behind your subject at face level or with one slightly above and at 45 degrees to the model. Each side of the face is then lit, but not the front. Fill that in with a reflector held beneath the camera lens to throw back the light from the rear lights.

Two lights used in the right way with two large reflectors can produce a beautiful soft light for a glamour shot. The model is posed in front of a white surface and two reflectors (projection screens for instance) are placed on either side to form a triangle with the background as its base. The camera is set up at the triangle's apex, where the two reflectors meet. The lights are placed one on

either side of the model, angled away from her at about 45 degrees and facing the background. The light from each is then reflected off the background, to the reflectors and back onto the model. The result is a soft, flattering light that is practically shadowless.

Three lights
Perhaps the most common use for the third lamp in a portrait is as an effect light. Start by setting up the conventional lighting already discussed: keylight at an angle to the side and above the face, fill-in on the lens axis to adjust shadow detail. Now place your third lamp diagonally opposite the keylight and at about the same height. Angle it down towards the back of your subject's head. A spotlight or snooted flash works best, throwing light across the hair, giving it extra life and, in the case of dark hair against a dark background, separating one from the other. As the light is lowered, its effect gradually vanishes from the top of the hair and a rim of brightness is drawn around three-quarters of the face and one shoulder. Take the light all the way round the back and you'll get the usual rim around the face and hair. Use your light in a deep reflector suspended from a boom above your model's head and the light will splash the top of the head, giving extra life to the hair. Be careful with all these positions to keep light from the third lamp off your model's face. The third light is there only for effect. Spillage on to the face will show up in your picture as odd patches of light, ruining the effect of the keylight and fill-in. Watch too that your effect light

Black hair can be separated from a black background by correct lighting. The highlights on the model's hair were supplied by a spotlight behind and at 45° to the subject. Front lighting came from the conventional keylight and fill-in positions. The model sat two metres in front of a black background.

An interesting lighting set-up for a face with character. Two lights were positioned behind and at 45° to the subject, while a third was placed beside and above the camera.

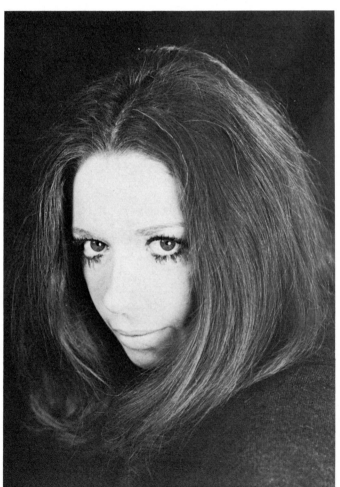

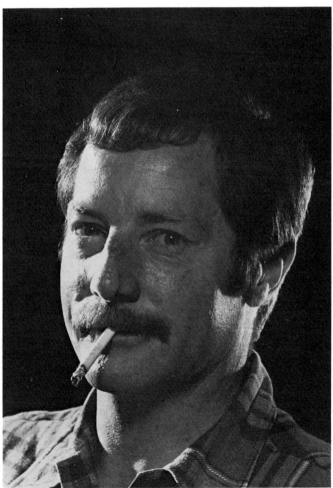

isn't brighter on the subject than the keylight. It's there to add to the overall image, not dominate it.

A more unconventional, though very effective, way of using three lights is to position two behind and one in front of your subject. It's a lighting set-up that works best with male models, since it tends to show up the texture of the skin. The two lights behind are placed level with the subject and at 45 degrees to give a double rim of light on the back of the head and the cheeks. Placing one slightly higher brings the rim lighting further up into the hair. The third light is then used in front of the subject to light the eyes, nose and mouth, which are untouched by the rear lights. This third light can be used high above the camera or even, for a more sinister effect, right down at floor level.

Another positioning for a third light is below your model to fill in ugly shadows. Using any of the already-mentioned two-light set-ups, ask your model to hold a reflector a little under her chin (out of camera range, naturally) and bounce a weak light from this. Be especially careful not to let this light overpower the main light or it might give a really gruesome effect. An atmospheric type of lighting will result from using all three lights to one side of the camera and above the subject. Place light number one at 45 degrees to your model, number two at 90 degrees and number three at 45 degrees behind. Soften your lights with a diffuser or by bouncing into brollies, and the final result will look as though your model has been lit by natural light from a nearby window.

Backgrounds

Any surface that is flat and plain can make a background if you are taking head-and-shoulders or three-quarter-length portraits. A plain wall or projection screen can work well. A sheet or tablecloth, if it has been carefully ironed to remove creases, can also be effective. But steer clear of curtains: the folds they inevitably hang in will be too distracting. For a full-length portrait you need a roll of coloured background paper. Pull it down the

76

wall and across the floor so that it falls in a gentle curve, and ask your model to stand on the paper. That way you will get a smooth continuous tone to the background with no ugly joins such as you would otherwise see where the wall meets the floor.

A word of caution here: take care not to mark background paper when using it this way. When you are setting up the pose, ask your subject to slip his or her shoes off, otherwise it will take only a minute or so to cover the paper with dirty footprints that will ruin the picture. High heels or any prop with sharp legs to it can also give problems as it is particularly easy to puncture the paper, especially at the point where it curves from the wall to the floor. Having prepared the model for the problems, don't forget them yourself. It's all too easy to wander on to the paper to arrange the pose, forgetting that your own shoes are going to leave dirty marks. So take off your shoes as well. Being only paper, this type of background material is practically impossible to repair or clean. If you do mark or tear it, pull more down from the roll and cut away the offending area.

The choice of background can make or break a portrait. Backgrounds can be as plain or as complicated as you like. The important thing is that they should match the mood of the subject. I prefer my studio portrait backgrounds to be completely plain, either black or white when shooting in monochrome. It's only a personal preference, but one that I recommend, especially for head-and-shoulders shots. Outside, or when

For full-length portraits, background paper should be shaped into a gentle curve with no sharp corners; the model then stands on the paper itself.

Strong side lighting gives texture to a face, making it more suitable for male character studies than for subjects like pretty girls.
Chris Tselios.

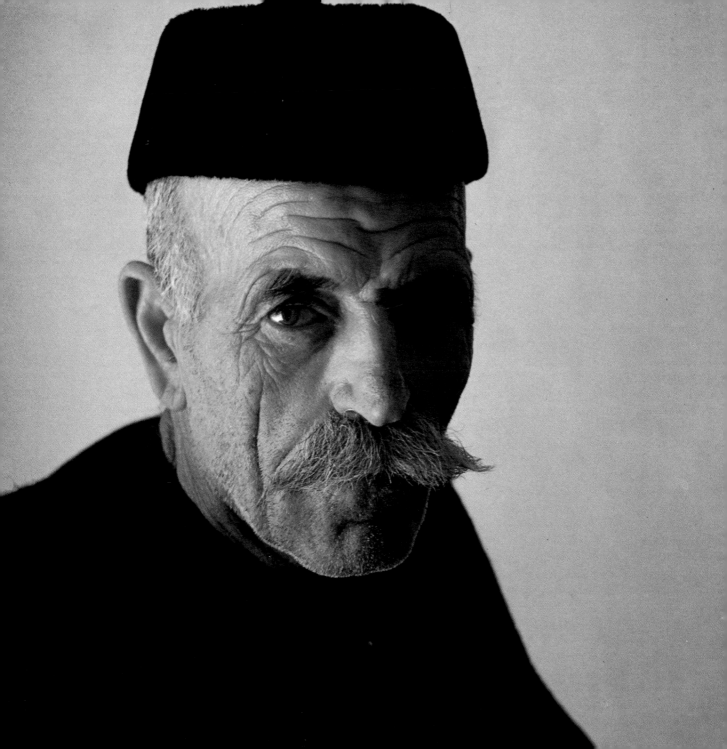

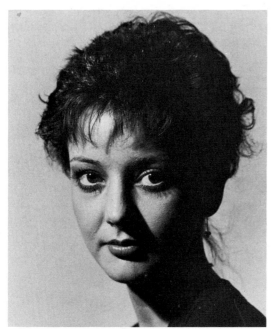

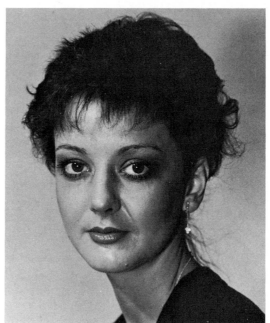

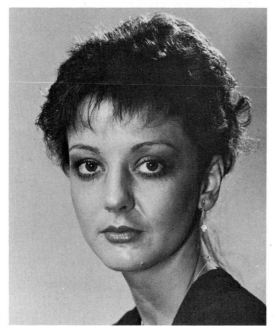

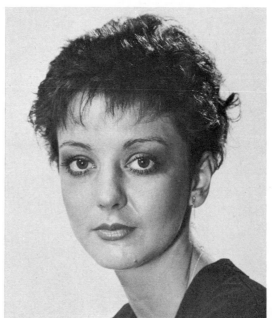

Four stages to building a conventional portrait. Keylight only, at 30° to the left and above the subject; second light, beside the camera and on the same side as the keylight, fills in shadows; third light, at 45° behind and to the right of the subject, adds a little life to the hair; fourth light lights the white background.

shooting by available light, the portrait will often look more natural if the subject is linked with some object or recognisable background, but in the studio it's different. The picture you are taking is, in a way, more false, and you can afford the falseness of a plain background that would not otherwise be seen in everyday life.

The totally black background can give terrific impact to a portrait and shouldn't be reserved for light-haired subjects only. It works equally well for a dark-haired model, provided you use your lights to separate the subject from the background. Don't forget, though, that even the densest of black background papers will reflect some light. So to keep your background jet black, pose your subject as far in front of it as is possible with the combination of studio dimensions and focal length of lens in use. Any light that does fall on the background will then be underexposed and so fail to register on the film. Virtually non-reflective matt black paper is available, and goes most of the way towards solving the problem. Even so, if you have the room, move your model away from the background.

To get a pure white tone behind your subject, it is best to light the background separately. Place an extra light behind your subject, to one side, above or below, but aimed only at the background. Make sure no light from this lamp spills on to your subject. I find that a small cine light on the floor, pointing up at the background, is ideal. If the exposure is arranged to be correct for the lower portion of the lit area, the fading-off higher up will give a gradually darkening background towards the top of the picture area. Alternatively, you can arrange the light so that the exposure for the background is one or two stops more than for your subject's face. That will compensate for the fact that the background is obviously brighter at the edge nearest the light, giving a pure white tone over the whole background. It will probably also kill any shadows that your model might be casting on the background from the main lights.

An intermediate shade of grey can be obtained in your background by posing your subject some way in front of it. Arrange the keylight so that it doesn't strike the background within the picture area; the background will then be lit by spill from the fill-in light. Since the subject's face is nearer to the light that the background, the latter will obviously be slightly underexposed compared to your model's face, and will therefore register as grey.

Similar effects can be obtained with coloured backgrounds when shooting in colour. Treat black backgrounds in exactly the same way as you would if shooting in monochrome, light-coloured backgrounds as you would white. But remember that, in colour, the amount of light on the background affects colour saturation. A red background, for instance, might be underexposed to give a crimson effect, or overexposed to register as pink. A white background, however, should not be underexposed when working in colour: rather than appearing a neutral shade of grey, it will more often take on an ugly colour cast. An interesting effect can be made by daubing splashes of paint over a background in an irregular pattern, then placing your subject far enough in front of it to render the pattern out of focus. Black paint on a white background (or vice versa) is effective for monochrome work, but for colour use three or four different colours on a white base. Aerosol cans are particularly effective for applying the paint.

A wide halo of light around the back of the model's head can be obtained by turning out the background light, arranging your other lights for a grey background and then placing a naked light bulb just behind your subject. Branches, basketwork, even upturned chair legs placed in front of a background light can throw interesting shadows on to a white background. Rendered out of focus, they break up the area behind your model. Sometimes it's a good idea to bring objects like branches into the actual picture area: behind the subject and out of focus, they can sometimes be arranged to make intriguing backgrounds. But be

79

careful not to let such objects, or their shadows, detract from your model. A studio background is there to complement the portrait, not to compete with it.

Measuring exposure

Everything we have learned so far about lighting and backgrounds will be useless if you measure exposure incorrectly. The first thing to remember is not to trust the meter built into your camera. Most meters tend to take an *average* reading for the area within their field of view; so in a portrait a reading taken at camera-to-subject distance will give the wrong exposure for the most important part of the picture: your model's face. If, for instance, you are using one light to illuminate a white background, just switching that light on can make two stops difference to the meter's average reading, consequently underexposing your model.

Readings, then, should be taken as close as possible to the face, but make sure that the meter's cell is not taking a reading from its own shadow. A separate, hand-held meter is best. If you have nothing other than TTL metering, take the camera right up to your subject, to within a few centimetres of his or her face. Point the lens at the area you wish to meter, note the reading and transfer it manually to the camera. Return to the taking position, and from then on ignore anything the meter seems to be suggesting. When taking a close-up reading with the camera this way, it's usually a good idea to explain to the model what you are doing. The sight of you coming really close, camera to eye, might lead him or her to think you are actually going to take a picture from that ridiculous position. By the same token, when you look through the viewfinder, don't be put off by the fact that you are too close to focus accurately. The view through the viewfinder may be fuzzy, but the metering should still be accurate. Don't focus the lens when taking a reading in this way. Some lenses might focus close enough to affect the meter reading, giving an exposure recommendation that would be accurate for a close-up but inaccurate for the portrait.

80

Whether you use your camera or a hand-held meter, there are several methods of taking reflected-light readings. Remember, though, that if you want a conventionally-lit portrait, with detail in both highlights and shadow areas, the lighting ratio between these areas should be no more than 4:1 in mono and 2:1 in colour. It is, of course, possible to take pictures with lighting ratios far wider than these but you will lose detail in one of the two areas. For an evenly-lit picture with detail in all parts, then, you should have no more than two stops difference between highlights and shadows when shooting in monochrome, and no more than one stop difference when shooting in colour. Assuming your lighting is arranged correctly and that those ratios are correct, start by turning off any background lights you might be using. Take one reading from the highlights, one from the shadows, and find an average between the two. Set that average on your camera, and turn on the background light again. You are then ready to shoot.

Alternatively, you can use a grey card. These are obtainable from Kodak. They are about 25×20 cm and are a solid 18 per cent grey in colour. A reading taken from this card held in front of your model's face will give an average reading for a typical European flesh tone. When photographing someone with a darker skin you should open up by as much as one or two stops, depending on how dark your model actually is. If you don't have access to a grey card, use a plain sheet of matt-white cardboard. This, of course, reflects far more light than the average face and so, having taken your reading, you should open up by around three stops to compensate. The first time you try it, bracket and make a note of your exposure. Then next time you will have a standard, based on experience, from which to work.

All the methods described so far apply to portraits that keep within the contrast ratios noted above. You may, however, be taking a portrait that has been purposely lit to give a far greater ratio

When photographing a subject with a darker skin tone than the European flesh tone, it is advisable to open up by one or two stops. *Michael Barrington Martin.*

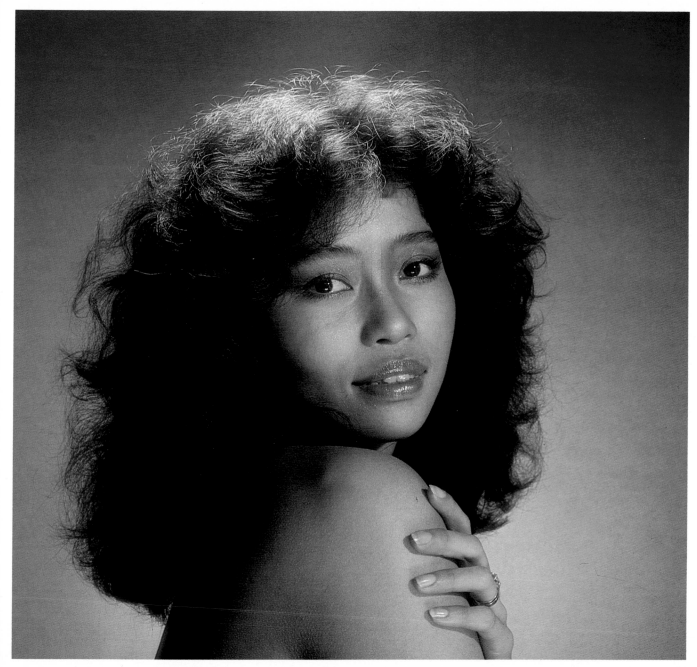

Low-key or high-key? This low-key shot was taken with a single light a little way behind the subject, and a gold reflector to light the shadows.

The high-key picture was taken with a keylight at 30° to the left and above the model, a fill-in light to the right, a spotlight from 45° above and behind, and a strong flood on the white background.

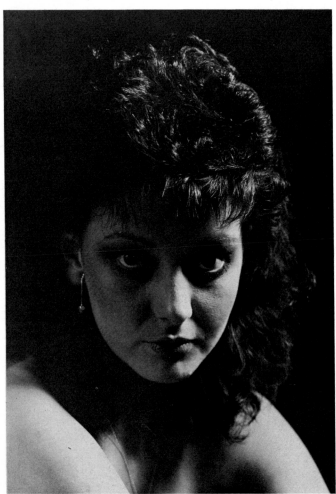

A totally black background can give impact to the right type of portrait. This one was lit by a single, hard light to the right of the subject. *Janette Mussot.*

83

between highlights and shadows: a three-quarters backlit face, maybe, with just highlights on the salient features and the rest falling into shadow. Since your film won't be able to cope with such contrast, don't try to force it. Taking an average reading on this type of portrait would leave the highlights completely washed out and the shadows with no more than a hint of detail. In this instance, then, take your exposure reading only from the highlights.

Most hand-held meters can also be used in the incident-light mode. This involves no more than clipping a small, white translucent diffuser over the meter cell. The diffuser is usually hemispherical or conical in shape; once it is in place, the cell will take an average reading over about 180 degrees. Once again, take the meter close to the subject's face, but instead of reading light reflected from the skin, turn it back towards the camera to take its reading directly from the light aimed at your subject's face. Since the meter's cell is pointing away from the background now, there is no need to turn off background lights before taking the reading.

Everything I have said above applies to portraits taken by tungsten lighting. With flash, you need a flashmeter. You use it the way you would use a normal meter for incident-light or reflected-light readings, depending on the make. Hold it in the correct position and fire your flash set-up. The meter takes the reading from the brief burst of light and displays it long enough for you to read. Flashmeters are invaluable for the photographer working solely by flash, but they are expensive. If you can't afford one, here's an inexpensive little gadget that you can make for yourself; it will enable you to use your normal exposure meter or TTL metering to measure flash.

All you need is two pieces of wood joined together in a T shape, a standard flashgun, a bulb holder with some wire and a plug, and a bulb, preferably a reflector-type Photoflood. Fix your flashgun to the crossbar of the T and screw the bulb-holder to the

84

tail so that, with the bulb fitted, both bulb and flashgun are facing in the same direction. Set this gadget up facing any subject you like and, from the flashgun's guide number, work out the correct exposure for that subject at that distance. Let's say this is $f/5.6$. Now turn on the lamp. Take a reading of the same subject and work out what shutter speed you would require for a correct exposure at $f/5.6$. Let's say this is one second. From then on, one second is your magic number. You can set up the combination of lamp and flashgun anywhere you like with any subject you like. You can use it as direct light, diffused lighting, even bounced lighting from the inside of a brolly. All you have to do, to get the correct exposure for the flash, is turn on the lamp and take a reading. The aperture that is then indicated against the one-second mark is the correct exposure for the flashgun in that position. Details obviously vary with different flashguns that have different guide numbers, so always use the same flashgun with the same bulb set-up.

Mixed lighting
Until now, everything I have said about lighting has applied to tungsten alone or flash alone. It is possible, with care, to use both at the same time. The way the lights are set up doesn't alter, but the way you measure exposure does. Remember that flash makes its own shutter speed, leaving you to calculate only the correct aperture. With tungsten light you have both aperture and shutter speed to worry about. So, when measuring exposure for mixed light, first work out what aperture you'll need for the flash and then find out which shutter speed ties in with that aperture to give correct exposure on the tungsten side. (Make sure that the chosen shutter speed is not faster than the maximum sync speed for flash). With black-and-white film there are no further complications. With colour, you have colour balance to worry about. Flash and tungsten are not compatible so one or the other must be filtered, depending on which type of film stock you are using: see the chapter on colour for more details of this topic.

Tungsten and flash can be mixed if exposure is adjusted correctly. For this shot, the skin tones were correctly rendered on daylight-balanced film by a single electronic flash bounced from a brolly at 30° to the right and above the model. The hair was lit by a Photoflood in a deep polished reflector on a boom directly overhead. The unfiltered Photoflood has registered on the daylight film as amber, not white, giving a pleasant warm colour to the hair. The exposure was found by calculating the correct aperture for the flash and matching this against a suitable shutter speed to record the Photoflood light on her hair.

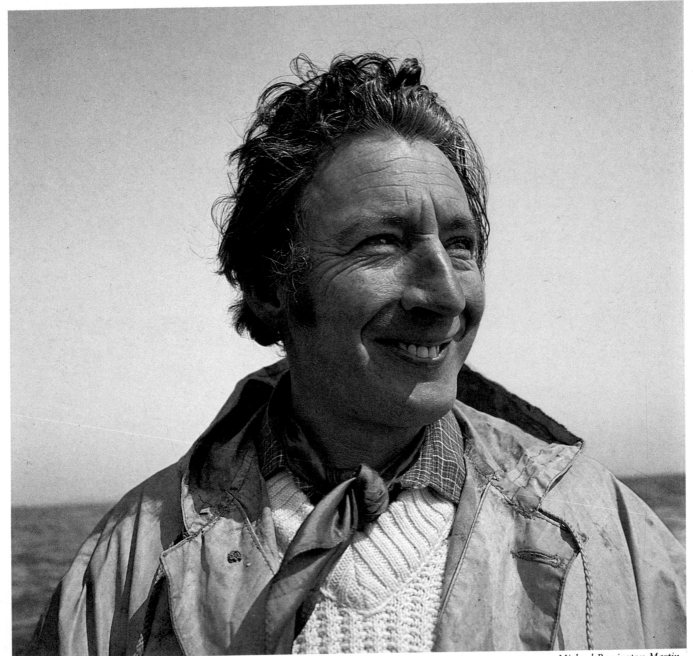

Michael Barrington Martin

Portraiture outdoors

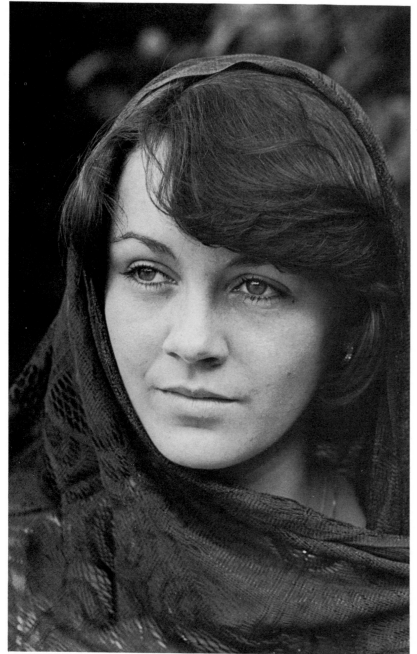

Len Stirrup

Because there are no lights to position, portraiture outdoors might seem at first sight to be simpler than portraiture indoors. In fact, the reverse is more often the case: you *don't* position lights because you *can't* position them. Everything you learnt in the last chapter still holds true. The difference now is that you have little or no control. In the studio, your lighting is adapted to suit the picture; outdoors, your picture, to a large extent, must be adapted to suit the lighting. What's more, unless you are using flash you have only one light, the sun. Your various effects must be organised by means of reflection and diffusion. For the former, you can use reflectors from the studio or those that are all around you outdoors: trees, walls, grass, water or anything else that might be handy at the time (provided its colour doesn't give an unwanted cast to the subject). Diffusion comes from the clouds. So if you have been tempted to take your first steps in portraiture by shooting outdoors simply because studio work seemed too complicated, you'd better think again. Turn round and get back into the studio. What you learn there will stand you in good stead for what you'll later find outside.

When to shoot
Time of day and weather conditions both control lighting outdoors. Between sunrise and sunset the light is continually changing direction and colour. Just as in the studio, outdoor portraits work best when the main light (in this case the sun) is between 30 and 45 degrees to the subject. The best time of day, then, is early morning or late afternoon when the sun is low in the sky. Towards the middle of the day in summer, it is far too high. It's like trying to light a studio portrait with one light directly over the subject's head. In winter, in parts of the world well away from the equator, the sun remains low in the sky all day, but the other weather conditions associated with that time of year make it largely

impractical to work outdoors. So work early or late in the day, in spring, summer or autumn, but beware of working *too* early in morning or *too* late in the afternoon. For around an hour after sunrise and an hour before sunset, the sun takes on a red tinge that will affect skin tones in both colour and black-and-white. It can be filtered out in ways described later or it can be used for its own effect, but if correct skin tones are what you want, steer clear of these times. Immediately after sunrise or before sunset, you'll be able to see the cast with the naked eye, but it could still be there even when you don't notice it. Your eye and brain often adjust for colour casts; your film won't.

A day when the sun is shining brightly in a clear, blue sky might seem ideal for a day's shooting, but in fact nothing could be further from the truth. The sun is like a spotlight. It is harsh and throws hard shadows. The only type of portrait it suits is that of a middle-aged or older man, someone with character in his face, a person whose portrait benefits from showing his many lines and wrinkles. Even so, you'll need a good reflector to fill in those dark shadows; or you can use fill-in flash, the use of which is explained later in this chapter. One way out of the problem, especially if your model is female, is to take her into open shade, shielded from the sun itself and lit by the open sky. Shade lighting is softer than direct sunlight. It is kinder to faces and, as described in more detail later, it allows you to work at wide apertures, throwing ugly backgrounds out of focus.

The best weather for outdoor portraiture is what film manufacturers' instruction leaflets are keen on calling 'cloudy bright'. This could be a sunny day when the sun is momentarily obscured by light cloud, but the practicalities of waiting around for the precise moment when this might happen make it far better to work on a day when the sun is generally diffused by a lot of cloud. Remember, even in these circumstances, that the light is still directional. You may not be able to see the sun, but it's still up there behind the clouds and so the

lighting will be strongest from one particular direction. It's up to you to position your model at the right angle to the light, in exactly the same way as you would if the sun were shining.

Lighting effects
We've looked at lighting in general terms, now let's be more specific. Here are nine different types of lighting, all of which rely on you positioning your subject in the right place at the right time.

1 The best type of lighting is with the sun fairly low in the sky, between 30 and 45 degrees to the subject and diffused behind light cloud.

2 Frontal lighting, with the sun low in the sky and right behind you, gives a flat, two-dimensional look to the face. It's also uncomfortable for your model, who will be forced to look straight into the light, and an uncomfortable model means bad pictures.

3 Side lighting, again with the sun low in the sky, gives a strong, dramatic effect. Unfortunately it also accentuates wrinkles, spots etc. on the subject's face. That could be all right for old men, but it isn't recommended for young girls and children.

4 Three-quarters lighting, once more with the sun low in the sky, but this time at 45 degrees behind the face, illuminating only one quarter when viewed from the camera angle, can be effective and works best when a reflector is used to fill in some of the shadow area. Alternatively, a low-powered flashgun can be used. A standard flashgun with a few layers of white handkerchief will do the trick: two layers of white handkerchief will reduce the light output of most flashguns by about one stop, but experiment and bracket exposures until you get the balance right for your particular gun.

5 Top lighting, with the sun high in the sky, despite everything I've said before, *can* be used for its own effect. It's a case of learning the rules before you break them. In this case, keep the face in shadow and allow the sun to fall from behind the subject on

sun

brick wall

Posing your subject against the sun and a dark-toned background (in this case, a tree) gives an effective halo of light around the hair. A brick wall behind the photographer has reflected a little warm light back into the face.

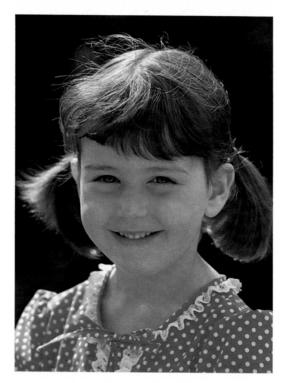

to just the hair. Add a reflector to throw some light back into the features, and take your meter reading from the face where it is unaffected by the sun on the hair.

6 Back lighting, with the sun once more fairly low in the sky, produces different effects according to your exposures. A reading taken from the highlights gives a low-key effect to the face. Increasing exposure gives the portrait a light, high-key effect.

7 Filtered lighting can be obtained by allowing the sunlight to fall through the leaves of a tree, a straw hat maybe, or perhaps a light-coloured umbrella. Give ample exposure for the shadows and you'll get a nice, summery effect. But watch out for patterns of shadows that can wreck a picture, and for colour casts, when working with colour film; see later.

8 Shaded lighting looks good when the subject is posed in the shade with a well-lit scene for a background. Expose for the subject and allow the background to take care of itself. The contrast between the correctly exposed subject and overexposed background gives an effective, three-dimensional look to your picture.

9 Silhouette lighting works in the same way, but this time with the exposures adjusted for the background. Your subject will now be thrown into silhouette, and since that leaves little or no detail in the face, profile shots work best.

Backgrounds

In the studio, backgrounds as well as lights are under your control. You can make them plain or fancy just as you please. Outside, like the light, they are already there. You can use them or abuse them. What you must never do is ignore them. Remember what we learnt, in the chapter on posing, about looking accurately through the viewfinder. Filling the frame with your intended subject is especially important in outdoor portraiture, where all sorts of out-of-focus odds and ends might intrude into the picture area from the top, bottom and sides. So move in close. Move in to the point where your subject and the background you want fill the frame. And then look closer at your picture. This time look behind your subject. Make sure there is nothing distracting there. Many a good outdoor portrait has been ruined by a lamp post or tree that appears to be growing out of the top of the subject's head.

If it's possible, move your subject away from an offending background; if it isn't, try to throw the background so far out of focus that it ceases to be a distraction. You can do this by controlling your depth of field. When you focus on a subject, say, 1½ metres away, other objects at infinity will naturally be out of focus. But there will be a degree of latitude either side of 1½ metres in which objects *will* be in sharp focus. So you might find everything between 1 metre and 2½ metres is actually sharp. This is your depth of field and it is controlled by

three factors: aperture, distance from the subject, and focal length of the lens. With your lens focused at a given distance, the smaller the aperture, the greater the depth of field; the wider the aperture, the shallower the depth of field. With your lens at a given aperture setting, the closer the subject is to the camera, the shallower the depth of field; the further away the subject is, the greater the depth of field. And, because a longer focal length lens magnifies the image, fall-off in depth of field becomes easier to see, making it appear shallower.

Depth of field is one of the most important aspects of outdoor portraiture. It determines whether the background is going to be sharp or out of focus. Each type of background has its place. It's up to you to find which best suits the picture you have in mind and then to exercise the correct amount of control to make your idea work. So, when considering outdoor portraiture, look for backgrounds the way you look for models. With some portraiture, you might find the background actually comes first. You find an interesting place that cries out to be used as a background and then you have to find the model to suit it. Very often, as we discussed in the chapter on posing, the resulting picture ends up far from portraying the model the way he or she really is. But the final result makes an interesting picture, which (provided your model does not object) is the all-important thing. That was the case with two of the pictures shown here: the young man in front of the power station and the girl on the railway line.

For the girl on the railway line, a full-length portrait dictated a camera-to-subject distance of 3 metres; at the fairly small aperture of f/11, this meant that the railway line would be in focus for some way behind her, gradually going out of focus at around 8 metres from the camera. The subject and the background are consequently brought together as an entity; one without the other would have made a far less interesting picture. For the young man and the power station, the depth of field

90

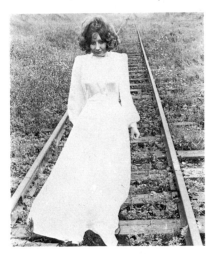

In a picture like this, the background is as important as the model. Neither would be effective without the other.

Using a fairly wide aperture has kept the background recognisable without allowing it to become overpowering.

A background that is distracting at one aperture/focal length combination is an almost invisible blur at another.

Left: standard 50 mm lens at f/16. Right: 200 mm lens at f/4. The model stood at the same distance from the background for each shot.

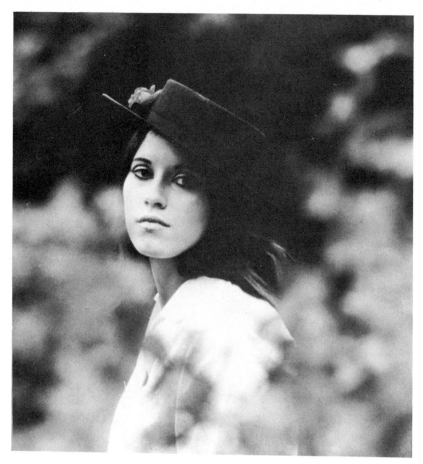

than abstract designs against which to position your subject. Look at the two pictures of the man in front of the office block. At *f*/16 on a standard 50 mm lens, the building is almost as sharp as the man, making an ugly, distracting background and a bad portrait. But change the aperture and focal length to *f*/4 and 200 mm respectively and the building becomes a fuzzy blur that accentuates the man and makes for a far more pleasing result. You can use the same idea to frame your subject through, for instance, the branches of a tree. This time the 'background' is actually in front of the subject, but the principle is the same. A pin-sharp frame around the subject's face would be a distraction; an out-of-focus ring of leaves is far more pleasant.

There are two methods of determining the exact depth of field you are actually getting with any aperture/subject-distance/focal-length combination. On a single-lens reflex that focuses at its widest aperture and closes down to the required *f*-stop only at the moment of exposure, there is usually a depth-of-field preview button. Pressing this closes the aperture to the chosen stop without an exposure being made, so that you can actually see how much of your picture is in focus. On reflex cameras without a preview button, or on non-reflex models, you must use the depth-of-field scale inscribed on the lens barrel. This scale shows a series of *f*-stops radiating in each direction from the lens's focusing mark. Simply focus the lens on your subject, then look along the scale on each side of the focusing mark to the aperture in use. Read this aperture against the focusing distance on the lens to see how much on either side of the focused point is actually in focus.

Something very plain like a wide expanse of wall might look, at first sight, like a suitable background for outdoor portraiture. Using it as such, however, is a different matter. A wall is in a fixed position and it's a lucky photographer who finds the right kind of wall, facing the right way, for the light

Sometimes the 'background' can be placed in front of the model as in this picture, which uses out-of-focus leaves as a frame.

was deliberately shortened. The power station is an integral part of the picture, but rendered as sharp as the man it would have been overpowering. So an aperture of *f*/4 was used with a camera-to-subject distance of around 1½ metres. The result is a background that is sharp enough to be recognisable, but not so sharp as to dominate.

In these pictures, each of which was shot with a standard lens, the backgrounds are as important to the final result as the people being photographed. But backgrounds can also be used as nothing more

available. Place someone against a wall on a sunny day and you have the same problem as being in a studio with only one light. In this case, that one light is the sun and it's going to cast harsh shadows on the wall.

If you must use a wall, do so on a cloudy, overcast day when the diffused light casts softer shadows, and then make sure the wall is a plain one. Brick walls are too distracting, even when they are thrown out of focus; and in colour, if the bricks are red this overpowers the subject. Even with a plain wall, get your subject to stand a little way in front of it, far enough to render it unsharp in the picture. Again watch for the colour: a natural, flesh-coloured face against a pale blue wall might look nice in colour, but in monochrome the two colours could well end up the same shade of grey, giving a nasty, muddy look to the picture.

All in all, walls are better avoided in outdoor portraiture. If you do want a plain background, it is better to get slightly above your subject and point your camera down, using the ground as a background. But watch your subject's eyes. Remember that while you are looking down at them, they are looking up at the sky or, worse still, the sun. Unless it's a really cloudy day the brightness will make them squint, and half-closed, squinting eyes are the last thing you want to see in a portrait.

One of the plainest backgrounds to use outdoors is the sky. But beware. You must know *how* to use it. For a start, unless you are taking pictures on the brow of a hill and can look straight ahead at the sky, you are going to have to find a low viewpoint and your model is going to have to look down at the camera. That's fine if it happens to be the object of the photograph. But never lose sight of what the final picture is going to show. If you are using the sky merely as a background and want your portrait to look conventional in every other respect, the result could be a far from conventional picture. The

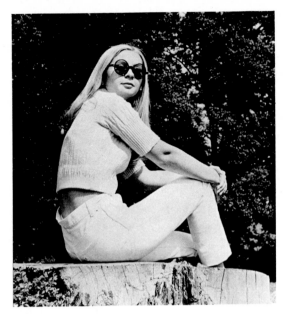

Unless carefully watched, backgrounds and skin tones often register as the same shade of grey in a black-and-white print, giving the picture a muddy appearance. Avoid that by contrasting light and shade: in this case, a fair-skinned blonde against the darker background of summer trees.

subject's body will appear to be sloping almost horizontally towards the camera and the downward turn of the head could be producing some ugly wrinkles in the neck, not to mention double (or even treble) chins.

Photographing against the sky can also present exposure problems. This is no place to trust TTL metering. The sky can be brighter than the face itself by two or three stops, or even more. If you give your camera's meter a glimpse of that sky, although it will try to average out the reading it will still be too heavily influenced by the brightness, resulting in a severely underexposed face. The answer is to take a reading, either with a hand-held meter or with the meter in the camera, close up to the face, then to use that reading on the camera, irrespective of what the automation seems to indicate at the moment of exposure.

But your problems don't end there. Giving the correct exposure for the face means that the sky will now be hopelessly overexposed. Over most of

the sky area that doesn't matter, since it means that you will get the plain background you were obviously after in the first place. But it *does* matter around the edges of the face, particularly in the hair, where the overexposed light is now shining through. The contrast between that halo of light and the intensity of the light on the centre of the face will be too much for your film to handle. If you are using black-and-white film you might be able to hold back the face and burn in the hair at the enlarging stage. With colour film it's a different matter. The lower contrast ratio that the film is capable of handling reduces your chances of burning in and holding back on a print, and of course with transparencies you have no control at all. A far better idea, then, is to reduce the overall contrast by using a reflector near the camera to bounce some light from the sky back into the face. Or you can use fill-in flash to balance out the different levels of light (of which more later).

Colour casts and filters

Watch out for colour casts when photographing outdoors. Remember that most of the light you are using is reflected, and any reflector will tinge the light with its own colour. Suddenly, that beautiful girl beneath a summer tree takes on a green face as she is lit by light reflected from the leaves. The same goes for a nearby wall. Unless it is white or a neutral shade of grey, it is going to affect the colour of the subject's face and clothing. Even if you can't actually see the colour cast yourself, always check for the colour of nearby objects: your film might pick up colours that your eye has 'filtered out'.

You can correct colour casts by the use of filters. In monochrome photography, the basic rule is this: a filter lightens its own colour and darkens its complementary colour. Hence, if some nearby object is giving a cast to your subject's face, you can eliminate that cast by the use of a filter of a similar colour. In correcting one colour, of course, you are also altering others, and that too can be put to advantage, using a filter to put a cast *into* a picture

in the right place. The most obvious example is the use of a green filter to darken lips and give your model a more tanned appearance, since green darkens red, its complementary colour. Beware of using red filters. It may seem like a good idea to photograph your model against a dramatic, red-filtered sky, but think what it will do to skin tones. Filters lighten their own colour, so your model will appear pale-faced and white-lipped. It is true that professional fashion photographers often use a red filter to create a deliberately pale look. The effect can be beautiful, but it needs the right model in the right context.

Turning to colour, the green-faced girl under the tree really begins to look sickly, but the filter law changes. Now you need complementary colours to reduce casts, and very pale colours at that. A pale pink filter, then, might help to reduce the green on the girl's face, but it will of course give an overall warm tinge to the rest of the picture. Since the colour of the light changes as the day goes on, this too can give an unwanted colour cast to your pictures. Being an overall cast, however, this is something you can correct. When shooting early in the morning or late in the afternoon, you can correct the warm colour of the light with a pale blue filter such as an 82A.

There are several conditions that might induce a blue tinge in your picture: an overcast day, shadow areas in sunny weather, electronic flash used as a fill-in for shadows or faces. All these can be corrected with the appropriate 81 series filter. There are six in all, the most popular being 81A, 81B and 81C, each a shade stronger than the previous one. A slightly overcast sky will give only a light cast to the picture, so the palest of the filters (81A) might be enough to make the correction. The blue sky on a clear day is more likely to produce a stronger cast in shadow areas, and an 81B or 81C is likely to be needed. Such advice can only be a guide. Any of the 81 series of filters can be used to correct blue in a picture, depending on the strength of the cast and the final effect required.

Synchro sunlight

I've already discussed some of the places where you would be advised to use fill-in flash, or 'synchro sunlight' as it is often called. Now let's look at how. If your camera has a focal-plane shutter, you must first find your maximum sync speed. On many modern cameras this can be as high as 1/125 second, but some shutters will not synchronise with flash at speeds in excess of 1/60 second. Suppose then that you are photographing your model against a dramatic landscape. The sun is back-lighting the scene, throwing your subject's face into shadow. The problem is clear: expose for the landscape and underexpose the face, or expose for the face and overexpose the background.

The answer is to use flash to fill the shadows. But instead of positioning your flash first and then working out the exposure, you start with the correct exposure for the landscape and position the flash accordingly. First take an exposure reading of the landscape. Suppose this is 1/60 second at $f/11$. Use a manual flashgun or, if you have only an automatic model, switch it to manual and place it at a distance from the subject that demands an aperture of $f/11$. If, for instance, you are working to a guide number of 33, place the flash 3 metres away. (Guide number 33 divided by flash-to-subject distance 3 equals $f/11$.) Don't forget that we are talking about *flash*-to-subject distance, not *camera*-to-subject distance. So the flash may have to be used on an extension cable, otherwise its position will dictate the camera position, and hence the size of the subject in the viewfinder.

In theory now, your subject should be overexposed, since he or she is being correctly lit by the flash, plus a little more exposure from natural light. Guide numbers, however, are calculated for use in an average-size room, taking reflections of the flash from walls and ceiling into account. Out of doors there are no reflections, so you actually get less light from your flash than the guide number indicated. In theory, one factor tends to cancel out the other,

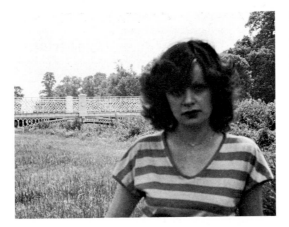

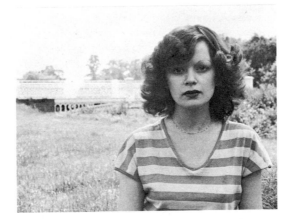

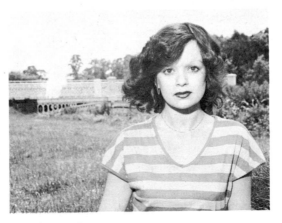

Sometimes, especially with backlighting or portraits taken in a shadowed area, it is impossible to find an exposure that allows both background and model to register correctly on the film. That's when fill-in flash or synchro sunlight can help. Top: correct exposure for the background, underexposing the model. Centre: exposure adjusted to record the model correctly, overexposing the background. Below: a small flashgun was used close to the camera. Calculate the correct aperture for the flash on the girl's face, and match that with a shutter speed to record the background accurately.

giving a near-enough correct exposure. In practice, however, the 'correct' exposure often provides too much fill-in to look realistic. In that case it is better to underlight the face by about one stop, relative to the background exposure. Do that by closing the aperture and compensating with the shutter speed, thus leaving the background correctly exposed.

You can use an automatic flashgun for synchro sunlight, but it might present you with problems if you are using a single-lens reflex. Let's look again at the supposed scene described above. The system with an auto gun would work like this. Exposure for the landscape is still 1/60 second at f/11, but your automatic gun might only work at f/5.6 with the particular speed of film you are using. You can now place the gun any distance from the subject, provided the camera's aperture is set at f/5.6. But for the landscape already metered, that means using a shutter speed of 1/250 second, which is faster than the sync speed on a focal-plane shutter. By the same token, when using a manual gun, or an auto gun in the manual mode, with an SLR, your first metering of the landscape must be adjusted to use a shutter speed at which flash will synchronise on your particular camera.

Of course, if you are using a twin-lens reflex, one of the single-lens reflexes with leaf shutters, or any camera with a between-lens shutter, then there is no problem. If you keep the sync setting on X, electronic flash will synchronise at any speed. Remember, though, that an automatic gun does not rely on a guide number for exposure calculations. It measures the exact amount of light falling on the subject, whether you are inside with reflections from walls and ceilings or outside with no reflections at all. So if you use an automatic gun for synchro sunlight, it is still best to bracket exposures to be on the safe side.

Synchro sunlight will also fill in ugly shadows *behind* a subject that is correctly lit by natural light, provided your flash is powerful enough to reach the shadow areas. In this instance, calculate first what

aperture you would need to light the shadows with flash only. You can calculate that from the guide number (guide number divided by distance from flash to shadow area equals f-stop) or by using the aperture dictated by an automatic gun. Say this is f/5.6. Set that aperture on your camera, then meter your subject and adjust the result to find the correct shutter speed for an aperture of f/5.6. Of course, if that shutter speed is faster than the camera's sync speed, you might still need a between-lens shutter rather than a focal-plane type. Alternatively, use the gun manually and place it nearer the shadow area, so that a smaller aperture, and therefore a slower shutter speed, is used. Make sure, wherever you place the flashgun, that you keep it pointed only at the shadows you wish to light, shielding its beam from your subject.

Yet another use for synchro sunlight in outdoor portraiture is for capturing fast action, a girl bursting out of the sea for instance. With the aid of your flashgun, you can freeze the droplets of water better than the fastest shutter speed would. Simply find the right aperture for flash-to-subject distance, and couple that with the correct shutter speed for daylight alone. Once more, to compensate for overexposure from flash and daylight, close down one stop and bracket. For this type of shot you may need a between-lens shutter.

Since electronic flash is designed for use with daylight colour film you will have few problems matching colour temperatures when shooting in normal daylight. The problems arise early in the morning or late in the afternoon, when the ambient light is warmer in colour, and light from a fill-in flash will look bluer by contrast. A UV filter will help correct that. Naturally there will be no such problems when shooting in black-and-white.

Outdoors at night
Portraiture outdoors doesn't finish when the sun goes down. You can still take pictures in the dark if you know how. All you need is a camera capable of taking time exposures, a tripod, a cable release and

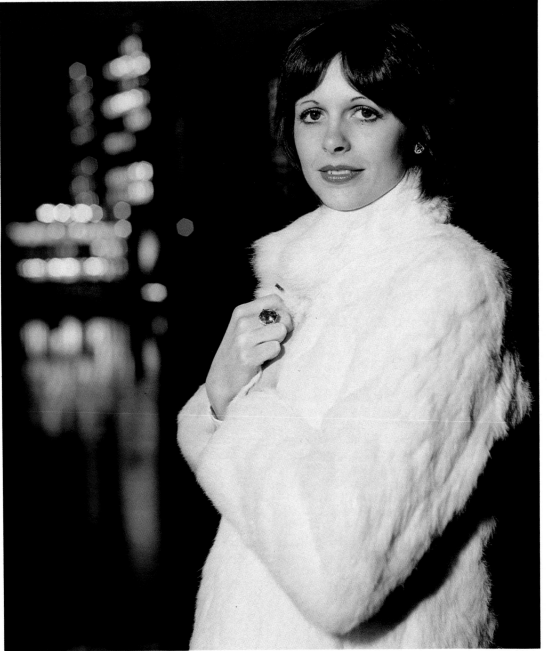

Shooting outdoors at night is not unlike mixing flash and tungsten light in the studio. The shot was taken at dusk, with still a little light left in the sky. The correct aperture was calculated for the flash and used with a two-second time exposure to record the background. Since the office block behind was lit by fluorescent light, the windows appear green on the daylight-balanced film.

a flashgun, preferably with an extension cable. First choose your location. Somewhere that is pitch-dark is next to useless. All you'll get is the subject surrounded by blackness. If that's what you want, fine. But you could achieve a similar effect with better lighting in the studio. So go for a location where you can use lights as a background. In the illustration used here, an office block across a lake provides the interest. Equally interesting would be, perhaps, Christmas lights (especially suitable for children), or seaside illuminations.

The best time for pictures is a little after dusk, at that time when it is almost dark, but there is still just a little light left in the sky. That way, buildings stand out in silhouette against the sky. If you wait until it is completely dark, all you'll see is lights from the windows. Place your model in the chosen spot, preferably shaded from the actual background lights so that no ambient lighting is falling on his or her face. Set your camera on its tripod, turn the shutter speed dial to B and fit the cable release. Connect the flashgun, on an extension cable if possible, and hold it away from the camera at an angle to the subject as described in the section on using one light (page 68). If some kind of natural lighting, a lamp post for instance, is to appear in your picture, it is often a good idea to hold the flashgun in a position to suggest that its light is coming from the lamp or whatever, to give your portrait a more natural look. Focusing can be made easier in the dark by asking your model to hold a small flashlight beside his or her face while you focus on the bulb.

Unlike more conventional forms of photography, the outdoor portrait at night is going to need two different exposures: one for the subject and one for the lights in the background. The flash will take care of your subject, while a time exposure looks after the lights. First calculate what aperture you'll need to light the subject with flash. If you are using an automatic gun, simply set the aperture recommended for the film speed you are using. If you are using a manual gun, and working out the aperture by the guide number, remember that outside there are no reflections from walls or ceilings and a lot of light is going to be lost on account of it. In theory, it should be a matter only of opening up by one or two stops on the calculated aperture to compensate. In practice, it's not always that simple. Some manufacturers give guide numbers that should work outdoors with no adjustment, others publish guide numbers that don't even work correctly indoors. Different equipment will give different results and it is wise to experiment, bracketing exposures by one or two stops each side of the supposedly correct aperture.

Having found the correct aperture, calculate the shutter speed you will need to record detail in the background. This could vary enormously depending on the subject. Again, the only solution is to experiment, but as a general guide here are a few recommended exposures for common night photographs on which to base your experiments: with a film speed of ISO 125/22° and an aperture of $f/5.6$, bonfires and fireworks should record with a shutter speed of $\frac{1}{8}$ second; well-lit shop windows, $\frac{1}{15}$ second; well-lit streets, $\frac{1}{2}$ second; floodlit buildings, 2 seconds. Having selected the correct combination of shutter speed and aperture, simply fire away. But tell your model to stay still for the duration of the exposure, so he or she doesn't move in front of the background lights.

In black-and-white, it's straightforward. In colour, watch out for colour casts. Since you are using electronic flash, you must use daylight-balanced film. That means tungsten lighting will register yellow rather than white. And beware of those office blocks with hundreds of lit windows. They are probably lit by fluorescent light, and that will register as green. Since the lighting on your subject will be correctly balanced, a colour cast in the background lighting may not bother you too much. If it does, you can filter the flash as described on page 110, and shoot with artificial-light film.

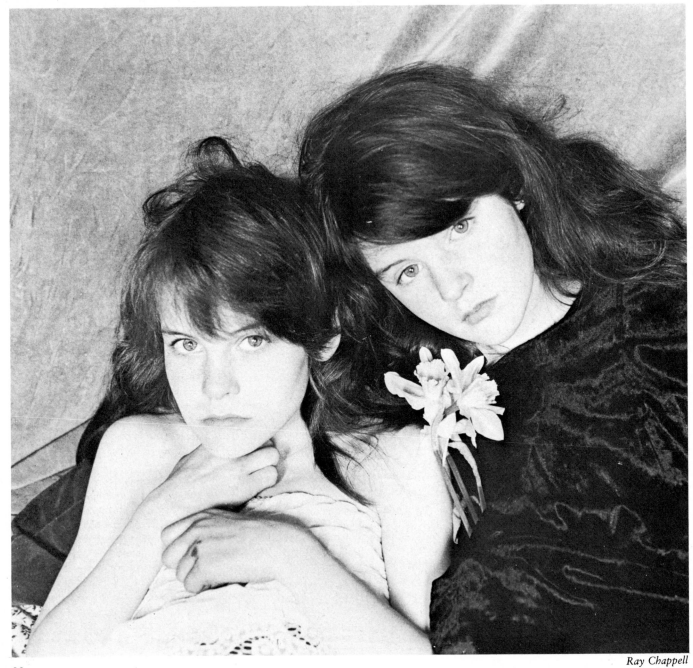

Ray Chappell

Available light

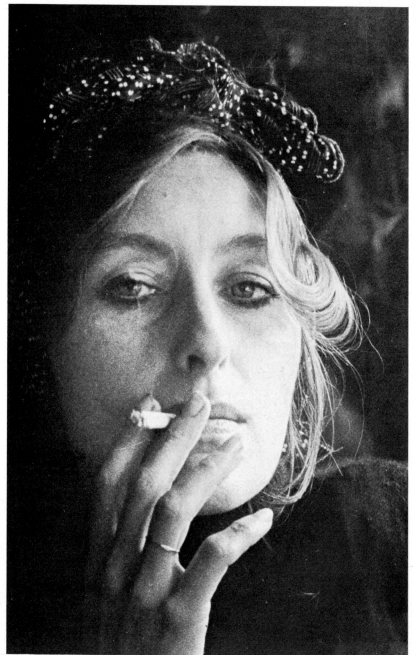

Ray Chappell

Available-light portraits are, as their name implies, pictures taken with natural light, rather than by studio lights or flash. Most outdoor portraits could be considered as available-light shots (unless, as in the case of professional fashion photographers, extra light is taken on location in the form of floods or flash), but the term is more often applied to pictures taken indoors, either by light from a window or by artificial light available at the time. Because of the light levels associated with this type of photography, you might think at first that fast film is a necessity. It is my opinion, however, that it is best to stay with the quality obtainable from medium-speed films, and to use a tripod when necessary.

This type of portraiture gives an opportunity to take pictures in the home that, by the very nature of their surroundings, can give an atmosphere that would be impossible to recreate in the studio. So often, though, the background that looks pleasingly informal at the time of shooting turns into a jumbled mess in the picture. Such pictures therefore need a great deal of care and attention, and more often it is better to use the home to take studio-type portraits. That's the method I shall be concentrating on here.

Available-light portraits can be taken in any room that has a window, but for the purposes of this chapter, I am assuming that the pictures are to be taken in an average-sized room in an ordinary private house with the minimum of sophisticated equipment. If you want a 'studio' look, it is better to empty the room of all furniture, pictures, ornaments etc. In the majority of cases, however, that will be impossible, so we shall also look at ways of disguising or concealing those messy backgrounds that an ordinary domestic room provides in abundance.

Window light

Taking portraits by the light of a single window is a lot like studio work using one lamp, and much of what you learnt in the chapter on studio portraits holds true here. The light should ideally come from a direction of around 30 degrees to the side and above the model; it is best diffused, and reflectors can be used to fill in the shadows. The direction of the light can be controlled by masking. Sit your subject beside the window so that, from the camera's view, light is falling on the face at an angle of around 30 degrees. Now black out the lower half of the window to a height just above your model's head. You now have the effect of a single light shining from the traditional 30 degrees above and to the side.

Your next requirement is a method of controlling the *type* of light, keeping it soft and diffused, just the way you would in a one-lamp studio set-up. To this end, the weather outside plays an important role. The best time to take portraits by available light indoors is when the sky outdoors is obscured by light cloud. Direct sunlight streaming through the window *can* be used to good effect, but it acts like, and has all the disadvantages of, a single spotlight. The best window for available-light work is one that faces north. Here's why.

During the course of a day, the sun moves (or rather appears to move) from east to west across the sky. So, on a clear and sunny day, a window facing in either of these directions is subject to direct sunlight for at least a part of the time. What's more, the intensity of the light is constantly changing throughout the day, making any kind of exposure standardisation impossible. The sun makes its apparent movement from east to west, roughly along the equator. In the northern hemisphere the equator is to the south, so a south-facing window is also unsuitable: again you'll get direct sunlight around the middle of the day, and again the intensity of the light is constantly changing. A north-facing window gets round all these problems. The sun is never seen

through this window, and the room is lit by light reflected from the northern sky. The light is soft and diffused, and its intensity hardly changes all day. (All this applies only if you live in the northern hemisphere. If you live south of the equator, the sun will appear to be moving across the sky to your north and so a south-facing window is best.)

Available light can also be softened by hanging a diffuser in front of the window. A sheet of muslin or white plastic is fine, but many household windows have their own ready-made diffuser, namely a net curtain. Stick to the old-fashioned types with a uniform tight mesh. The more modern curtains with large holes and fancy designs will project weird patterns on to your subject's face.

Once you are inside the room, you must look upon the window itself, not the light outside, as the light source. Treat it like a large, static lamp and position your subject in relation to it. Learn and always

Here, a piece of black paper was pinned across the lower half of a north-facing window, so that light fell on the model only from above her head. The model faced the window, and another sheet of black paper was draped over a free-standing projection screen some two metres behind her, to cut out an unwanted background and to emphasise the contrasty light from the window.

white wall

window

One large window and a projection screen reflector were used for this shot. The window was at 90° to the left of the model, the white reflector at 45° to the right, and there was a white wall as background.

window

This time the window itself was used as the background, and the exposure necessary to put some detail into the face eliminated all detail outside. A white reflector was placed close to the camera to reflect some of the window's light back on to the model's face.

remember the 'inverse square law'. This states that as light travels from a source, its intensity is inversely proportional to the square of the intervening distance. In plain English, it means that moving your subject from, say, one metre from a window to two metres (twice the distance) doesn't, as you might at first suspect, halve the amount of light falling on the face, but quarters it. (The inverse of twice the distance squared equals one-quarter the light intensity.)

Objects close to the window are naturally better illuminated than those further away. So if you place your model near the window, the room behind him or her will become progressively more and more underexposed, helping to suppress messy backgrounds. Move your subject further into the room, however, and exposure for the face will get nearer to the exposure required by the surroundings. Backgrounds begin to appear more dominant in the picture and so need to be watched more carefully.

Beware of cluttered backgrounds. Watch out too for colour casts from walls or ceilings. Use a plain wall as a background, and steer clear of patterned wallpaper. Sufficiently out of focus, it might produce an interesting abstract background, but it's surprising how little focus it needs to become a distraction. It's not a bad idea to carry a portable background with you when you are anticipating available-light portraiture. Setting up a complete background-paper support unit rather defeats the object of using available light in the first place, but a portable, free-standing projection screen or a plain sheet hung from the wall can be very useful.

Look carefully at different levels of light in the room. Don't trust your eyes. Explore the room with a hand-held exposure meter or use the meter in your camera. Close to the window, the contrast between highlight and shadow areas will be extreme. Further into the room and away from the window (assuming there are no room lights to add their effect), the contrast gradually lessens. Find the

101

For this shot, the model was facing at 45° to a window, looking into the corner where it joined a wall. A projection screen was placed behind her to obscure an otherwise cluttered background.

place where the ratio is the magic 4:1 for mono or 2:1 for colour, and you are ready to begin shooting. You can achieve those ratios either by the position of your subject relative to the window, or by moving closer to the light and using a reflector to balance the levels. The latter method is better.

Here are seven available light set-ups that involve no more than one window and one reflector. Study them in conjunction with the accompanying diagrams to understand them more fully.

1 Start with your model facing side-on to the window, so that light falls along one side of the face only. Now place a reflector on the opposite side of the face at 45 degrees to the subject. Shoot straight-on.

2 Turn the reflector so that it is parallel to the window, and this time ask your subject to turn so that he or she is at 45 degrees to each. Shoot a profile, with the camera at 45 degrees to the window and reflector.

Seven available-light set-ups, using one window and one reflector. Use them as a basis for your own experiments.

102

masked window

window

Two windows in adjacent walls can act as a main light and fill-in light. Since the windows face in different directions the light intensity will be uneven: an advantage in portraiture. The effect is enhanced if the window acting as the main light is masked along its lower half.

Two windows, one at each end of a long room, can be used in much the same way as a main light and reflector if the model is positioned correctly between them.

3 Leave the reflector where it is, and ask your model to turn back slightly so that both window and reflector are directly side-on to the face. Shoot straight-on.

4 With the reflector in the same place, ask your model to turn slowly until he or she is at 45 degrees to the window and reflector. Shoot a profile.

5 Move the reflector around to a position 45 degrees to the window and directly behind the subject's head. Shoot with the camera back to the window and at 45 degrees to your model's face.

6 Leave the reflector in the same place and ask your model to look directly out of the window. Shoot in profile.

7 Leave the reflector where it is and move the camera around until you are using the window as a background. Shoot straight-on.

These seven positions can be used as the basis for your own experiments. Each time you set up one of the shots, ask your model to turn his or her head slightly, watching carefully how light falls on the features. Remember the rules of lighting you learnt for studio portraits (nose shadows, eye sockets etc.); they hold as true with available light as with studio light. Adjust the distance between your subject and the reflector each time until you get the best ratio between highlights and shadows, and use an exposure averaged out between the two.

window

window

Using two windows
Just as an extra light makes a better studio portrait, so an extra window enhances available-light portraiture. Many modern houses have rooms with a window at each end. Depending on the direction the windows are facing and the quality of the light from outside, your model can be placed in exactly the right position for one window to act as a main light, while the other acts as a fill-in, in much the same way as we used a reflector parallel to the single window in the examples mentioned above. Again, don't trust your eyes. Move your model backwards and forwards between the two windows, checking the levels of illumination on each side of the face with an exposure meter until the ratio is right. Having found the right place, ask your model to sit down and to turn his or her head slowly from side to side. Watch the light from different angles and explore different camera positions until you get just the right combination. Two windows used in this way can provide interesting effects, but beware of backgrounds. If you have moved your model far enough into the room to get the right balance between highlights and shadows, it is likely that the shadows behind the subject will also be fairly well lit. Try, then, to arrange your model some way in front of a plain wall, or use a portable background such as a sheet or projection screen.

Better results can be obtained if you have a room with two windows in adjacent walls. Set your camera up in the corner between the windows with your subject a little way into the room and facing you. The different directions faced by the windows will probably mean that one admits more light than the other. That's to your advantage. So much so, in fact, that if it isn't the case, the subject should be moved away from one window and closer to the other until there *is* a suitable imbalance of light on the face. One window can now be used as the keylight, while the other provides the necessary fill-in. Use the stronger of the two windows as your main light, masking it as described earlier to allow its light to fall on your model at around 30 degrees

to the side and above. The second window can be used unmasked and with a net curtain across it to give a soft fill-in light to the shadows.

Since this lighting set-up necessitates taking your pictures from one corner, the background behind your model will be the opposite corner, looking diagonally across the room. This can provide problems. In a large room, the fade-off of light as it travels to the opposite corner will be sufficient to render the background black in the final picture. In a smaller room, you may not be so lucky. Any light on the background, however underexposed it appears in the final photograph, will be a distraction, especially since the corner where the two walls meet will make a nasty vertical line running from the top to the bottom of your picture.

Keeping your subject as close as possible to the windows is one way out of the problem. Closer to the light, less exposure is required for the face, and therefore the background becomes more underexposed by comparison. But the medium telephoto lens you'll probably be using for the face will dictate placing the subject at least two metres from the camera for no more than a head-and-shoulders shot. The wall behind you will stop you moving back, so the subject will have to move a suitable distance into the room. This, then, is one case where a portable background is almost a necessity. A free-standing projection screen is ideal. Even a normal sized screen will be suitable for a head-and-shoulders portrait, and because of the soft shadows from this type of light it can be erected fairly close to the subject. Even so, it should still be far enough behind your model as to be rendered out of focus, but this is not difficult with the wide apertures that available-light photography usually dictates.

Adding artificial light
Artificial light can be added to available light in certain circumstances, but care should be taken not to destroy the natural look that is the hallmark of this type of portraiture. One case where additional

lighting may be necessary is in full-length portraiture where the distance the subject must be placed from the window to be evenly lit from head to toe means that the overall light intensity is too weak for an average-sized reflector to fill the shadows. In this case, some extra artificial light can work wonders, but use it only as a fill-in, never as the main light if you want to retain the atmosphere. One of the biggest advantages of available light lies in its power to give a natural, sometimes almost candid, type of lighting to the picture. Overpower the natural light with artificial light and that advantage will be lost. The added light can take the form of ordinary tungsten bulbs, Photofloods, standard studio floods or flash. Any of these will be suitable when working in black-and-white, but only flash will give the correct colour balance when working in colour.

With tungsten or Photoflood bulbs, the light source can be adjusted and meter readings taken to get the right ratio between the daylight-supplied highlights and the artificial-light fill-in. Place the lights in the positions you have already learned for reflectors, and move them back and forth until you get the right intensity of light on the face. Flash can be placed in similar positions, but complicates things a little. Unless you are using studio flash, with its own built-in modelling light, you have no way of seeing the effect you are getting, and exposures too are more difficult to calculate.

If you must use flash, treat it the way you would when mixing flash and tungsten in the studio. Switch the gun to manual and use the guide number to work out the aperture required to light the face, then reduce this by one stop, since the flash in this case is being used merely to fill in the shadows, not as a main light; use of the correctly calculated aperture would mean that the shadows received the same amount of light as the highlights, thus destroying modelling. Alternatively, if you are using an auto gun, set one stop smaller on the camera than that indicated by the flashgun's scale for the speed of film you are using. Now take an

If the subject is photographed close enough to a window, the background (which might otherwise have proved distracting) can be underexposed to black. *Len Stirrup.*

104

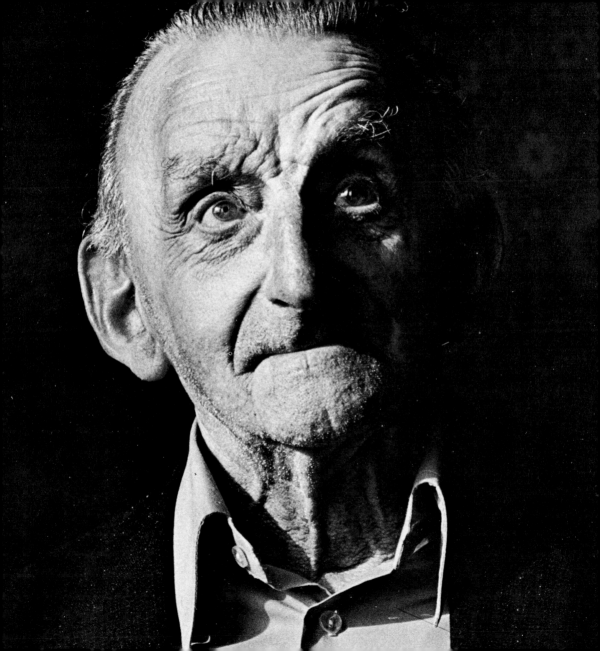

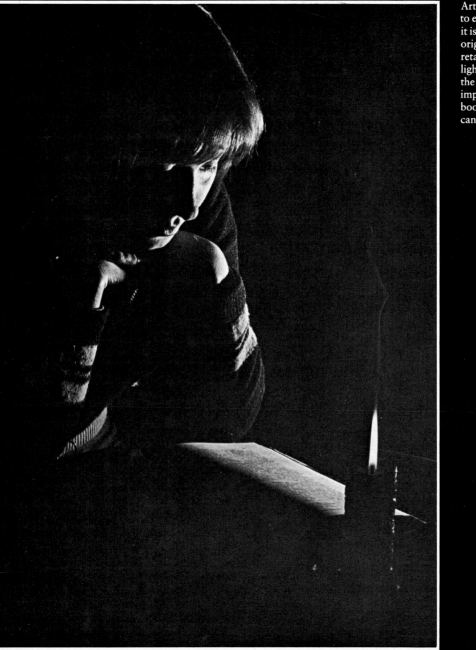

Artificial light can be added to existing light, provided it is unobtrusive and the original atmosphere is retained. Here, a little extra light has been added from the right, giving the impression that the face and book are being lit by the candle. *Henryk Kuglarz.*

exposure reading from the highlights. The shutter speed you then choose should be one that matches the aperture originally indicated by the scale, not the aperture actually set on the camera.

One of the few situations where artificial light works well as a main light in this type of portraiture is when you are posing your subject with his or her back to a window, using the window itself and a correctly exposed scene outside as a background. In this case, using flash, you calculate exposures the way you would synchro sunlight. Work out the correct exposure for the flash, take a reading of the scene outside the window, and adjust shutter speeds to match the flash aperture. The window and the scene outside will give a background to your portrait, while the available light will give a nice rim to your model's hair. With tungsten or Photoflood lighting, you must take your exposure reading from the background first, then adjust the lighting indoors, moving it backwards and forwards until the exposure on the face and that already metered for the scene outside are in the right ratio. Watch out for unwanted reflections of your lights or flash in the glass of the window. When using artificial light in these circumstances, there is a chance that you might find exposures difficult to match because the artificial light is too bright compared to the daylight. Tungsten or Photoflood lighting can of course be reduced by using bulbs of a lower wattage, while a flashgun's output can be lessened by covering it with one or two layers of white handkerchief.

Artificial light can also be used in available-light portraiture to help destroy ugly backgrounds. Suppose, for instance, you are picturing someone by light from a window and against a messy background, such as highly patterned wallpaper. Instead of trying to underexpose and render the background dark, as I have suggested up until now, you can use your artifical light source to *overexpose* the background, thus wiping out the detail. Adjust your lamps or flash so that the background is getting around two stops more exposure than the face. But remember to take your exposure readings with this light off, otherwise your meter might be affected by the extra light, giving you an underexposed face and a too-well exposed background.

Using existing artificial light
The other type of available light is the artificial light that you find in a room and that cannot easily be moved: ceiling fittings, wall lamps etc. This is one place where you will need high-speed film, and of course when working with colour reversal materials you should change to artificial-light stock. It must be said that the lighting described below is not recommended, giving as it does the worst of artificial light with none of the benefits of available light. Its effects are far too harsh for the type of pictures we are interested in taking, and . while it *can* make interesting photographs, they have little to do with serious portraiture.

If all you have is one light from the centre of the ceiling, remove any shade or fancy fitting and hang a piece of card or thick paper on the camera side to stop the light shining into the lens and to direct the maximum amount of light forward. Be careful not to hang your card too near the naked bulb because of the heat it generates. Position your model below and to one side, beyond the lamp so that its light falls on the face from the traditional angle to the side and above. This will give you a main light of sorts, but one that will leave your model with dark eye-sockets and ugly shadows under the chin. Place a reflector below the face to direct some of the light back into the face. Alternatively, if there is one available, you can use a table lamp with a lower-wattage bulb than that in the ceiling to act as a fill-in light. It is best to draw curtains and block out any daylight, which will register as blue on artificial-light colour film. And if you *must* use this type of lighting, avoid fluorescent lamps at all costs. They will give a green cast to your pictures and to your subject's face.

Ed Buziak (left), *Michael Barrington Martin* (right)

Handling colour

Until a few years ago, photographers started by taking black-and-white pictures, and when they were proficient in that field they progressed to colour. These days colour is more often the starting point. Yet there is more to using colour than merely slipping a roll of the appropriate film into your camera. Colour can enhance your portraits, but if not used correctly it is more likely to ruin them. To handle colour correctly, you have to combine art with science. The problems that arise, and the rules that help you overcome them, are both technical and aesthetic.

Colour temperature

Although you may not see it with the naked eye, different types of light actually vary in colour. Daylight is far more blue than artificial light; artificial light is more red than daylight. These differences are known as 'colour temperatures' and they are measured in kelvins. The following table gives an idea of the colour temperature of various light sources. The higher the figure, the bluer the light; the lower the figure, the redder the light.

skylight	12 000–18 000 K
daylight	5500 K
electronic flash	5500 K
flashcubes	5500 K
blue flashcubes	5400 K
noon sunlight	5400 K
white-flamed carbon arc	5000 K
clear zirconium-foil-filled flashbulbs	4200 K
clear aluminium-foil-filled flashbulbs	3800 K
500-watt Photoflood	3400 K
tungsten lamps	3200 K
household bulbs	2650–3000 K

The human eye, together with the brain, compensates for these differences in colour temperature. For instance, if you walk out of

daylight into a tungsten-illuminated room, you won't notice the light becoming more red. Colour film cannot compensate the way your eye does, so it must be balanced for either daylight or artificial light. Use the wrong film and your final picture will show a distinct colour cast. Daylight film in artificial light gives an overall red tinge to the picture, artificial-light film in daylight makes the result too blue. In fact this applies mainly to colour reversal film. Colour negative stock is a different matter, since colour casts caused by different colour temperatures of lighting can be adjusted by filtration at the printing stage.

When using transparency film, then, for all practical purposes there are only two stopping-off points on the colour-temperature scale: at 5500 K and at 3200 K. These are the two colour temperatures for which the majority of colour films are balanced. Normal daylight-balanced film such as Kodachrome 25 and 64 or Ektachrome 64 and 200 are balanced for 5500 K and can be used in ordinary daylight or with electronic flash. Artificial-light colour film is actually broken down into two types: type A balanced at 3400 K for Photofloods and type B balanced at 3200 K for studio tungsten lamps. However, although Kodachrome 40 type A film is readily available in the US, elsewhere type A film has now almost disappeared and we have only the tungsten-balanced films such as Ektachrome 160 for artificial-light work, forcing the photographer who is determined to work with Photofloods to use type B film with the appropriate filter.

All colour temperatures can be adjusted by filtration. If the film you are using is totally wrong for the light source, the filter is best used on the camera. But if you are mixing daylight or flash with artificial light, filtration is best applied to the light source itself. The conventional glass disc that screws into the camera lens is not the only type of filter. Sheets of gelatin in similar colours and densities are also available from professional photographic suppliers. These can be cut to fit in
110

front of lamps, provided that suitable air space is left between the gelatin and the lamp to prevent overheating. They can also be taped to windows to alter the balance of daylight. This leaves you free to use either daylight or artificial-light film, whichever is the more convenient; it also allows you to mix light sources when working in colour.

What isn't always appreciated is that flash too can be filtered. Tape a piece of the correctly coloured gelatin to your electronic flash and you can use it with tungsten-balanced film. That makes it ideal for outdoor portraits at night (see page 95), as it allows correct rendition of both the model and the lights in the background. In the same way, if you are shooting a session in the studio with tungsten light and tungsten-balanced film stock and you wish to add flash for a certain special effect, then you can filter the flashgun so that the two light sources are balanced. The effects you can achieve with this mixture are more fully explained in the chapter on special effects. Here again is a reminder of the filters you need for the various conversions.

1 An 85B is an amber filter for exposing type B tungsten film in daylight or electronic flash. It converts the colour temperature of the light from 5500 K to 3200 K and requires an exposure increase of two-thirds of a stop.

2 An 80A is a blue filter for exposing daylight film in tungsten light. It converts the colour temperature of the light from 3200 K to 5500 K and requires an exposure increase of two stops.

3 An 80B is a blue filter for exposing daylight film in Photoflood light. It converts the colour temperature of the light from 3400 K to 5500 K and requires an exposure increase of $1\frac{2}{3}$ stops.

4 An 81A is a pale yellow filter for exposing type B tungsten film in Photoflood lighting. It converts the colour temperature of the light from 3400 K to 3200 K and requires an exposure increase of one-third of a stop.

Importance of correct exposure

Colour film has a lot less latitude than monochrome. Exposures, therefore, must be spot-on. Once again, we are talking essentially about colour reversal film. Colour negative film, while not having the latitude of its monochrome equivalent, does allow a certain amount of leeway; wrongly exposed negatives can, to a small extent, be compensated for at the printing stage. But, just as with black-and-white, results will be far better if the exposure is accurate in the first place, so it is best to work towards getting your exposures right first time and every time. Even then, don't be afraid to bracket those exposures. There's no harm in covering yourself, even if you are convinced you are right. A few frames of wasted film at this stage are far better than having to reshoot later. What must be realised, however, is that 'correct' exposure can mean different things to different people. Some prefer the paler tones of a slightly overexposed transparency to the fully saturated tones of what the meter tells you is correct. Projectors too play their part. If yours has a strong lamp and you project only in small rooms, the pictures will be bright, making your idea of correct exposure a stop or two less than if your projector were old, with a weaker light source. Depending on the projector and the tastes of the viewer, there can be as much as two stops difference between what different people accept as the correct exposure.

Accurate exposure in colour is especially important if you are considering submitting your work for reproduction. Printers like a good, rich transparency, full of saturated colours. The washed-out look that comes from overexposure is no good to them, as it is impossible to put back detail that too much exposure has wiped out. For this reason, you may have heard that printers want only underexposed colour slides for reproduction. That's not strictly true. They want a *correctly* exposed transparency or one that, if wrongly exposed, errs in the direction of 'under' rather than 'over'. But even then, they want one that has been underexposed by no more than one-third of a stop,

and you're not likely to be able to detect that with the naked eye. The sort of underexposure you *can* easily detect (more than about one stop) produces muddy transparencies, and they make only muddy reproductions.

Many photographers, when they come to analyse what is the correct exposure, find that they have been overexposing their colour slides for years without realising it. The slides look fine when they are projected, and the photographer becomes accustomed to his slides looking a little on the light side. To him, they are correct. It comes as quite a shock when he tries to get his slides reproduced to find that they are overexposed and the *correct* exposure is what he has always considered to be *under*exposure. That's how fallacies about printers' requirements begin. So learn what correct exposure in a colour transparency looks like. When projected, the slide might appear at first to be too dark. Yet every colour is there in full richness. Underexpose on that and some of the colours begin to block up, overexpose and the colours quickly pale into pastel shades. For the purposes of normal projection, half-a-stop overexposure might seem more acceptable than the exposure demanded by a printer, and if all you want to do is project your slides then there is no harm in allowing for that extra half-a-stop. But if you want to see your portraits in print, stick to the richer results given by less exposure.

Having said that, it must be admitted that it isn't always easy to get every part of the picture correctly exposed. Dark colours absorb more light than light colours, and therefore need more exposure. The classic case is a girl dressed in black. Her dress might need as much as three stops more exposure than her face. Even if you take an average reading between the two, you are still going to get overexposed skin tones. In all colour portraiture then, take your correct exposure reading from your subject's face. If exposure changes the colours of a dress or suit subtly, it won't be nearly as noticeable as a change in skin tones.

This lightening and darkening of colours according to exposure can actually be used to advantage when lighting a background. One roll of background paper can be used to make several different shades of a colour simply by underexposure for a dark effect or overexposure to lighten the colour. Blue, for instance, can be lit to give a full range of shades from deepest royal blue to the palest of sky blues. Provided that the subject of the portrait is correctly exposed, this difference in exposure on the background won't matter, even in work intended for reproduction.

Colour harmony

The technical side of shooting portraits in colour is naturally important. But, as with all types of photography, technique should be cultivated until it is second nature to the photographer, leaving him free to concentrate on the actual subject matter. That's where colour harmony comes in, where you begin to learn how to combine colours to their best effect. Much has been written on colour characteristics, hues, notation, chroma; all of it is relevant, most of it seemingly complicated. What I aim to do here is to concentrate only on the aspects of colour harmony that you are likely to encounter in everyday portraiture. In the attempt to make things simple some details have had to be left out. If you want fuller explanations, textbooks on colour will give them to you.

There are five basic colours that must be considered: red, blue, green, yellow and purple. Each of these has its own effect on the viewer. Red is a powerful and exciting colour. It dominates any picture and must be used with care not to overpower the portrait. Blue is cooler. It recedes in a picture and has a more calming effect. Green is neutral, giving neither the hot impression of red nor the cold feeling of blue. Yellow is a 'happy' colour. It is strong without being overpowering. Purple, being a mixture of red and blue, acts as a balance between these two extremes. The colour suggests dignity, but can also give a certain erotic feeling to the right picture.

The easiest way to see how these colours work together is to arrange them in a circle such as that shown in the illustration. This is a simplified version of a colour wheel devised by Albert Munsell. The five basic colours are represented, alternating with five more colours, each of the latter being an equal mixture of those on either side. I shall be talking about *saturated* colours, meaning the ten pure colours seen around the wheel, and *desaturated* colours, meaning paler versions of these originals.

Travelling clockwise around the wheel, the colours from red to green inclusive are warm colours. They will seem to advance in any picture. Red is the strongest in this respect, with the effect growing weaker the further around the wheel you travel. If you want to use one of these colours as a background, you must be careful to dress your subject in a colour that advances more than the background colour. Yellow, for example, makes a good background for someone dressed in red, but bad for a subject in green. With the latter combination, the background would appear right on top of the subject. For that reason, red makes the worst background, because it advances on every other colour. Anticlockwise around the wheel, the colours from purple-red to blue-green are cold colours. They will seem to recede in a picture, the effect growing stronger as you travel around the wheel. Blue, then, makes an excellent background, keeping it in its place behind the subject.

Maximum contrast is found between any two colours diagonally opposite each other on the wheel. Red therefore contrasts strongly with blue-green, yellow with blue-purple, blue with red-yellow and so on. But don't mistake *contrast* for *harmony*. Using these contrasting colours together will give a striking effect. It's the sort of effect you might see on posters, record sleeves or magazine covers, where the idea is to grab the attention of the passer-by. What creates this sort of impact, however, doesn't necessarily make good portraiture. If you use equal areas of any of the

red

red-yellow

yellow

yellow-green

green

blue-green

blue

blue-purple

purple

purple-red

Tungsten-balanced film shot in daylight gives an overall blue cast to the picture.

An 85B filter on the camera lens corrects the cast, allowing tungsten film to be used out of doors.

Daylight film shot in tungsten light gives an overall orange cast to the picture.

An 80A blue gel over the lights corrects the colour cast when daylight film is used in tungsten light.

A simplified version of Munsell's colour wheel. Use it to check colour harmony and contrast, and to establish which colours advance and recede in relation to others.

strong colours, they will clash, making a disturbing effect in the picture. Desaturating one of the colours makes a far more pleasing effect. In practice, this means dressing your subject in a strong colour and slightly overexposing the background to make it paler. Equally, if you choose the right colours you can dress your model in a paler colour and use a strong, saturated colour for the background. Don't forget, though, how certain colours recede or advance in relation to each other, so make sure that your subject's dress is of a colour that advances over the background.

Having understood that, you must still find the right combination of colours for the most pleasing results. Go back to the colour wheel and look at the triangles in the centre. Any three colours that are joined by the sides of any individual triangle will compose well together. Yellow, for instance, looks good with purple-red and blue. By the same token, colours that are near to each other on the wheel will usually clash. There is an old saying, 'blue and green should never be seen'. I doubt if the person who first said that knew the first thing about Albert Munsell's colour wheel, but he knew a thing or two about colour.

Really, that's what it all comes down to. Reading the theory might sound complicated, but most of it is commonsense. If you have what is generally regarded as a fairly good dress sense you already know, almost by instinct, which colours go best with each other and which clash badly. To that basic knowledge you need add only two rules. First, don't mix equal areas of saturated colours in a picture; make sure one is less saturated than the other. Second, make sure your subject is dressed in a colour that advances over the background colour.

The only two colours we haven't mentioned yet are black and white. They aren't on the colour wheel because neither is a pure colour. (White is a mixture of all the colours of the spectrum, black is merely the absence of colour.) Both black and white can be used with any other colour you like, but each has its own effect on the subject. Any colour against a black background will appear stronger, more saturated. In a transparency, the colours will look more luminous against black. But beware of using black for prints that you aim to have trade-processed. The averaged-out exposure that most processing houses produce automatically could turn your black background into a grey one, and the slightly wrong exposure that caused *that* effect will also dull other colours in the picture. (If it happens to you, complain to the lab. Better still, use a lab that hand-prints individual negatives.) White registers differently in prints and slides. On

prints it shows up as a straightforward white background, and other colours in the picture will appear more saturated by comparison. On a transparency, white is nothing more than clear film through which light is shining, and its very brightness weakens the other colours.

Theory into practice
So far, this chapter has dealt far more with theory than with practice, mainly because much of the practice of colour portraiture, such as correcting colour casts outdoors or warming skin tones indoors, has already been covered in previous chapters. I am devoting the practical side of this chapter, then, to the pure use of colour to build or destroy feelings, effects and the overall character or mood of the portrait. What we have learnt about colour harmony is relevant to the conventional portrait. But the rules can be broken to produce an equally striking, if somewhat unconventional, picture. Now that you know the rules, you can start learning how to break them.

Let's start by recapping and then taking a few steps further what we have already learnt about colour harmony. We have learnt that the best way to achieve harmony is to match colours related by the triangles in the colour wheel. Harmony can also be produced, however, by using several shades of the same colour. In practice, for the best effect, these colours should be blended together, rather than used separately with a sharp-edged boundary between them. Soft focus (dealt with in more detail on page 133) helps blend the subject into the background. Soft lighting adds to the effect. Use reflectors or a diffuser in front of the light source if you are working indoors. Outdoors, work in the shade and use plenty of reflected light. Colours on the wheel between red-yellow and blue-green work well for this type of picture. The colours on the opposite side of the wheel need to be muted, when they too will produce the required effect.

Exactly the opposite effect can be achieved by using highly saturated colours that are *not* related by the

triangles in the wheel. This won't make a conventional portrait, but it will make an eye-catching picture. Use it for subjects like disco dancers or very lively children. The lighting should be harsh. The focus can be razor sharp, in which case you should use small apertures to keep everything from the subject to the background in focus, or you can use a wider aperture to keep your subject in focus against a brightly-lit, highly colourful and out-of-focus background.

If a simply-lit, calmly composed portrait is more what you have in mind, this can be enhanced by using several shades of the same colour against a neutral black or white background. Alternatively, pick one basic colour and keep all the other colours in harmony, using a small splash of the basic colour's exact contrast to give a little emphasis to the shot. A girl's scarf maybe, or a man's tie. Just that small amount in a contrasting colour can give a portrait the extra little push that makes all the difference between a good picture and a really successful one.

At best, any picture is only two-dimensional. But a feeling of the third dimension can be added by contrasting the subject with the background. We have already learnt that red advances more than any other colour, while blue recedes. To put a red subject against a blue background, then, would seem to give the ultimate in depth; the reverse, a blue subject in front of a red background, gives a static, flat look. You don't have to rely on this red/blue combination for depth, however. To make your subjects stand out, you have only to dress them in one of the saturated colours and place them against a background that is both desaturated and colder in relation to the principal colour.

Colour can also affect the apparent brilliance or dullness of the picture. For the most brilliant effects, stick to saturated colours, light them with direct light and keep them sharply focused. To add to their brilliance, shoot them against a black background for a transparency or a white background for a print. Just about the most brilliant effect possible can be obtained by shooting a red subject against a black background on colour reversal film. The opposite effect can be found by going to the other side of the wheel and using blue, blue-purple or blue-green. Keep the colours as dark as possible without actually going into underexposure, and light them with diffused or reflected light.

Colour can be used to suggest strength or delicacy, depending on your subject. Dark shades of any colour, composed with a black background, can be very effective for certain types of male portraiture. But try, as mentioned before, to add one small ingredient in a contrasting colour to help lift the picture. For young girls or children, where a more delicate effect is needed, paler versions of the same colours work equally well. Again, use harmonising colours from the colour wheel, with a small patch of a contrasting colour.

Finally, here are a couple of colour tips that will help give an ordinary subject just that little extra when shooting in colour. Unless your model is particularly suntanned, skin tones often look far too pale in the final picture, however perfectly exposed. If that's the case, use an 81 series filter (say the 81B) to warm them up. The final effect might not be true to life, but it will *appear* to be true: far more so than a correctly-rendered, but naturally whiter, face. Gold reflectors for filling shadows or inside brollyflash set-ups have a similar effect. Use filters and reflectors together, and the palest of models will appear to have that beautiful golden tan we all dream of but so few of us ever attain. Tip number two: coloured gels, used with discretion in spotlights or over flashguns behind the subject, can work wonders for the girl with neutral, mousy-coloured hair. Position the spots exactly as you would for normal backlighting, but add a suitably coloured gel in front of the light. The result won't necessarily look natural, but used in the right way, and with a little practice, it will look very effective.

Available light gives portraits an atmosphere that could never be recreated in the studio. In this case, the slight blurring that results from hand-holding for ¼ second is more than justified by the end product.

Right: neither photographer nor model was out to take a picture that summed up the subject's true character; the shot was taken purely for fun, but makes a striking picture.

Rudy Lewis

Candid camera

Ed Buziak

Candid portraiture, by its very nature, is bound to produce the most natural expressions. There's no sense of nervous anticipation as the subject waits for the shutter to click, simply because he or she doesn't even know the camera is there. Lively, uninhibited, atmospheric pictures, otherwise impossible to create under controlled conditions, can be created by candid photography, but the technique can also be unkind and unflattering to the subject. That's where your conscience must play a part. You might poke a little harmless fun at your subjects through your pictures, but if the picture shows them in an embarrassing situation it's up to you to keep the picture to yourself or, better still, to destroy it. There is nothing to stop you photographing anyone in a public place. But if it can be shown that your picture has had a detrimental effect on the subject, you could find yourself in trouble with the law. A good rule of thumb is to put yourself in the place of the subject when you come to look at the picture. If *you* wouldn't mind being photographed the way you have caught them, it's a fair bet that the picture is acceptable.

Equipment

The equipment you use for candid portraiture will vary with the way you like to go about it. Some photographers like to hide behind a telephoto lens, taking their pictures from as far away as possible. Others prefer to work close up with a small, hand-held camera. Both methods have their uses and each should be tried. There are times when it is impossible to get close to your subject, and then a telephoto lens is essential. Equally, if you are shooting in a crowd (one of the best places for candid work) you may not be able to get far enough away from your subject, in which case a telephoto is only a hindrance. A zoom lens can be worth its weight in gold for candids, especially if you are

A 400 mm lens, used for this shot, has allowed the photographer to work at a distance that kept the subject unaware of his presence. The shallow depth of field characteristic of such a lens has also blurred an otherwise distracting background.

shooting colour transparencies. Since you can't position your subjects exactly where you want them, the zoom will help you fill the frame for better composition. Whichever lens or method you use, fast film is best. It allows you the luxury of fast shutter speeds for hand-held, long-lens work, and it helps you cope with the sudden changes in light levels that the candid photographer encounters.

Motor drives only make extra noise and draw attention. However convenient they may seem, don't use them for candid work. A waist-level camera can be an advantage over the eye-level type, because the photographer who is seen glancing casually down at his viewfinder is so much less conspicuous than one who has a camera to his eye. Also, the waist-level camera can be turned sideways, so that the photographer is actually facing at 90 degrees to his subject, while still framing him in the viewfinder.

There are also special gadgets on the market that fit to the front of the lens of a single-lens reflex and, by means of a mirror, take pictures at 90 degrees, also giving the impression that the photographer is facing away from his intended victim. Such accessories have their place for the shy photographer. But, quite honestly, if you *are* shy you shouldn't be trying your hand at candid work. The direct approach is better, either with a long-focus lens at a distance or with a small, unobtrusive camera closer to your subject.

Technique

Your first duty, even before you begin to look for a subject, is to know your camera. Candid photography is one place where actual camera operation must be nothing short of second nature. Make sure you know in advance which way the barrel of each lens you aim to use rotates for infinity, and which way to turn it for closer focusing distances. Keep the camera set at the right exposure at all times, continually adjusting it as the light varies or as you concentrate on areas of different lighting levels. Learn to judge distances

and pre-focus your lens so that, when you eventually put the camera to your eye, the lens is as near as possible to sharp focus on the subject. I have a particular way of judging distances which is worth a try. Knowing my own height, I look at the space between myself and the subject and imagine how many times I could lie down in the distance to be measured; it sounds crude, but it's amazing how accurate you can get after a while. All these things are designed to save you time at the moment of exposure. With candid photography, a split-second can make the difference between a good and bad picture, as the light changes, as the subject moves out of range, or as an expression fleetingly crosses the subject's face.

The whole point of candid portraiture is that the subject is unaware of the photographer. So learn how to work unobtrusively. That doesn't necessarily mean hiding your camera under your coat or disguising it as some other object like a parcel. You can get to the point where, the more you try to hide, the more attention you draw to yourself. Let people know you are taking photographs, but don't let them think you are taking photographs of *them*. A good place to start is in a pleasantly crowded area, but not one in which you are going to be hemmed in or jostled. Somewhere like Speaker's Corner in London's Hyde Park is ideal. Be seen to be taking photographs. It's amazing how quickly people get used to something and, in accepting it, become blind to it. Pretty soon, the people around you won't even notice you. But they will notice you if you begin behaving oddly. So don't overdo it. Just because I've said let them see you taking photographs, don't think that means theatrically leaping about with a *look, I'm taking photographs* act. Just behave perfectly normally. Saunter through the crowd, lifting your camera to your eye, focusing, going through the motions.

When you spot a face you want to photograph, work your way slowly towards the person concerned, again maybe taking one or two pictures

on the way. Appear unconcerned. Glance round you, seemingly taking in the crowd in general, but in the general sweep of your gaze pay particular attention to your intended subject. You'll find you can develop a way of looking at people, while focusing your eyes slightly over their shoulder. If they look at you they'll be convinced that you are looking at someone or something else behind them, and they'll be too polite to turn round to find out what it is.

Having sized up your quarry and positioned yourself in a place you know from experience will be suitable for the focal length of lens you are using, raise your camera. Point it anywhere but at the subject. Sweep it around the crowd a few times. Prefocus it as accurately as possible by lining it up, perhaps with the back of a head that you judge to be about the same distance away as your subject. Carry on looking at the crowd through the viewfinder, and now sweep past the person you want to photograph. As you pass, stop long enough to adjust the focus accurately, press the shutter and then (very important) carry on sweeping your camera around the crowd. If you stop playing with your camera the moment you have taken your picture, the subject may catch on. But, on the other hand, if he or she sees you're still there, still messing about with your camera, there will be little reason to believe that you have just taken a photograph. Give it another couple of minutes, then drift away and start somewhere else.

Remember that candid portraiture differs from other types only in so far as the subject is unaware of the photographer, so don't use the difficulties in taking the photograph as an excuse for forgetting all the other rules. If you are working outdoors, you should try as much as possible to use what you learnt about conventional portraiture outdoors in an earlier chapter. Of course, you won't be able to position reflectors, or arrange your subject so that the light falls correctly. But you *can* remember what makes a good picture and watch out for subjects who are already in the best positions.

No more than a 100 mm lens was used for this candid shot, working in a crowd. The old lady was completely oblivious of the photographer's interest in her.

Be careful with backgrounds. Try to photograph dark-haired people against lightish backgrounds and vice versa. This is where a telephoto lens is invaluable. However muddled the background might be, the limited depth of field attainable will allow you to pick your subject out, while rendering even a close background fuzzy. Beware, when using black-and-white, of contrasting colours that will register as similar tones of grey. Your subject may stand out very well against the background in

Right: if the subject is sufficiently wrapped up in himself, he will fail even to notice the camera. A standard 50 mm lens was used for this shot as the boy turned to remonstrate with a group of people behind him. The photographer was one of the group.

colour, but will he or she merge too much in monochrome?

Another place worth trying candid photography is a location where people are preoccupied with some sport or game: the sidelines of an amateur football match, for instance. Amateur games are best because there will be fewer people than at a big professional match, leaving you freer to move around. Expressions on faces as spectators become involved with their team's success or failure can make wonderful pictures. And, with four sides to every football pitch, you can choose the best position for lighting. You won't of course be able to get full-face shots without going on to the pitch itself, which isn't the best way to remain unobtrusive. But there can be a wealth of pictures in profiles and three-quarters shots, taken with a long lens across one of the corners. What's more, your camera will be accepted from the start, since a football match is the obvious place for photographers. Who, among the spectators, is going to imagine that you might be there to photograph *him*?

Fairgrounds are also fair game for the candid photographer. Get round the games stalls and watch expressions change as players win or lose. Stand on one side of the stall and photograph people on the other. What with the excitement of the game and the crowds, they'll just never notice you. Possibly the very best subjects for candid portraiture are children. They can be so completely natural, and when they are wrapped up in a game they are oblivious to everything, including you and your camera. Even when they know the camera is there, they tend to ignore it as something of no importance, leaving you free to follow them about, photographing from only a couple of metres away.

All this applies to candid photography outdoors. Taking your candid camera indoors produces problems, but they can be overcome with a little thought. No existing light is going to be ideal for photography. So think about the way we learned to

make the best of existing available light, earlier in the book. Try to keep ceiling lights between you and your subject and, where possible, photograph the person when he or she is standing a little to one side of the light. Fast film, wide apertures and slow shutter speeds are a must. But keep exposures as accurate as possible. There is no point in adding to the grain that comes with a fast film by turning out wrongly-exposed negatives.

Theatrical candids

One place where the photographer can take as many candid photographs as he likes, without having to work unobtrusively, is in the theatre. Of

A member of a drama school practising improvisations provided the subject for this shot, taken with a standard lens by available stage lighting.

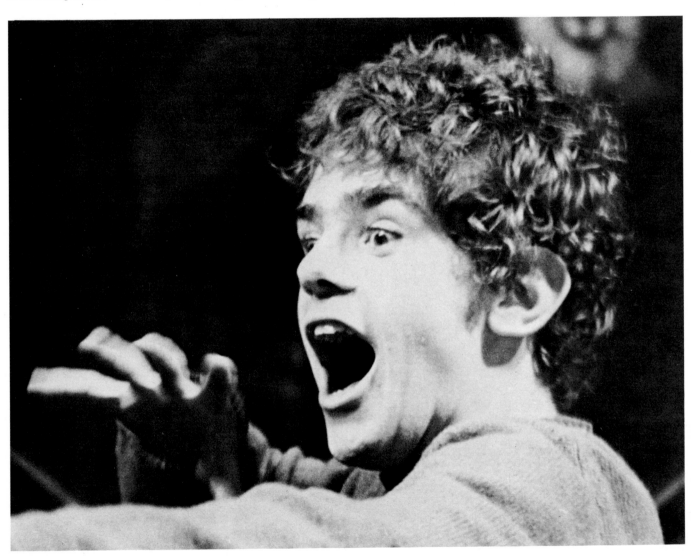

course that doesn't mean you should sit in the front row clicking away at a live performance! Get to know your local amateur dramatic society and get yourself invited to their dress rehearsals. Better still, see if there is a drama school in your area. Whereas the dramatic society will only perform plays, the drama school will be involved with dramatic exercises, improvisations, etc., all of which provide a wealth of photogenic material for the candid portrait photographer. Being actors, the participants won't be self-conscious, and you will probably be allowed to take as many pictures as you like without having to make yourself inconspicuous.

Theatres and jazz clubs can provide a wealth of candid shots. *Roy Pryer.*

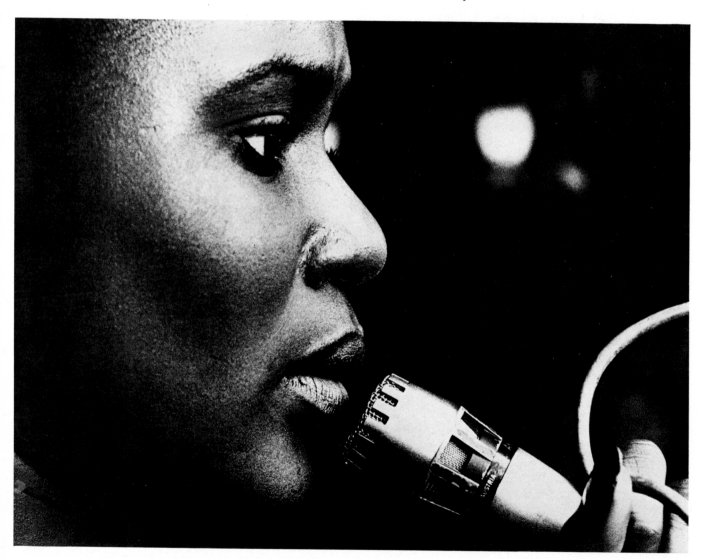

The 135 mm lens used for this shot allowed the old man to be photographed while he was in conversation with a friend out of camera range.

Right: candid portraits are easy to shoot with your subject in profile. The model is less likely to be aware of the camera and you can move in close with a standard lens. A longer lens on this shot might have isolated the subject too much and so destroyed the atmosphere given by the surroundings. Also, the wide-aperture/slow-shutter-speed combination demanded by the location would have proved difficult to handle with a telephoto. *Ron Tenchio*.

The lighting is already arranged for you, and you'll find hand-held exposures of around 1/60 second at f/4 are quite possible on Tri-X (ISO 400/27°). Try to take your pictures lit by spotlights rather than by footlights. The latter throw weird shadows on faces, giving the subject a totally unreal look. Shoot from the auditorium rather than from the side of the stage, because that's the place the lighting is arranged for. But don't trust your meter. A stage is full of light and shade, with the actor in the spotlight lit far better than another actor only a metre or two away and out of the spot. If you allow the TTL metering in your camera to take an average reading of such a set-up, your exposures will be totally inaccurate. It's better to use a spot meter or, failing that, to ask for a few minutes alone on the stage, with the lights on, to take individual readings at various places. Make a mental note and then, when you are back in the auditorium, you'll have to adjust your exposures accordingly. In such circumstances your pictures will stand a better chance of success if you bracket all exposures.

Ethics

I said at the beginning of this chapter that if you produce a photograph that is detrimental to the subject, then you could be in trouble with the law. Clearly, though, if you produced that type of photograph it would be a bad portrait anyway, even if, in other circumstances, it might make a good news picture. (Photojournalism, indeed, is almost exclusively candid, although few news pictures could be called good portraits.) Since we are talking about nothing more than a way of taking different and interesting portraits, you are not likely to turn out a picture that would offend the subject, and so I strongly advise showing the finished pictures to the models whenever possible.

If a model violently objects to the pictures, destroy them. You're not a news photographer whose job depends on getting photographs of people whether they like it or not. You're a portrait photographer, and at the end of the day it's better if your model shares your enthusiasm for the photograph.

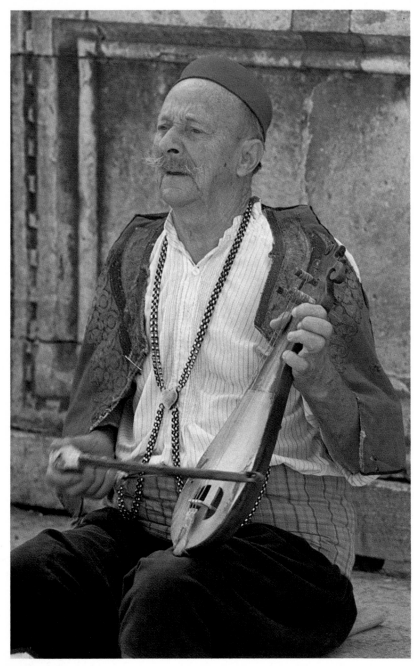

Left: the colourful clothes of the street musician stand out well against the sombre background when colour film is used. If this shot had been taken on mono film, however, the tones of the face, jacket and background would have merged into similar shades of grey, making the shot far less effective. *Len Stirrup.*

Right: watch out for the unexpected when shooting candids, and when it occurs be ready for it. The use of a long lens has isolated the subject against a crowded background. *Ed Buziak.*

Carlos Scheurweg

Special effects

Special effects must be handled with care. If a photographer uses any effect that varies from the straightforward recording of the subject, there must be good reason for it. Never use a special effect in an attempt to make what you know to be a bad picture good. The picture will still be bad and the special effect will dominate it, making it worse. The effect should become part of the overall picture, adding some mood or feeling, contributing to the whole, rather than standing apart as something that has merely been added on for the sake of it.

For the purposes of this chapter, I am considering two types of special effect. On page 45, I said that a portrait is either the subject's picture or the photographer's picture, and nowhere does this become more apparent than in the field of special effects. If the portrait is the subject's picture, the effect should be used only to enhance what is already a good photograph: the addition of soft focus to a picture of a pretty girl maybe, or the deliberate use of blurred action in a portrait of an athlete. But if the portrait is the photographer's picture, special effects can justifiably be used for their own sakes, to make an interesting photograph in which the model plays only a small part and in which the overall effect is the very reason for the picture. You'll be told that this isn't good portraiture because the subject isn't represented the way he or she really is. I don't agree. It *is* good portraiture provided three things hold true: *you* must like the picture, the *model* must like the picture, and of course it must be technically a good photograph.

That last aspect is the most important. Using special effects must never be an excuse for bad technique. If the effect involves the use of unusually coloured lighting, for instance, that lighting should still be arranged according to the rules we learnt

Michael Barrington Martin

Window light lends itself well to soft-focus effects, provided here by a special soft-focus lens. Light was from a single window at 90° to the model's right, with a silver reflector parallel to the window on the left.

Soft focus can be achieved by a wide variety of methods. Here it has been provided by a special lens in which the degree of softness can be controlled by shifting elements within the lens.

earlier, and the rules we learnt about posing and composition still hold true, whatever effect is being added to the picture. So don't try special effects until you have mastered the more straightforward forms of portraiture. That's why this chapter is near the end of the book; you should learn the basics before you begin to experiment. Here, then, are a few effects you might like to try.

Soft focus

This is probably one of the most popular special effects around. It can be achieved in many different ways. Right at the top of the price range are the specially designed soft-focus lenses. These utilise a special control which moves elements within the lens to create and control a certain amount of aberration, thus giving various degrees of soft focus. At the other end of the scale there is the time-honoured practice of smearing petroleum jelly on a filter. The reason for using a filter is obvious. In theory you could spread it on the camera lens itself, but though the jelly is easy to apply it is difficult to remove, especially from the delicate surface of your lens's front element. So stick to smearing it on a filter and then screw the filter to the lens. Don't use a lot, just a trace will suffice, and smear it around the edge, leaving a clear space in the middle. The effect will be a sharp centre for your subject's face, growing more and more misty towards the edge of the frame. Different apertures will produce different effects, as will different amounts of petroleum jelly. So experiment, checking the effect with your camera's depth-of-field preview button before you press the shutter. In colour, you must of course use a clear filter such as a UV or Skylight. In monochrome, you can use any filter that doesn't interfere badly with your subject's skin tones. Yellow or green, for reasons mentioned earlier, are probably the best.

Another type of soft focus can be obtained with a piece of black nylon stretched over the lens or lens hood. Fix it with a rubber band and pull it tight. Then touch a burning cigarette to the centre of the taut nylon to make a hole for sharp focus as the centre of your picture. The cigarette has only to be touched lightly to the material to make the hole, and extreme care must be taken not to apply too much pressure that might result in the burning end touching the lens. As with petroleum jelly, different apertures vary the effect. So check and experiment as you go along. Different gauges and colours of netting also give different effects, but it is not advisable to use coloured material with colour films unless you want to give the picture a colour cast.

An overall soft-focus effect can be obtained by taking an old clear filter or a piece of optically flat glass (ancient glass plates with the emulsion removed by bleach or neat fixer are ideal if you can get hold of any), sticking a disc of opaque material in its centre and fixing it to the front of the lens. The degree of soft focus can be varied with the aperture in use, though you may have to experiment with the dot size to make the effect work. Another idea, with a filter you no longer require, or with a piece of flat glass, is to take a tube

of clear adhesive and 'draw' a spiral pattern on the glass with the glue, leaving a little space between the lines of the spiral. Leave it to dry until the glue is rock-hard, and then hold it in front of your lens. Crumpled cellophane over the lens gives another type of soft-focus effect, as does breathing on the lens just before making the exposure. Even the steam from a kettle can be used if you can arrange to boil one on location or in the studio. For that effect, hold your piece of glass or filter in the steam so that the water droplets condense on the surface, then slip it in front of your lens as you take the picture. It is important to remember that all these effects vary with the size of aperture, so preview the picture at your working aperture before exposing.

And finally, here's one way to get a particularly interesting soft-focus effect without the use of any other accessory. You can, however, only take the shot in a studio, since you need long exposure times and therefore a low level of lighting. Set your portrait up and adjust the aperture to combine with a longish shutter speed of around 1/8 second or lower. Focus accurately, but as the exposure is actually being made, slowly rotate the focusing ring toward infinity. The effect will grow more pronounced, the longer the shutter speed.

Zoom techniques

A good zoom lens is very useful for portraiture, but its use doesn't stop with its ability to frame the subject correctly in the viewfinder. It can also be used for special effects. Once again, you need a slow shutter speed, so the effect works best in a studio (although you can create the effect outdoors with slow film and/or neutral density filters). Basically the idea is simple. Frame your subject at the wide end of the lens's range, then, during the actual exposure, slowly and smoothly zoom in towards the telephoto setting. Alternatively, start at the tele end of the range and zoom out during exposure. Do this on a normally lit portrait and the effect will be a series of lines, all converging on a centre spot. For that reason, if you are shooting a head-and-shoulders picture it's a good idea to

ignore the rules of composition at the shooting stage; instead, position your subject with one eye in the centre of the frame, so that it makes a central point for the pattern. The composition can be rearranged at the printing stage to correct the composition or, if you are using reversal film, the slide can be cropped or duped accordingly.

A slightly different effect can be obtained by using the zoom in a similar way while mixing tungsten and flash for the lighting. Set up your flash heads as for a standard portrait, but use a tungsten lamp behind the subject to give a rim light to the hair.

Calculate exposures so that the aperture looks after the flash, while the shutter speed, coupled with that

Zooming during exposure can provide two distinct effects. Left: the portrait was conventionally lit and the lens zoomed from wide angle to telephoto during a half-second exposure. Right: the model was lit by flash while the rimlight was provided by a tungsten spotlight directly behind her head. The lens was zoomed from wide to tele during a one-second exposure.

particular aperture, looks after the tungsten. Now take your picture as before, zooming in or out at the moment of exposure. The effect this time will be a sharply focused and correctly rendered face with lines radiating out all around. If you start at the wide end of the range and zoom to tele as you expose, the lines will appear to be streaming from your model's head like a halo. If you start at the tele end of the range and zoom to wide, the lines will appear to be starting from the edge of your model's head, streaming towards the centre of the face. The former effect is probably the better.

If you are trying the effect with colour reversal film, you must use daylight-balanced stock to match the flash. For true accuracy, you should then filter the tungsten light with a blue filter. In practice, however, the warm effect given by the unfiltered tungsten light often makes a far more pleasing effect. Whether you use conventional or mixed lighting, a black background is a must, since it shows the streams of light to the best effect.

Slide projectors as light sources

A slide projector can be used, together with a selection of suitable slides, as the main light in a special-effect portrait. The idea is to project the slides on to your subject's face. In fact two projectors are better than one. They can be arranged in traditional two-lamp lighting set-ups, a slide in each. Alternatively, for a simpler but equally effective picture, the projectors can be used to project straight colours. Pieces of coloured gel bound in slide mounts give the required effect. Failing that, coloured Cellophane from wrappers can be bound between glass and projected on to the face. However, the best type of slide is some kind of abstract pattern: skies, water reflections, coloured lights at night. Even better, shoot the slides specifically for the purpose. For my illustration, I started with a set of slides that had been made with special-effect filters such as those that give highly coloured patterns around bright sources of light like the sun. Fitting these to my camera lens, I photographed a spotlight shone through a small

hole, no more than 2 mm across, in a piece of black paper. The patterns were enhanced by rotating the filters and/or zooming the lens during exposure.

You need a patient model for this type of photography. The light from a projector with a slide in place isn't as bright overall as floods, but it is more concentrated and will seem to the model to be shining painfully into the eyes. Also, because the projector isn't as bright as normal studio lighting, you will need fast film or long exposure times. So your model will not only be uncomfortable but may have to sit extra still. Explain this before you start.

A black background is best to add sparkle to the colours on the face. Position the projector where you would normally place a keylight, and add a reflector if necessary. Because parts of the face will fall into shadow, it helps if you rimlight the subject's head from the rear with a spotlight. To add to the effect, a gel of a contrasting colour can be added to the spot, but unless you have some way of reducing the power of the light, the long exposure times necessary to record the projected image will overexpose and desaturate any colour you decide to use. One way to get a more saturated colour is to use a flashgun in place of the tungsten spot, calculating exposures in the way previously described for mixing tungsten and flash (see page 84). Mixing light sources this way, of course, gives you problems with colour balance when shooting on colour film, but since you are aiming for a coloured effect by filtering the flash anyway, the difference between the two colour temperatures rarely matters much.

Double exposure

The first requirement, obviously, is a camera capable of taking more than one exposure on a frame. If yours is a 35 mm model with no override for the double-exposure prevention, try this. After the first exposure, turn the camera's rewind knob gently back to take up any slack, then press the rewind button. Keeping a tight grip on the rewind knob, carefully advance the film-wind lever. That

Projectors used as light sources can provide interesting effects when an abstract slide is projected on to the model's face. In this shot, the projector was at head-height on the model's left, while a red-filtered spotlight provided a rim around her hair.

way the shutter will be cocked ready for a second exposure, but the film should have stayed in the same place. Once you have made the double exposure, wind on twice to prevent any overlapping of frames caused by the rewind button remaining depressed for the first part of the wind. Apart from this basic consideration, probably the best camera for double-exposure work is a view camera; next best is a medium-format single-lens reflex with interchangeable viewfinders. With the viewfinder removed you get access to the ground-glass focusing screen, and this can be marked with the subject's position on the first exposure for reference when making the second. A grease pencil is quite suitable for this purpose. It writes easily on the glass, and the marks can be removed when necessary with a soft cloth.

Double exposures can take many different forms. They can be used to expose the model twice on the same frame of film, once in profile maybe and once full-face. A black background is essential so that only the model registers on the film during each exposure, and lighting must be carefully worked out. A good starting point would be strong side-lighting for the full-face shot, leaving half the face in shadow so that, on the second exposure, a profile can be introduced into the dark area; or a profile might be exposed in silhouette against a light-coloured background and a face introduced inside the profile on the second exposure.

Another way of using double exposures is to combine your subject with, perhaps, a landscape or sky. Photograph a dramatic sky as normal, then, in the studio, take a second exposure of your model against a black background. The two images will merge and flow into one another. A variation on that theme is to photograph a landscape, leaving one area deliberately underexposed and therefore black. A sunset behind hills makes a good example, exposed only for the sky so that the hills remain in silhouette against it. Mark in the viewfinder the point where the hills meet the sky, and in the studio pose your model below this line, once again against

a black background. In both these examples you are of course mixing light sources, so a suitable film/light/filter combination must be found when working in colour. The best idea is to use daylight-balanced film, then work in the studio with flash or filtered tungsten light.

Controlled blur

In a way this is a variation on the 'zooming during exposure' technique. The difference is that for controlled blur the camera and the focal length of the lens remain fixed, while the subject moves. Lighting is best arranged as described for the second of the two zooming techniques: use flash to freeze the subject and tungsten to record the blur. Black again works best for the background, and exposures are calculated as before with mixed flash and tungsten lighting. Just as with the zoom shot, the tungsten light should be filtered for accurate colour rendition, but the picture will look just as good, if not better, if you allow the tungsten light to warm the blur behind the accurately rendered subject. The shot can be as simple or as sophisticated as you like to make it. At its simplest, it means having your subject move his or her head and/or arms during a long exposure, while using the flash to freeze the action at a suitable point. More ambitiously you can use the effect on someone dancing, or maybe a gymnast, freezing the shot at the peak of the action. The top of a high jumper's leap would be a perfect example.

Tracing with light

Light trails around your model's head, or, if you have the room, round most of her body, can be 'painted in' with a flashlight. Set up a portrait as normal, allowing space for you to move around the model when necessary. Use a dark background and black out the studio so that no stray light is falling on the model. Using a tripod, take a shot as normal. Then, if you are using tungsten lighting, immediately turn out all the lights. Your model must now keep as still as possible. Facial expressions don't matter, but ask her not to move her body more than she can help.

138

A double exposure made in the camera. The first exposure was the model's profile in silhouette against a white background; the girl's face was then conventionally lit and composed smaller inside the black area for the second exposure.

Lines of light can be traced around your model with a flashlight during a time exposure. For this shot, four exposures were made: the first to light the girl, the other three to record the light trails from a flashlight with three different coloured filters held over its beam.

Right: photographing your subject's reflection in a thin metal plate or a sheet of mirror plastic can give strange, distorted effects. *Henryk Kuglarz.*

Override the double-exposure prevention on your camera and open the shutter on the B setting. Move around the back of your model, switch on the flashlight and trace it around her body, head-and-shoulders, or however much is to appear in the picture. Move the light slowly and steadily, keeping it pointed at the camera. Using an average film speed such as Ilford FP4 (ISO 125/22°), an aperture of f/11 and a tracing time of about one second for every five centimetres moved makes a good starting point for experimentation. You can try as many tracings as you like, but remember where the previous one started and finished, so that you don't overlap the next time around. In colour, filters can be added to the flashlight or the camera, though the former is probably better.

Even though the studio has been blacked out, you should keep the shutter open for as short a time as possible. If double exposures are no problem it is best to close the shutter between each light trace, especially if you are working with different colours and need extra time to change filters. Another tip, to help the operation run smoothly and quickly, is to calculate what aperture you are going to need for the tracing and to make this the basis for your exposure on the actual portrait. That way, when the lights go out, you have only to change the shutter speed setting to B and not worry about changing the aperture as well. Little things like that save valuable time.

Distortion
Strange effects can be obtained by photographing your subject's reflection in various materials. Thin metal plates or sheets of mirror plastic can be particularly effective, as they can be bent and moulded to give different effects. Experiment to find the effect you like best, then try other reflective surfaces: aluminium foil, sheets of black plastic like those used for dustbin liners, shaving mirrors . . . As in just about every other type of special-effect work, or, for that matter, portraiture and photography in general, you are limited only by your own imagination.

142

Gerry Chudley *Neville Newman*

Presentation

Photography doesn't end the moment you press the shutter. After picture *taking*, you must start to think about picture *making*. The end product of any branch of photography is obviously the photograph, the effect of which can be considerably strengthened or practically destroyed by the way it is presented. Nowhere is this more true than in the presentation of portraiture.

Presentation in processing
It is not the purpose of this book to talk about developing and printing, which form the subject of others in this series. Basically, the developing and printing of portraiture is not so very different from the processing of any other subject. At the end of the usual darkroom work, however, there are some options open to you that are worth considering: surfaces of printing paper, a few simple effects that can be introduced at the printing stage, the actual tone of the image . . . little extras that give your print just that added difference that lifts it above the norm.

The first option open to you is the choice of a matt or glossy printing paper. Such a choice is often a matter of personal preference, but it is worth considering that it can also be used to enhance the subject matter. A soft-focus, romantic type of picture, with muted pastel shades if it's a colour print, works best with a matt surface. On the other hand, if your subject is harder, using strong contrasts or strident colours, the effect will be enhanced by printing on a glossy surface. By the same reasoning, portraits of women often work best on matt paper, while male portraiture looks better on glossy. But don't be afraid to break those rules if, for instance, you are picturing a very modern girl with extra colourful clothes and way-out makeup. Without a doubt, she would be a subject for the glossy treatment. The exception to

all this is when you are submitting pictures for publication. Despite the effect you are trying to achieve, the printing process involved demands glossy originals. Printers *can* reproduce from matt-surface papers, but the reproduction loses contrast and therefore quality.

Toning is another process worth considering for more effective presentation. Sepia toning (the old-fashioned brown-print look) is the one that immediately comes to mind, but don't forget that black-and-white prints (or mono slides for that matter) can be toned with many other colours as well, including blue, red and green. The basic process means little more than making the right type of print and soaking it in the toning solution either as soon as the print has been made, or at a later date. The black in the original image is then converted to the required colour. Don't confuse *toning* with *dyeing*. A colour dye affects the paper base, leaving the blacks as they are. The two can be combined to give a two-toned picture for even more weird and wonderful effects.

All these effects of course have to be matched with the type of model originally photographed. The multi-coloured effect just described would work perfectly with a young person, dressed and acting out of the ordinary, but that same subject would be destroyed by the use of a sepia toner, which gives the feeling of an age and days gone by. Similarly, for a particularly striking effect, you might like to dress your model in vintage clothing, pose him or her in a suitable setting and try to recreate some of the old-time pictures. Sepia toning would give just that little extra needed to lift the presentation into something special, especially if, in that particular example, the toning were combined with the next technique.

Vignetting at the printing stage is an effect that works better with portraiture than with any other subject. A vignetted picture is one that shows the principal subject in the centre, with all other detail towards the edge gradually fading away to clear,

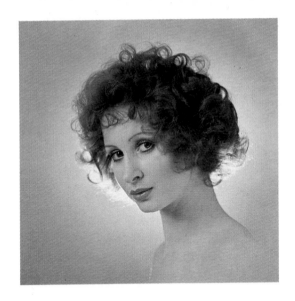

Vignetting at the printing stage gives a simple method of presenting your portraits in a slightly different way. *Michael Barrington Martin.*

white paper. The effect can be achieved by cutting a hole in a piece of card and holding it midway between the enlarger and the baseboard during printing. Different effects can be created by differently shaped holes, but the most effective for our subject is an oval shape. Soft focus or diffusion can also be introduced at the printing stage for a different form of presentation. Obviously, as before, it must be used with the right subject: a dreamy, glamorous picture of a woman, rather than a hard, straight picture of a man. The effect is made by any of the methods previously described in the section on taking soft-focus portraits in the previous chapter. From soft-focus lenses to petroleum jelly on a filter, all methods work as well on the enlarger as they do on the camera. But note that on the camera soft focus works by diffusing light into the darker areas, whereas in the enlarger diffusion spreads the shadows into highlight areas.

Texture screens make another interesting variation in presentation. These are small pieces of film with a texture printed on them. They are sandwiched with a negative (mono or colour) and the two are placed in the enlarger together. Processing is then

A texture screen bound with the negative at the printing stage gives your portraits a different presentation, making photographs look like paintings.

carried out as normal, the final picture showing the portrait combined with the texture. The screens can also be used bound with transparencies. One of the most effective uses is for making pictures that appear like oil paintings, a form of presentation that could lead to extra sales if you are out to make money from your portraits. Texture screens commercially available from, among others, the Paterson company include: old master, reticulated grain, tweed, rough linen, tapestry, dot screen, drawn cotton, gravel, centric, denim, rough etch, stucco, grid line, steel etch, scramble and craze. The names speak for themselves.

Mounting prints
The most common mistake that many photographers make when they first begin mounting prints is to make things too complicated. A good picture will stand or fall by its subject matter. The mount is there to complement it, not to try to make a bad picture good, or to outdo it. So here's what *not* to do. Don't mount your print in the middle of a white mount and then begin to draw black lines around it. Don't mount it at a peculiar angle just for the sake of it. Don't use brightly coloured mounts. Don't use strangely shaped mounts. And finally, don't take any of the above too seriously. Right back at the beginning of this book, I said that you should never be hidebound by rules, but that you should always learn the rules before you attempt to break them. Print mounting is a perfect example of just that. Everything I've just said *not* to do *can* be done when you know what you are doing and when you have the right print to play with. But start by keeping things simple.

Mounts need not be seen at all. They can be used purely and simply as a method of keeping your prints stiff. For exhibition work, in which the picture is the most important aspect, it's often best to use a mount that is exactly the same size as your print and then to stick it down flush with the edges. (In practice, it is best to use a mount that is very slightly larger, mount the print and then take a very slight trim off all the sides to keep it clean.) If you do decide to use a mount that is larger than the print, the most conventional mounting, with equal space all the way round, can still be very effective. If you want to add ornamentation to the mount, keep it simple, nothing more than a *thin* black line, maybe a centimetre from the sides of the picture and drawn neatly with a proper artist's pen. Don't try to use black ball-point, you'll only end up smudging it. And if you are in any doubt at all about your proficiency with a pen, ask a qualified artist to do the job for you, or don't attempt it at all. Drawing four lines equidistant from a print, all of the same thickness and all meeting at an exact right angle, seems the simplest thing in the world . . . until you try it. If in doubt, leave it out.

White mounts are probably the most popular, with black coming a close second. Choose your mount to match the mood of the picture. Grey is fairly popular, but it needs exactly the right picture to make it work. More often than not, the colour gives the overall composition a drab, muddy appearance and destroys the effectiveness of the picture on account of it. Coloured mounts can be used with colour prints, providing the colours are chosen with care. The colour of the mount should always complement the picture, and it is best to stick to dark shades. A black mount suits a pale picture, but can work equally well with a dark-toned portrait, especially if a thin white line is drawn around it. Coloured mounts should rarely be used with black-and-white prints.

Another rule that can be broken, providing you do it for the right reason, is mounting the print off centre. If your picture is of an unconventional subject and you really think it warrants off-centre mounting, then try it. Think of the mount the way you thought of the picture area when you were first composing the photograph. Even here, the rule of thirds still works. So move your picture to the appropriate area of the mount, leaving maybe equal distances top and bottom, but with one-third space on one side to two-thirds space on the other. Or move it down as well so that there is a one-third/two-thirds ratio above and below the print as well as on each side. If you are going to do this and your picture indicates movement, mount it so that the larger of the spaces on either side is on the side of the print *into* which your subject appears to be moving. For example, if your subject is looking to the right, there should be more space on the right of the mount for him or her to 'look into'; mount the picture the other way round and the effect is immediately jarring. Again, if the subject warrants it, don't be afraid to stray from the traditional shape of mount. If your picture is long and narrow, use a similarly shaped mount. If the subject is off-beat, you can go for even stranger shapes like triangles. Or you can display a round or oval picture on a square or rectangular mount.

Most of what has been said above applies basically to conventional cardboard mounts. But prints can be mounted on other materials too. Wood is the most popular alternative, but one that should be reserved for flush-mounted pictures. Wood makes a good mount, but not a very suitable surround to a picture. You can mount on most wood-based boards in the conventional way, using dry mounting tissue or specialised adhesives. Also, you can buy commercial woodblocks made specially for the job. These are available in all standard printing-paper sizes, and comprise a block of wood with an adhesive coated on one side protected by a sheet of paper. The paper is pulled away and the print placed on the adhesive, pressing it down as the paper is carefully and completely removed. When the whole print is mounted, it can be trimmed with a sharp knife to cut off protruding edges. The back of the block can then be fitted with a stand or hanger for displaying the picture.

Framing and hanging
Framing is a lot like mounting, in so far as the same basic rule applies: make the frame complement the picture, not compete with it. Remember that the real subject, the reason for hanging it on the wall in the first place, is the photograph, or possibly the combination of photograph and mount. The frame is there only to hold it all together. So keep it simple. The days of the elaborate frame are dead.

Picture-frame mouldings plus glass can be bought in standard sizes and fitted together quickly and easily. When you buy a frame, however, buy one slightly larger than the print and then mount the picture within the frame. A print can look good flush-mounted on its own, but once a frame is added, it tends to need a little space around it, separating the margins of the print from the edges of the frame. In this instance, it is better not to fix the print directly on to the mount, but to mount it *behind* a sheet of card in which an aperture has been cut for the print to be seen through. The effect, when hung in a frame, is far more appealing than a print standing slightly proud of its mount.

Presentation is also about hanging frames in the right place, and the position isn't always dictated by aesthetics alone. Chemistry comes into it too. Colour prints tend to fade when left in the sun for long periods, so if you are hanging such a picture, avoid a wall on which the sun shines continuously. It's worth considering in advance that a picture to be hung in a shady part of a room might be worth making a little lighter than normal in the first place. Another tip is not to hang frames directly opposite windows, otherwise reflections in the glass will make it difficult to admire the picture. And don't be afraid to hang several prints together in a group. Four pictures arranged in a square of small frames can often have more effect than a single picture in one large frame.

Albums

Picture presentation has come a long way since the days of the family album with its row after row of snapshots, held in place by their corners, slipped into slots in the page. These days, presentation of prints can be arranged far more informally and given more effect on account of it. The two most popular forms of photo album now are the clear envelope type and the self-adhesive-page type.

The first of these consists of pages that are, in effect, clear acetate envelopes. In some, the envelopes are page size; in others, each page contains a number of separate envelopes into which several prints can be slipped. The latter type obviously caters only for a stock size of print, usually a standard enprint size, and because of its layout very little imagination can be used in design of the pages. The album that features page-size plastic envelopes is far better. These can be used to hold large prints the size of the page itself, or a sheet of thin card on to which several smaller prints have been mounted. This allows greater freedom of presentation. You can arrange prints in the way you want them in relation to each other, choose a suitable background colour for the mount, or change pages round as required. The pages are often bound on a loose-leaf principle, allowing

them to be detached and rearranged at will. You can even mix prints with slides, slipping in black card mounts with appropriate apertures cut out, through which the slides can be viewed.

The other type of album is even more versatile. Each page is coated with a permanently sticky adhesive and then covered with a sheet of clear plastic. The plastic is peeled back, the prints placed in position on the page, and the sheet replaced over the top. The prints are held firmly in whatever position you choose to place them, and can be easily viewed as the pages are turned. The prints are well protected and can be re-arranged when necessary, simply by peeling back the plastic, removing the print and replacing it with another.

Presenting slides

There are eight different ways that a slide can be viewed (upside down, back to front, etc.) and only one of them is correct. When presenting your transparencies, then, your first objective is to make sure your viewer sees them correctly, starting with the mounting. There are three types: card, plastic and glass. Card mounts are now dying out, though when you can get them they are still the cheapest and, in my opinion, the most convenient. The transparency is simply placed in position, the mount folded over it and the two sides pressed together for instant adhesion. They are simple to use and ideal for writing exposure details etc. directly on to the margin. Plastic mounts come next, in which the transparency is held in a more secure framework that keeps it from slipping. The mount is in two parts; one is pressed into the other and secured with a firm 'click'. Glass mounts are a variation on this, with the added protection of a sheet of ultra-thin glass built in to protect the transparency; more complicated aluminium and plastic versions have to be sealed in a mounting press. Out of the three, glass mounts protect your slides the best. But both slide and mount must be completely free from dust before mounting. They must also be dry, as the slightest drop of moisture will produce Newton's rings.

Once the slide is mounted, it must be spotted. It is the spot that tells the viewer which way round to look at the picture, so it is most important to get it right. The spot, which can take the form of a special self-adhesive disc of paper or can equally easily be drawn in with a pen or pencil, should be in the bottom left-hand corner when the slide is viewed correctly. That way, when it comes to be projected, the spot will fall in the top right-hand corner and naturally between the fingers of the projectionist as he slips it into place. If slides are to be projected, they can be kept either in slide boxes, ready for projection on a manual projector, or loaded into magazines ready for showing on an automatic type.

For the photographer who wants to keep his slides on file for possible publication or to show his work to potential customers, there are a number of neat methods that combine tidy storage with an ease of effective presentation. These take the form of plastic storage wallets of around 40×25 cm in size. Each has a set number of pockets to accept mounted slides, some have diffused plastic backs to make viewing easier, and a few have a second plastic oversheet that covers the whole thing, adding extra protection. The number of slides held in the sheet varies with the size of the transparency. An average-size sheet might take twenty 35 mm slides, twelve 6×6 cm, nine 6×9 cm, four 5×4 inch or two 7×5 inch. Some sheets are made to fit into their own ring binders and so present the slides in album form, others are made with metal bars to fit a standard filing cabinet.

A variation on the same idea, but one that gives a rather better form of presentation, comes in the shape of a selection of professional slide-display products. These are made from stiff black card with suitably sized apertures cut away, the shapes and sizes varying to suit all the standard formats. Card-mounted slides can be slipped into the back of the sheet and the whole thing encased in a clear acetate envelope. When viewed, only the pictures themselves can be seen against a black surround. A similar idea is also produced for single slides from

35 mm up, which slot into small sheets of 5×4 inch card, each of which in turn fits into its own plastic envelope. Using only one for each transparency is something of a luxury, but it makes the very best of your work. If you are out to sell your pictures, presentation is a major part of the battle.

Projecting slides

It is very difficult to devote an entire slide show to portraiture. There is a vast difference between a single portrait viewed on its own and a whole sequence of them projected one after another at a captive audience. It is better, then, to make portraiture a section within a larger and more varied show. The trick is to keep the slides as varied as possible. If you have a set of six similar pictures, all of which you consider to be good, be strict with yourself and pick out the one slide that is the best of the bunch. It will have far more impact that way. The best show is one that is made up from a varied selection of pictures, all shot with different models, at different times, under different conditions. That will keep things far more interesting for the audience.

When putting the show together, keep similarly toned slides next to each other. Don't jump from a high-key subject to a low-key picture and back again, because the sudden appearance of a light screen after a relatively dark one hurts the eyes, and you are there to entertain your audience, not to irritate them. During the course of the show, vary the angles of the portraits continuously, interspersing close-ups with full-length and three-quarter-length shots. Keep the show varied and keep it short. The best slide show is the one that leaves the audience wanting more, not wishing it had all ended ten minutes before.

Presentation to clients

In the next chapter I shall discuss ways to sell your pictures, but there is more to a sale than merely taking a picture and finding a market. Even when you have done both those things, there is still

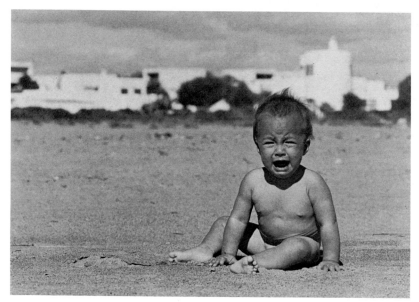

It's not the sort of picture that a proud parent would want in a frame on the wall, but it is the sort of picture that you can quite easily sell when you know your market. *Graham McEune.*

and bottom with two sheets of *stiff* card. Better still, use a wood-based board, although it must be admitted that this does tend to make the parcel rather heavy and therefore expensive to post. You'll have to weigh the cost of that against the value you put on the prints and how much they might be making you if someone wanted to buy them. Once the package is securely sealed, buy some *Photographs Do Not Bend* labels. Stick one in the top left-hand corner of the envelope and another on the back. Again, don't stint. Warn everyone what's in the package.

Transparencies are best presented to a prospective client in the black professional display sleeves mentioned earlier. Second only to those are the transparent storage wallets also mentioned. Remember that if you are showing your work to someone whom you hope to interest in a sale, it's to your advantage to give the customer the easiest way of looking at, and comparing, a selection of slides. An editor, for instance, who might be looking at your work with a view to using some of it in his magazine, won't want to stop to look at each slide individually. He will want to see a good selection at a glance, to get a general idea of the quality and subject matter before looking at things in more detail. When sending slides through the post, steer clear of glass mounts; they crack too easily. If you are sending your work to a market for possible publication, use only card or plastic mounts. The process involved in printing a colour transparency necessitates the printer removing it from its mount, and he will want the easiest way of doing so. Glass mounts only make his life more difficult.

something that will help give your pictures a greater chance of success: the way you present your work. If you are selling prints, or even giving them away, cardboard folders will do a lot for the presentation. They can be bought relatively cheaply from photographic suppliers and overprinted with your name to help publicise your work. The folder opens like a book, and the print is secured either by the corners or by slipping it into an inner sleeve with an aperture for the print to be seen. This latter type might be slightly more expensive but is better for the job, especially since you can buy them with a variety of differently shaped apertures. An oval, for instance, would be ideal for one of those old-time sepia portraits discussed earlier.

If you are sending prints through the mail, don't skimp on the packing. It might cost just that little extra, but it will be worthwhile in the end. There is nothing worse than a tatty, dog-eared print: if you send yours by mail with no form of stiffening in the envelope, that's just how they will arrive. Pick an envelope that is slightly larger than the print or prints that you wish to send, and pack them top

Presentation of the final product is every bit as important as the technique that went into taking the pictures in the first place. First impressions count, and your presentation is the first thing that anyone sees of your work even before they look at the actual pictures. It says a lot about you and, by definition, says much about your photography too. So take the time to do the job properly. Never ruin a good picture by poor presentation.

John Le Bas

150

Portraiture for profit

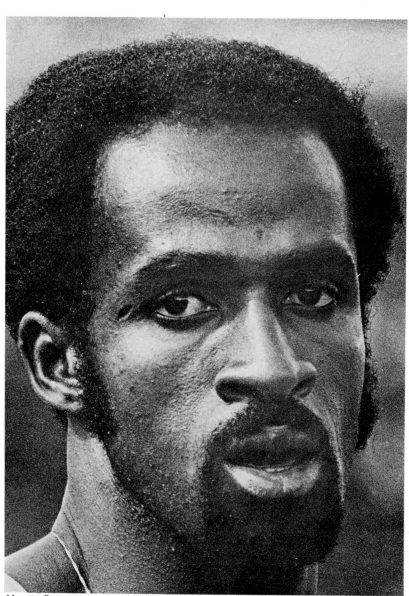

Mervyn Rees

Anyone who makes money out of portraiture (or, for that matter, any other type of photography) has first a moral obligation to the customer. As a photographer, you should know what good quality is. The customer, as often as not, doesn't. The result is a lot of mediocre photographers, both amateur and professional, turning out bad work for people who pay up because they don't know any better. Before you even consider making money from your portraiture, then, make sure your work is of a professional quality. Having done that, charge an economic fee that will compensate you for your time and materials.

Largely speaking, there are two areas in which you will sell portraiture: direct sale of prints to people who want photographs of themselves, friends or family, and markets that will print your work for their own use, paying you a reproduction fee for the picture. Those markets can then be further divided into many variations on the two themes. If you are out to sell pictures to the public, consider first whether you want them to come to you or whether you want to visit their homes with a mobile studio. Do you want to concentrate on adults or children? Each has its own merits and pitfalls. On the publications side, there are obvious markets like newspapers and magazines, but there are other publications too that you might not have considered, like greetings cards, calendars or travel brochures. And, in a different section of the same field, there are photographic contests. Each market has its own particular needs. Once you've learnt those needs, and given that you are a competent photographer,there is no reason why you shouldn't start making money from your pictures.

Selling to the public
Your first objective is to let your prospective customers know you are available. Once you start

151

taking pictures and have a few satisfied customers to your credit, the word will spread. But to get started, you have to advertise. An advertisement in your local newspaper is inexpensive and a good way to reach a lot of people in a concentrated area. You need only a small display advertisement, about five centimetres deep by one column width. Keep the wording to a minimum, describing simply what you are offering (family portraits, children etc.) and adding your phone number. Keep it simple and to the point and run the advertisement for a few months. It won't be long before your phone starts ringing. Another fairly inexpensive way to advertise is to have some handbills printed, and then have these distributed around large residential areas. Choose the areas that house a lot of young families and you should pick up work from mothers wanting their children photographed. Such customers are very useful, since you can often take two types of pictures in one session: you can take the picture the parents want for their family album and, with their permission, you can also take pictures for your own files for sale to various publications. Of which more in a moment.

You can operate in one of two ways: from your studio or with a mobile studio; the latter is better, being more versatile and thus encouraging more sales. If you decide to work from a fixed studio, everything you need to know about setting it up has been said on pages 63–65. A travelling studio is slightly different. The equipment you use will be the best compromise between your basic requirements and your restrictions. Look at things from your customer's viewpoint. You are a stranger walking into their house with a lot of strange equipment. Spend half an hour unloading gear and erecting it in the lounge and you will generate a feeling of tension. Your subject will start to feel nervous, and that isn't going to help you get good pictures. Apart from that, you don't want the inconvenience of carrying and erecting a lot of equipment. Studio flash is the most convenient type of lighting. Two heads with brollies and perhaps a diffuser are the most you will need, and for simple, straightforward

portraiture, you can even make do with one flash and a brolly placed just behind and very slightly to one side of the camera. It results in fairly unimaginative lighting, but it provides much of what you need for a simple, no-nonsense portrait aimed at this kind of market.

One piece of equipment that is important for the travelling portrait photographer is a portable background. Working in the confines of a private house, you will rarely find a suitable background and need to carry your own to block out the inevitable domestic scene that will fall awkwardly behind your sitter. Rolls of coloured background paper and the stands necessary to support them are totally impractical in the circumstances. Material such as sheets and tablecloths might seem the ideal solution, until you come to fold them for transport and then unfold them on location. Creases are inevitable and a distraction behind your model. Curtains already in the room are an obvious temptation, but one that should be avoided. The folds they naturally fall into make an impractical background. A small roll of felt is a possible solution: it needs to be no more than a metre wide for the average head-and-shoulders shot, it rolls easily and unrolls without creases. Carry two if you have the space, a roll of black and another of a lighter colour. If you have room for only one, go for black. It's the closest you'll get to a universal background colour; it goes with just about any shade of clothing your model might wear and it always looks smart in the finished print. Also you don't have to light it, and that's a definite bonus when you are travelling with the very minimum of equipment. A folding projection screen is another useful accessory. It can be used to support a background, or as a background itself, and doubles as a handy reflector.

When you arrive at your customer's house, be efficient, cool and calm. Put them at their ease. Bring in your equipment and erect it quickly and methodically. The photographer who is forever tripping over wires and the like will only make his

You don't need a fixed studio to take professional portraits. One like this can be taken in the subject's home with just a piece of black felt as background and, in this case, three flashguns. *Kevin MacDonnell.*

subject nervous and so lead to bad pictures. Clear the largest space possible and hang your background. Find a suitable seat for your model, erect your lighting and begin taking your pictures. Keep the session brief (time is money) and exude confidence throughout.

Finally, a piece of advice that has nothing to do with photography, but has everything to do with being a good businessman. Don't keep your customers waiting for their pictures. Return as early as possible, while the session is still fresh in their minds. Take a set of proofs and offer to leave them to show friends and relatives so that they can sort out their actual order in private. Call back or phone for the order, and deliver the complete job with your invoice as soon as possible. The more efficient your service, the more you'll find yourself being recommended, and that's the best form of advertising there is.

Neighbourhood theatres and amateur dramatic groups can also provide fairly easy sales. Ask permission to go along to a dress rehearsal and shoot by available stage light as the action of the play progresses. With a good set of prints ready to show around, you can be pretty sure of sales both to members of the cast and to the management of the theatre for front-of-house stills. For the latter, it almost goes without saying that you should take your pictures as early as possible in the rehearsal period and get back to the theatre manager well before opening night.

Schools are another possible target for the freelance portrait photographer. Find a friendly neighbour with some children of school age, take some pictures, then do a tour of local head teachers, showing them your work and asking permission to come along one morning to photograph their pupils. You have only to consider the number of children in the average school, and multiply that by the number of pictures that each set of parents is likely to order, to get some idea of just how lucrative this branch of freelance photography can

be. But there are plenty of well-established schools photographers, so opportunities are likely to be limited in large towns.

When you come to advertise yourself for any of these potential markets, it's not a bad idea to make a special offer or two: four prints for the price of three maybe, or perhaps one free 10×8 inch (25×20 cm) print with each order of several of a smaller size. Almost invariably the demand will be for colour prints. A very few might want black-and-white, but hardly anyone will be in the market for transparencies.

Selling to local newspapers

Local newspapers are not especially lucrative to the freelance photographer and have little need for portraiture as such. What you must remember is that they all employ their own staff photographers and they are not going to pay you for one of your pictures when they could get the same shot taken by a staff man that they have to pay anyway. So shooting local personalities and sending their portraits to the paper is not going to make you any money. To get a picture published you have to take a shot that is unique and cannot be repeated by a staff man. An important factor that restricts the local newspaper photographer is distance. He will rarely stray far out of his own district to get a picture, and that's where you can score over him by photographing local people away from home. Notice the emphasis on the word *local*, because that's what local newspapers are all about: local people at home in the paper's area, or local people who have been involved in some newsworthy event elsewhere. The Local Boy Makes Good story is one they never tire of running. If you can provide a picture of the local boy (or girl) that they might not otherwise have access to, you're on your way to making a sale.

It's best, then, to forget your *own* local newspaper and to look for people whose home is outside your own paper's area. That could mean the other end of the country, or it could be as close as the next town.

When it comes to travelling expenses, it's surprising how ready editors are to draw boundaries around their areas and forbid their staff to cross them. Obvious targets are events in the public eye: talent shows, baby shows, beauty contests, military displays, anything in which people are doing things that are newsworthy, the sort of thing you might be interested in reading about in your own local paper.

Pictures can be taken using the 'unposed pose' discussed on page 57. But having taken a few 'grab' shots, try to get your subject alone for a few more formal poses. After that, get some details for a caption. You don't have to be a writer, just remember six words that will guide you towards the right sort of questions: who, what, where, when, how and why? *Who* is the most important, and the answers to that particular question should include name, address, daytime telephone number if possible, and age. Once you have those details, a staff reporter on the paper can fill in any information you might have missed.

Having taken your pictures, you still have some way to go before you make a sale. The next thing you must do is approach the paper concerned. The person you have photographed will more than likely know the name of their local newspaper. If not, you can get details of the paper's name, address, phone number etc. from one of the press directories that are published for the use of advertisers. (In the UK *British Rate and Data*, known as BRAD, is the obvious one.) There should be a copy in your local library. If not, your own local newspaper might let you see the copy in their advertisement department if you ask them nicely.

Get the phone number of the appropriate paper and telephone the news editor. Few local papers will have the luxury of a separate picture editor and, although they *will* have a photographic department, the decision as to what is and is not published will rest with the news editor, not the paper's photographers. Don't write, it wastes too much time. Even local newspapers that are published weekly have daily deadlines, and the more time you can save, the better your chances of a sale. Tell the news editor what you've got. If he is interested, he'll tell you to send it to him, probably on spec. Once you have got that far, speed is of the essence. Develop and print your picture (black-and-white only) and get it to the newspaper as fast as possible. The ideal size is 10×8 inches (25×20 cm). If the office is nearby, take it yourself. If not, post it first class on the day you speak to the news editor, so that it is on his desk the next morning while still fresh in his mind.

A couple of final tips about local newspapers. First, if what you're trying to sell is basically a feature item like the winner of a beauty contest or baby show, rather than hard news (and most of your particular market *will* be feature material, since hard news pictures are not likely to come under the heading of portraiture), try to arrange your approach on their press day. That's the day the paper appears on the streets. Press day, be it a Monday, Wednesday or Friday, is the start of the paper's week. They won't be looking for hard news stories until the end of their week, a matter of two or three days before the next press day. So at this time, they are scratching around for timeless feature material that won't be dated seven days later. Your work comes into that category and that's when it will stand the best chance of success.

The second tip concerns payment. Local papers rarely have a large freelance budget to play with, so they might not be too eager when it comes to paying you. Also, most local newspaper offices are chaotic. Once your picture has entered their system, they could easily lose any attached details about you, including the name and address to which payment should be sent. The answer is to wait until the paper comes out and then send an invoice straight away, addressed to the editor and asking a modest but competitive fee. Such an action will nearly always produce a cheque. If after a month you haven't received your fee, send a reminder. If that fails, start complaining to the editor.

Selling to mass-circulation newspapers

Don't be under any illusions, the major newspapers are difficult to break into. But don't be discouraged. It can be done. Apart from news pictures, four subjects are reputed to sell best to this market: royalty, animals, children and glamour. As a portrait photographer, you are primarily concerned with the last two, and out of those, you only stand a real chance of selling one. Glamour, although one of the more difficult forms of photography, is probably one of the few outlets for the portrait photograph in large-circulation papers. Just as with local newspapers, you have to beat the staff man for your pictures to make a sale. Many newspapers have their own specialist photographers and even their own favourite models for this particular type of picture, but there is still room for the good freelance to break in.

Market research is all important. Don't just shoot glamour pictures and hope to sell them to one of the papers. Instead, pick one particular paper, buy it every day for a week and study their style. Once you know the sort of pictures they use, you will be ready to submit. There are a few general points, however, that apply to all the major popular newspapers. Obviously, they are in the market only for black-and-white prints, which should be printed on glossy paper and be as large as possible. Most of the work their staff men produce for consideration will have been printed at least 15×12 inches (38×30 cm), and you have to compete with that. Reproduction is another point to consider. It might look good in the paper, but it's bad compared to the original print. With that thought in mind, pictures should be kept as simple as possible. Backgrounds, both in studio shots and outdoor location pictures, must be plain. Lighting is simple. This not the market for soft and subtle techniques. Keep it straightforward with no extraneous detail.

Poses also conform to a certain style. The girls must look glamorous but not offensive, sexy but smiling. Remember the pictures are meant for a mass family readership. The whole thing is something of a

Left: glamour shots like this can be sold to national newspapers if you learn and apply the rules. Girls should be sexy without being too provocative. *Ralph Medland.*

Right: when shooting a portrait as a prospective magazine cover, there is more to consider than the pose. Space must be left for the magazine's title and coverlines.

$2·50 U.S. & Canada **March 1980 55p**

PHOTOGRAPHY

FLASH
TECHNIQUES
**INDOORS
AND OUT**

INSTANT
PICTURES
**LIKE YOU'VE
NEVER
SEEN BEFORE**

**COLOUR
PRINTING
MADE EASY**

**KONICA
FS-1** AND
**YASHICA
FX-3**
ON TEST

contradiction in terms, and might be considered to be somewhat hypocritical. But that's the market. If you can produce the goods and beat the staff men, you stand a good chance of seeing your pictures in print. The paper will want a few details about the girl: name, age, interests, but little else; so supply these along with your pictures. Your point of contact is the picture editor, and he will want to see a selection from which to make his own choice.

Selling to magazines

For the portrait photographer trying to sell his pictures, magazines present a far better market than newspapers. They have three main outlets for your work: covers, one-off pictures and illustrations to articles. You have only to walk into any newsagents to see the potential in cover pictures. The vast majority of magazines use people on their covers, and that means portraits. Once again, market

research is essential. Don't just shoot portraits, then look around for a market. Choose a particular magazine and study its requirements over a period of several issues. Once you start to look at magazines in this way, you'll be surprised just how much each one conforms to its own individual style. One might go for head-and-shoulders shots only, another for three-quarter-length portraits. I can think of one British women's magazine that has exactly the same pose every month: square on to the camera, face cropped near the top of the frame, just a hint of cleavage. Only the model changes.

When you come to shoot pictures for this type of market, pay particular attention to the way the cover of your chosen magazine is designed. Apart from the picture itself, covers also carry the name of the magazine; most of them also use coverlines, the words that tell readers what's inside that week or month. Shooting for a possible cover therefore means leaving the right amount of space around your subject to allow for the design. Always shoot with some space above your subject's head to allow for the title, if that's the style, and leave space down each side for the coverlines. If your composition demands that you have space only down one side, arrange your picture so that space falls on the left. With so many magazines stacked on top of each other in the newsagents, the left side of the cover is often the only part visible to the passing public, and so that's the side they put their coverlines. When you are shooting covers, you must of course use colour and, despite the widespread acceptance of 35 mm these days, you will undoubtedly achieve far more success if you make 6×6 cm your minimum format.

Women's magazines are the biggest market, ranging as they do from the upmarket glossies to the teenage romance magazines, taking in on the way slimming magazines, hairstyle magazines, fashion magazines, wedding magazines, cookery magazines . . . anything and everything that appeals to women. The vast majority of them use a form of portraiture (usually women, sometimes

men, and often a man and a woman together) on their covers. Mother-and-baby magazines, as well as using the 'young mum' type of subject, also use children or mothers with children.

The second market within magazines is for the one-off picture, shots that can be kept on file to illustrate features or to be used merely as fillers. The main requirement is for black-and-white prints, although you might find a limited demand for colour. The trick is to photograph your subject actually doing something rather than just looking at the camera. That way, your picture might be used as a filler, but one that has an often tenuous link with the feature running beside it. Children make good subjects for this particular market, and pictures can be sold not only to the general-interest women's magazines but also to magazines aimed at parents, families in general, mothers in particular, nurseries, education etc. Action shots sell best. Shoot the children engaged in some form of activity: at play, day-to-day routine subjects such as feeding, learning to walk, nappy changing, looking happy, sad, angry, even crying. These markets don't want the pretty-pretty pictures you shot for loving parents to put into family albums; they want pictures of children the way they really are. Those are the pictures I mentioned earlier in this chapter when I said you can shoot two distinct types of picture in one session, one set for the parents and one set for your files. But please, if you are going to do this, tell the parents what you are planning. If they don't know and they suddenly come across a picture of their little precious bawling his eyes out in a national magazine, they could have good reason to be angry with you. Ask permission, and invariably they will be pleased to let you go ahead.

Character studies also have potential for this particular market. Faces in a crowd, especially on trips abroad, are worth looking out for. Peasants, traders, people in national costume can all make salable pictures. They are the sort of subjects that you photograph candidly to begin with, but don't worry about being found out. Sometimes,

especially in the case of subjects such as market traders, the almost forced look of the inexperienced pose can work tremendously well. The man selling fruit, for instance, who is proud of his merchandise, will register his pride in a picture. Don't forget, however, that your photography can be considered a form of intrusion, so never insist if a subject is unwilling to have his picture taken. In that respect, the offer of a small payment goes a long way. It need mean no more than buying some of the subject's wares or offering him a drink or cigarette. The price is small compared to the return you could make from publication. Be careful, though, in your choice of picture. It's wrong in both the ethical and legal sense to publish without permission pictures that could be seen as defaming or ridiculing the subject. Remember that in many countries you are open to legal action if you use an image of a person for commercial purposes without permission.

Another type of one-off portrait is the romantic situation picture that will sell to what are known in the trade as confession magazines. These are the romantic-fiction ones that are sold primarily to girls between the ages of sixteen and twenty-five, and until you start researching you'll never believe how many there are. Numerous weeklies and monthlies are sold, all of which use as many as eight stories per issue. The stories are termed 'true life' because they are supposedly true to life, *not* because they are true stories. They are all fiction and all written by freelance writers and, contrary to what many of the readers seem to believe, the people in the photographs are not the real heroes and heroines of the stories with which they are associated. So the magazines need files of pictures. They need to be pretty standard pictures that will fit several situations. For instance, a picture of a girl and a boy talking earnestly could be used to illustrate a love story in which the boy is supposedly telling the girl how much he loves her. On the other hand, that same picture could be depicting the boy telling the girl he has to go away or that he has found someone else. It could even be showing the girl telling her boyfriend that she is

pregnant! The pictures, then, have to be *situation* pictures: girl with boy, girl with mother, girl with father, girl reading letter and reacting with joy, girl reading letter and reacting with anguish . . . the list goes on and on. Once you have studied a few of the magazines, you'll see what is needed. Try a few similar ideas plus some new ones of your own, and you could find another market for your portraits.

The third possible market for your pictures in magazines is as illustrations for specially written features. Magazines primarily buy words more than pictures, but those words need illustrating, and freelance writers recognise that illustrated features sell better than pages of text without a picture. Despite that fact, very few writers use cameras themselves, preferring to work with a photographer. So, to sell in this field, first find a writer. All over the country, there are writing circles where amateur and sometimes professional writers meet to discuss their work. Find the one nearest to you, go along and volunteer your services. Alternatively, advertise yourself in a magazine read by freelance writers and journalists. (In Britain they read *UK Press Gazette* and sometimes *Campaign*. In the United States, you could try *Writers' Digest*.)

Once you have found a writer, you can begin to discuss how you can help each other. The freelance who is selling to magazines is invariably writing a human-interest story, an article with a group of people or some specific person at its core. People mean portraiture, and that's where you come in. The alternative of course is to write the article yourself. If you feel you can do that, then by all means try. But if you don't feel confident, work with someone else. The art of feature writing can be learnt, but it needs a book of its own to teach the tricks of the trade. So if photography is your main interest, work with an experienced writer. Your biggest market here will be for monochrome prints.

Whatever you are submitting to a magazine, be it pictures for possible cover use, one-off shots or illustrated articles, always submit direct to the editor. If you find a magazine that uses colour and black-and-white, don't be tempted to use colour for the sake of it. Colour pages in most magazines are limited and you will always have a better chance of selling black-and-white than you will colour. The exception of course is for covers. Present your work cleanly and tidily, with a simple, no-nonsense letter asking for your pictures to be considered at normal rates and enclosing a stamped addressed envelope for their return should they prove unsuitable. Don't fill the covering letter with details about your work. The editor doesn't want to know and won't have time to read it all. Whatever you have to say should be said in the pictures, their captions or the feature that accompanies them. The chance of a sale will stand or fall by that alone, not by your explanation of how difficult it might have been to secure the pictures. If you *are* submitting colour, send transparencies rather than prints. For reproduction, colours must be well saturated. That means getting your exposures deadly accurate, or even one-third to half a stop underexposed. Never send transparencies that are even slightly overexposed. A printer can usually get an image from a dense slide, but he can't put back what has been washed out by overexposure.

Selling to the photo press
As a photographer, there is probably one type of magazine that appeals to you more than any other, and one that is therefore worth a few words on its own. I'm talking about the photo press, magazines that sell primarily to photographic enthusiasts. A few years ago, photographic magazines were full of pictures. A feature would consist of around half-a-dozen pages with a single picture on each, coupled with the minimum of words, a profile of the photographer concerned, a description of why he took the pictures, his philosophy of life perhaps, and little more. In fact, nothing on how he took the pictures, or the techniques he used to achieve certain effects. Today, things are different. With few exceptions, photographic magazines are now much more concerned with technique. In general

they are aimed at amateur rather than professional photographers, and among those readers there is a tremendous thirst for knowledge. When they look at an interesting picture, they don't want to know *why* the photographer took it, but *how*.

Photographic magazines may all look alike at first glance but, just like other types of magazine mentioned earlier, they each have their own individual style. There is still a limited market for the picture portfolio, but the vast majority use mainly articles with a 'how to do it' type of theme. As with other magazines, you have three basic markets: covers, one-off pictures and illustrated articles. Photo magazines nearly all feature pretty girls on their covers and so are a prime target for the portrait photographer. Invariably, however, the editor is looking for something just that little extra: an interesting or clever photograph that will appeal to the amateur photographer irrespective of the subject itself. The something extra could be a different type of lighting, or some special effect, or maybe even a powerful male portrait. The point of the cover is, more often than not, the photograph or its treatment rather than the model.

Inside, the magazine will be looking for technique articles and pictures. If you're sending one-off pictures for their files, they will want to see pictures that have a point to make. There is a place for a well lit, perfectly posed portrait, but there is an even better place for a badly lit portrait, together with its correctly lit counterpart, or a series of pictures taken along the way to lighting a portrait that show the effect of each individual light on a face. For this particular market, the final effect isn't as salable as the steps that lead to the effect. The same goes for pictures taken, say, with different lenses. The best portrait might be the one taken with a 135 mm, but the best illustration is a set of pictures taken with 28 mm, 50 mm and 135 mm lenses, showing how perspective is distorted with the wrong lenses and how it is corrected with the right one. Special-effect pictures (soft focus, double exposures, etc.) can present another potential sale.

Don't just show the effect, show two pictures that illustrate your model *with* and *without* the use of that effect.

Combining your illustrations with someone else's writing is only an extension of that philosophy. Find a suitable theme, take the pictures, explain how they were taken to your writer friend, and get him to turn it all into a feature. What sort of themes can the portrait photographer sell to the photo press? If you have read this far, you should have at least eleven ideas already, namely the eleven previous chapters in this book, each of which would in itself make a single feature for a photographic magazine.

Greetings cards and calendars

These two markets, though quite different in their final product, are very similar in their photographic requirements. Hence the reason for combining them here. The keyword for both markets is quality. Each buys only top-class colour transparencies, and each prefers to deal with the largest possible format. Very occasionally, 35 mm might be used if the quality is exceptional; that means using only the best lenses, getting both exposure and focusing one-hundred-per-cent accurate and, in general, shooting only on Kodachrome 25, a film that is universally recognised for its highly individual quality. On the whole, however, you stand far more chance of success if you consider 6 × 6 cm as your absolute minimum format. If you can beg, borrow or buy a 5 × 4 inch camera, so much the better, because that's the format that most companies in this field regard as standard.

Pictures of children sell well to the greetings-card trade. A vertical format is almost essential, and space should be left for the company to overprint their greeting. The pictures should show children (whose ages should be no more than about fourteen) engaged in some activity. Pictures should be extra colourful. If the sky is shown, it should be blue. Depth of field should be at its very maximum.

Despite the fact that a few card manufacturers use special-effect or soft-focus glamorous pictures, the vast majority still go for the straight and, it has to be admitted, corny picture. Just as with magazines, market research can do more good than a thousand words written on the subject. So go into your local card shop and take a good look at what is being sold. For calendars, girls are still a popular subject; despite the fact that there are a lot of glamour calendars about, there is still a market for the 'pretty portrait' type of shot. Once again, the colourful, straightforward picture sells best.

To win photo contests, think of an idea, then take it one step further. This unusual portrait won a contest in *Photography* magazine. *Graham Whistler.*

Photographic contests

Many photographers, intent on getting their pictures published for a fee, often ignore the humble photo contest. And yet here is a market that is organised specifically for pictures, and one that pays in prizes far more than a reproduction fee ever would. There are photo contests everywhere, many offering prizes that range from expensive photographic equipment to luxury holidays, others offering cash. The photographic magazines are obvious sources. But there are many other specialist publications: from motorbikes to gardens, there is a magazine for every interest, and many of them run photo contests. Airline companies, film companies, even breakfast-food manufacturers, all run photo contests. Most, even those with set themes that might not at first seem to tie in with portraiture, can be won by the serious portrait photographer. It's the inclusion of a person in a picture that can so often make it a winner. What's more, the average photographer is rarely very good at picturing people, so the knowledge you now have should put you in an even better position to win.

Although a lot of people enter photo contests, it's a sad fact that few of their pictures are even average, either in quality or in the imagination used to take them. Most are pretty mediocre, but a few will be exceptional. It's that exceptional few that you have to beat of course, but bear in mind that they *are* only a very small percentage of the total entry. If you have any sort of an eye for a picture, and if you are a specialist in any one type, such as portraiture, you are in with a very good chance. That chance increases if you stick to contests aimed at the public in general, rather than photographers in particular. There are instances of serious, but amateur, photographers who have won three hundred prizes in ten years and yet rarely enter a contest organised by a photographic magazine.

If you want to win a contest, first read the rules and stick to them. It's amazing how many people fail to do that simple thing. If the organisers say they don't want prints larger than 10 × 8 inches (25 × 20 cm),

161

you may be sure that they have a good reason, so don't submit anything larger. If the closing date is the last day of June, don't think they'll stretch it to the first day of July for you.

Appreciating what goes on behind the scenes when a contest is judged will help you win. Because there will be a very large volume of pictures entered, none will be looked at very closely the first time round; so to get your picture considered seriously in that first round you must stop the judge. Do that by giving him quality and size. Produce the very best print quality and print it to the maximum size allowed by the rules. That goes for transparencies too. Keep exposures correct and, if you can, go for a format larger than 35 mm. The vast majority of entries will be 35 mm, and if yours is larger it will stop the judge. Those two things alone can be enough to get your picture shortlisted. To get it considered even further and placed in the short-shortlist, try your best to be original. If the contest has a set theme, think of a portrait version of that theme; but then try to take it one step further, because in all probability your first idea is the obvious one that others might also be trying.

At the end of the day, of course, it is the personal preferences of the judge or judges that will decide the winner, and all the experience in the world won't tell you what those preferences are, unless you happen to know the judge. But, even at this late stage, when the judge is down to maybe no more than a dozen entries, there are still reasons why the pictures that are finally rejected will fail. The black-and-white pictures will fail through bad print quality. The colour prints will fail because they are either good subjects badly printed or bad subjects well printed. The colour slides will fail because they lack that extra bit of sparkle, both technically and in the subject matter. Despite all this, however, they *will* be good pictures. Good, but not great. No one can really tell you how to make your pictures great, but knowing the failings of others will help push yours just that fraction past theirs. And it is that fraction that will win you the contest.

Using an agent

There is a lot to be said for using a picture agent, and there is just about as much to be said against it. On the plus side, you have the fact that he has the contacts to make sales that you might never have dreamed of. Apart from all the markets we have already listed, he might get your pictures used for book illustrations, travel brochures, record sleeves, jigsaw puzzles, advertising . . . even chocolate boxes. These are the markets that don't wait around for pictures to be sent to them. Instead, they know exactly what they need and go to an agent who they know can supply the right material.

On the minus side is the fact that the agent takes up to fifty per cent of your fee. On the other hand, if he makes two or three sales from the same picture, where you might only have made one or none at all, he earns his keep. Another minus is the length of time for which your pictures are tied up. Many agents demand that, once you have submitted pictures for them to sell, you must leave them on file for anything between two and five years, sometimes longer. Also, if you are a newcomer to an agency, you must have a good selection of work to begin with. Many agents won't even consider looking at less than 300 pictures first time from a new contributor. Some want even more, and most agents expect a continual flow of new pictures from the photographer once the initial set has been put on file.

If you decide to use an agent, you must first find one that is suitable to your chosen subject. Different agents specialise in different subjects, and it would be useless to submit 300 portraits to an agency that handles only wildlife. Having found your agency, write in the first instance, telling them what you have in mind. If they are interested, go along and see them with your material. Never try to outdo your own agent: if you have duplicates of some of the pictures he has on file, don't sell them under your own steam. That will only put you in his bad books and will eventually defeat the object of using him in the first place. And don't think of an

agent as a place to send all your unwanted or otherwise rejected material. If you have decided to use him, do the job properly. Send him your best work. He's not a miracle worker; even the best agent can't sell bad pictures.

The rights to sell

Whenever you come to sell your work, always make sure that you retain the copyright. Never sell it outright, unless you are actually being offered some earth-shattering fee for doing so. What you should be selling to most markets is One Time Reproduction Rights. That means they pay for publishing a particular picture once, and you then have the right to offer the same picture for publication elsewhere. So, theoretically, you can offer the same picture to several similar markets at the same time. In practice, you would be extremely ill-advised to do so. Such behaviour gets you a bad reputation, and bad reputations soon spread, cutting off your chances of further sales. So offer your picture to one market at a time. If it sells to, say, a women's magazine, don't offer it to another women's magazine for a year or so. On the other hand, there is no reason why you shouldn't offer it fairly soon to a completely different market, such as a greetings-card company.

Watch out for the copyright rule in photo contests. There are companies who launch contests chiefly to get cheap pictures for their own use. If there is a rule that says, in effect, *all entries become the property of Brand X Trading Company*, avoid the contest at all costs. The reason is simple. Let's say, for instance, that a baby-food company is running a baby-picture contest with a fabulous top prize. The company might get around 5000 entries, of which 4950 are no good. But, with that offending rule in operation, that leaves them fifty pictures that could be of use to them in advertisements, illustrations on packets of baby food, promotional leaflets etc., without any fee needing to be paid to the photographer. The company may have seemed generous in giving away a valuable prize in the first place, but its cost will have been covered a hundred times over by not having to pay photographers or agencies for the use of the pictures. Maybe the photographer who won the prize is happy to relinquish his copyright in the circumstances, but that still leaves a lot of other photographers who have lost their pictures and who will be losing money on account of it.

Where to find the markets

So far, we have covered what markets are available and how to interest them in your pictures. All that remains is to find out where to find those markets. Newspapers and magazines are easy to trace. They all have their addresses in their imprints. That's the small type that appears at the very bottom of the back page of a newspaper or usually on the contents page of a magazine. When you come to look for it, you'll probably find other addresses there too: sometimes the printer's name and address, and often, if it is different from the editorial, the advertisement department's address. What you want is the editorial address or the one that refers to the publisher.

Other markets such as greetings-card and calendar publishers and the like, as well as picture agencies, are harder to find, since you probably won't know the name of any company you are after in the first place. For that, you need some sort of guide. In Britain there is the *Writers' and Artists' Year Book*; in it you'll find the names, addresses and requirements of all British magazines and newspapers, many foreign publications, book publishers, greetings-card, postcard and calendar companies, picture agencies etc. The book is published annually by A. & C. Black of 35 Bedford Row, London WC1R 4JH, and it is truly invaluable to both the freelance writer and photographer. Also in Britain, you'll find the Bureau of Freelance Photographers, an organisation that publishes a monthly news sheet of markets for pictures, plus regular survey specials that concentrate on particular fields such as glamour, calendars, greetings cards and agents. The BFP is at Focus House, 497 Green Lanes, London N13 4BP.

Rudy Lewis

Glossary

Aberration Any deviation from optical perfection in a lens.

Ambient light Surrounding light, as opposed to that from any special light source.

Aperture A variable diaphragm behind or between the elements of a lens, adjustable to control the amount of light reaching the film. The size of the opening is expressed in *f*-stops, each of which allows through twice or half the light of its neighbour.

ASA American Standards Association. A scale on which the speed, or sensitivity, of film is measured.

Axis Straight line from the centre of a lens, out towards the subject, at 90 degrees to the camera.

Back projection The projection of a slide from the rear on to a translucent screen behind the subject in such a way that the model appears to be combined with the projected picture.

Ball-and-socket head A device fitted to the base of a camera and attached to a tripod or clamp, designed to allow the camera to pan and tilt in any direction. Locked by a single screw, pressing against a ball held in a cup.

Boom A bar attached to a lighting stand, designed to suspend a lamp or flash above the model's head and out of camera range.

Bounced flash Flash aimed at a wall, ceiling or other reflector, thus lighting the subject by reflection.

Bracket Applied to exposures. To take extra shots one stop, or sometimes half a stop, each side of what is considered to be the correct exposure. Allows for slight inaccuracies in metering.

Candid picture One taken without the subject's knowledge.

Colour temperature The difference in colour seen in different types of lighting. These differences are measured in terms of a theoretical 'black body'

heated to the point at which it gives out light of the appropriate colour. The colours range basically from red to blue, daylight being bluer than artificial light and artificial light being redder than daylight. The scale used to record these differences starts at absolute zero (−273°C) and the figures quoted for the different light sources are expressed in kelvins.

Compound lens One made up from several elements or individual lenses.

Concave lens One that is physically thicker at its edges than at its centre.

Convex lens One that is physically thicker at its centre than at its edges.

Depth of field The amount in a picture that is in focus each side of the point of actual focus. Depends on the aperture, and the ratio of image size to subject size (which results from subject distance and focal length). The larger the aperture, the closer the subject, or the longer the focal length, the less the depth of field.

Dupe Duplicate transparency taken from an original transparency.

Element Any one of a number of component lenses that make up a compound lens.

Film plane The area in a camera occupied by the film at its place of exposure.

Focal length The distance between the centre of a lens and the sharply-focused image that it forms of a subject at infinity. Used to calibrate and identify different lenses. Usually measured in millimetres. The longer the lens, the greater the magnification of its image.

Focal-plane shutter A shutter consisting of two blinds with a variable gap between them. As the shutter is released, the first blind begins its travel across the film plane, followed by the second. Shutter speeds are controlled by the speed of travel, combined with a variation in the gap between the blinds.

Format The physical dimensions of a negative.

Front projection A studio set-up that combines a live subject with a colour slide projected from the front on to a special screen behind the model. A beam-splitter is used to keep the projector and camera lens in exactly the same plane, thereby ensuring that the subject hides his or her own shadow on the screen.

Gel Large sheet of coloured gelatin, used to filter light sources or, in a smaller form, to filter the camera lens. Used essentially to adjust colour temperatures.

Grey card A grey-coloured card that reflects exactly 18 per cent of the light reaching it.

Guide number Sometimes called the flash factor. A number, variable with the speed of film in use and applied to individual flashguns, providing a means of determining exposure with that particular gun and film-speed combination. Guide number divided by flash-to-subject distance equals aperture.

High key A picture consisting principally of highlights, with the minimum of shadow area.

Highlight The brightest area of a picture.

Hot shoe An accessory shoe mounted on the camera and incorporating electrical contacts that mate with similar contacts in certain flashguns, eliminating the need for a cable connection.

Hot spot A too-bright spot in the middle of a photograph, usually circular and caused by inefficient reflectors or incorrectly placed lighting.

ISO International Standards Organisation. A recently introduced scale for measuring film speed. The ISO figure is a combination of ASA and DIN figures (e.g. ASA 400 becomes ISO 400/27°).

Keylight The main light in a portrait, one that gives the subject its modelling.

LED Light-emitting diode. An indicator light made from a special semiconductor material which, when supplied with a low voltage of around 1½ volts, lights up with a red or green light. Used in camera viewfinders or on camera bodies to signal certain

functions or indicate exposures. Some LEDs can vary their colour according to the current fed to them, making it possible for one to indicate two functions.

Low key A picture consisting principally of shadow areas, with the minimum of highlights.

M sync Flash synchronisation that fires the flashgun momentarily before the shutter is fully open. Designed for bulbs that take a certain time to reach their peak, thus ensuring that the bulb is at its brightest at the moment the shutter is fully open. Suitable for bulbs at all shutter speeds (focal-plane shutters excluded) and electronic flash up to around 1/30 second.

Modelling The degree and contrast of light and shadow on a face that ensures that the subject is recorded on film as a representation of its true shape.

Monochrome A range of tones of a single colour. Most often applied to the shades of grey in a black-and-white photograph.

Mounting tissue A special tissue, covered each side with an adhesive and sealed with wax. The tissue is inserted between a print and a mount and placed in a heated press. The heat melts the wax, releasing the adhesive and bonding the print to the mount.

Newton's rings Interference patterns, taking the form of concentric rings of colour that occur when two clear surfaces are not in complete contact. Moisture in the glass mounts of transparencies can keep the glasses apart, thus causing the effect.

Pan-and-tilt head A type of platform on a tripod. Consists of two lockable controls. The first allows the camera to be swivelled left and right (pan), the second controls tilt forward and back.

Parallax The difference in the view seen through the viewfinder on a non-reflex camera and that 'seen' by the lens.

Pentaprism Five-sided prism in a single-lens reflex camera, allowing the image formed by the lens on the ground-glass screen to be seen by the photographer the right way up and the correct way round.

Shadow area The darkest part of a picture.

Shutter speed A variable control over the length of time that light is allowed to fall on the film. Measured in whole seconds and fractions of a second, each speed being twice or half the duration of its neighbour.

SLR Single-lens reflex. A camera whose viewfinder system incorporates a movable mirror or prism to preview the picture actually formed by the taking lens, thus eliminating parallax.

Stop See aperture.

Synchro sunlight Flash used in conjunction with natural light to fill in shadow areas.

TLR Twin-lens reflex. A camera with two matched lenses, one to focus an image on the film, the other to project a same-sized image, via an angled mirror, on to a hooded ground-glass screen. The view is laterally reversed left to right.

TTL Through the lens. Method of metering built into certain cameras, in which the exposure reading is measured directly through the lens.

X sync Flash synchronisation that fires the flashgun at the moment the shutter is fully open. Suitable for electronic flash at all shutter speeds (focal-plane shutters excluded) and bulbs up to around 1/30 second.

Zoom lens A lens of continuously variable focal length, that does not shift focus when the focal length is changed.

Index